Volume IV

The Pallas Library of Art

# ROMAN PAINTING

Text by GILBERT PICARD

NEW YORK GRAPHIC SOCIETY

Greenwich, Connecticut

**SERIES DIRECTED BY ANDRÉ CHASTEL**

Standard Book Number 8212-0354-1

Library of Congress Catalog Card Number 70-86263

© 1968 in Italy by Istituto Editoriale Italiano, Milano

*Printed in Italy*

# Table of Contents

# List of illustrations

*Plan of Pompeii: This plan, taken from the book by R. Etienne,* La Vie Quotidienne à Pompéi, *shows clearly the extent of the excavations (one sees that more than one third of the city has not yet been excavated) and the sites of the most important houses with mural paintings; most of these are in Region VI, in the north-west, or along the Via dell'Abbondanza. The houses of Pompeii are designated by a proper name (perhaps that of the Roman owner – for example the House of the Vettii), or by a name relating to some event of the time of the discovery of the house (the House of the Silver Wedding was being excavated when the king and queen of Italy celebrated their silver wedding anniversary), or by a group of three numbers: the first indicates the region, the second the block, and the third the house itself. Thus the House of the Vettii is VI 15 1.*

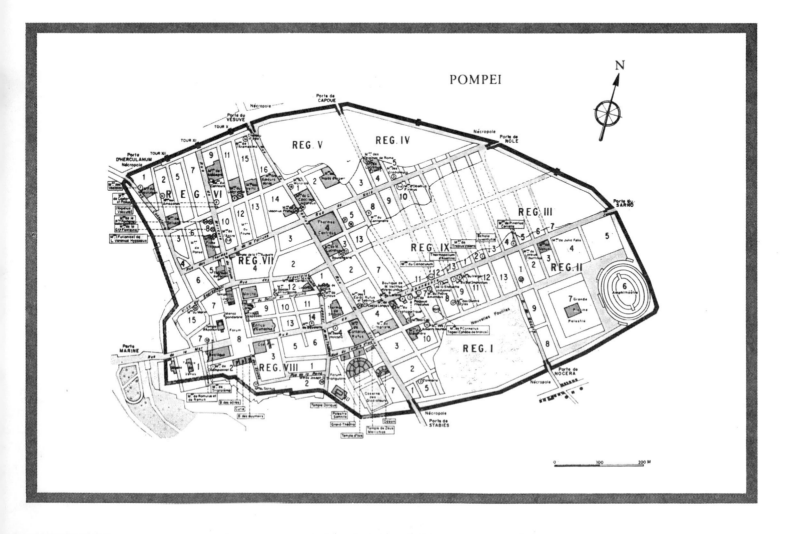

## CHRONOLOGICAL CHART

| | |
|---|---|
| 753 B.C. | Traditional date of the founding of Rome. |
| 650-510 | Reign of the Etruscan dynasty of the Tarquins. Probable beginning of painting in Rome. |
| 493 | Paintings by the Greeks Damophilos and Gorgasos in the Temple of Ceres. |
| 304 | Fabius Pictor decorates the Temple of Salus. |
| 256 | Messala exhibits a painting representing his victories in Sicily. |
| 2nd Cen. | Pacuvius decorates the Temple of Heracles in the Forum Boarium. |
| Before 80 | Pompeian First Style. |
| c. 80 | House of the Griffins on the Palatine. |
| 80-40 | Early phases of the Second Style: House of the Labyrinth, Villa of the Mysteries, House of Fannius Synistor. |
| c. 30 | "House of Livia" and Augustan constructions on the Palatine. |
| | In Pompeii, House of the Silver Wedding and House of Menander. |
| c. 20 | House of the Farnesina, Aula Isiaca on the Palatine. |
| 46 B.C. - 7 A.D. | Villa of Agrippa Postumus at Boscotrecase. |
| 1-30 | Classical phase of the Third Style: House of the Fatal Loves. |
| 30-50 | Romantic phase of the Third Style: House of the Priest Amandus; Isis Ceremony, Herculaneum. |
| 50-60 | House of Lucretius Fronto; Domus Transitoria of Nero. |
| 63 | Fire in Rome. |
| 64-68 | Earthquakes in Pompeii. |
| 64 | Golden House of Nero. At Pompeii, the earliest paintings of the House of the Vettii; Houses of Pinarius Cerialis, Apollo, Joseph II, Palestra. |
| 68 | Death of Nero. |
| c. 70 | Houses of the Dioscuri, of the Tragic Poet. |
| 70-79 | Houses of the Ara Maxima, of the Ancient Hunting, of Loreius Tiburtinus. |
| 79, August 24 | Destruction of Pompeii. |
| 110 | Baths of Buticosus at Ostia. |
| 120-130 | House of Ganymede at Ostia. |
| 127 | Mosaics of the Serapeum at Ostia. |

## A riches of Roman painting

The pictorial arts are among the most significant elements in the artistic legacy of Rome if only because of the sheer volume of preserved works. Thousands of frescoes have been recovered, chiefly in Herculaneum and Pompeii, where as the result of the eruption of Vesuvius which destroyed the two cities, a protective coating formed on the painted walls. The wealth of mosaics is perhaps still more abundant and in any case is more widely distributed over the entire empire. By a stroke of good fortune the expansion of this medium took place at the very time of the destruction of the Campanian cities, thus supplementing the source materials for the history of the pictorial arts as the wealth of preserved paintings themselves diminished. Our documentation is at first concentrated in Italy during the period when all the vigorous forces of the Mediterranean world converged there; subsequently the monuments were produced widely, from the Atlantic to the Euphrates and from Scotland to Nubia as the conquered peoples found themselves on an equal footing with their conquerors and free to partake of the benefits which peace brought for a time.

This mass of pictorial documentation is too great for the present volume to include in its entirety. We will therefore limit ourselves to the paintings and mosaic pavements found in the cities of Italy and that date for the most part from the first century B.C. Nevertheless, we do not agree with those who refuse to consider as Roman the art of the provinces. Even in those places where local traditions were strongest — in Greece, for example, or Asia Minor — no artist was able for long to hold out against the influences emanating from the capital; in fact, for a long time artists submitted to these influences so completely that their work appeared to be little more than a reflection of the products of Rome. The reawakening of regional differences coincided closely with a widespread aesthetic revolution, not even sparing Italy, against the prevalent style as it was beginning to decline. Toward 170 A.D. there occurred what the German art historian G. Rodenwaldt has called the great turning point of Antonine art. This juncture in time separates the final productions of Classical Antiquity from the first creations of the Late Antique, the principles of which are already those of the Middle Ages. The Italian heritage is, therefore, distinct from the Imperial heritage, not only geographically but chronologically and stylistically, and it is perfectly justifiable to examine it alone.

## Painting — an art guide to Rome

Painting — whether executed with fluid colors or with solid particles joined together — has an eminent place among the artistic efforts of Rome not alone because of the abundance and variety of the monuments. This medium of expression has always suited the Latin genius perfectly,

---

*I  Painting from an underground burial chamber on the Esquiline showing scenes of war, Museo Nuovo Capitolino, Rome; third century B.C.  A unique vestige of Roman historical painting, this work belongs, in our opinion, to the school of Fabius Pictor; one already finds here the "continuous style" which will be used in the second century A.D. on the Columns of Trajan and Marcus Aurelius.*

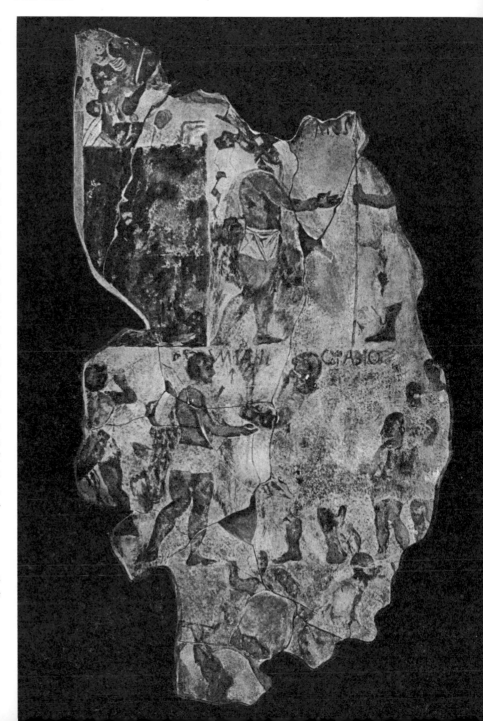

whereas in Greece it always held second place, after sculpture. It is significant that the first truly Roman artist known to us chose to become a painter: the ancient Fabius, who lived during the heroic period when the Roman Republic fought the Samnites for the hegemony of the peninsula. Moreover, his family, one of the six *gens* [clans] who became patricians by virtue of their antiquity and glory, found nothing shameful in his activity; on the contrary, the surname Pictor henceforth distinguished the artist's descendants and their cousins. The Fabii, whose estates were situated at the northernmost limits of the Latin territory, had always entertained close relations, often amicable ones, with their Etruscan neighbors, and for a long time the young men of the family had gone to Etruria to complete their education. Perhaps it was in the ateliers of Tarquinia that Fabius acquired both his taste for, and his facility with, the brush, but he no doubt would have found it difficult to admit his vocation to his family if his talent had served merely to give him aesthetic satisfaction. The great work which he completed about 300 B.C. was the decoration of the interior of the Temple of the Goddess of Health, which was erected on the Quirinal; this was a purposeful, practical job, intended to attract to the Roman people the benevolence of the divinity who prevented epidemics. Furthermore, it is generally accepted that these frescoes depict the victories won by the legions in the thirty-year war just ended against the Samnites. Thus a patriotic theme is joined with a religious one. Valerius Maximus, who relates the preceding information, unfortunately did not think it worthwhile to describe these frescoes; modern historians have often supposed a resemblance to such Etruscan historical paintings as those of the François tomb at Vulci, the date of which is still hotly debated (as is the case of most of the later Etruscan works). Such paintings were strongly influenced by the great Greek masters of the fourth century B.C., who were often interested in scenes of battle. But a tomb recently discovered on the Esquiline in Rome (pl. I) is decorated with military scenes that arc relatively much more naïve in style; they constitute a kind of film, the episodes following each other as in our picture books for children; this convention will be revived during the Imperial era on the great sculptured columns of Trajan and Marcus Aurelius. The manner in which the painter of the Esquiline tomb groups the figures, the ease with which he reduces the size of the buildings in relation to the figures in order to fit them into the space, all this also forecasts the great triumphal friezes of the Caesars. We believe, contrary to prevalent opinion, that the Esquiline paintings preserve for us a reflection of the work of Fabius, the true creator of Roman historical painting, a genre less skillful but more expressive and more effective that the Greco-Etruscan works; in the latter, if the names of the figures were not inscribed over their heads, nothing would enable us to distinguish the Tarquins or the Mastarna, authentic actors in Italian history, from the more or less fabled heroes inspired by Greek poetry. On the other hand, when confronting the figures in the paintings on the Esquiline — one of whom is a Fabius — we cannot doubt that these are people of the fourth or third century B.C., and if the work had been preserved in its entirety, we would have a very satisfactory report of their exploits.

From the beginning, therefore, Roman painting appears in sharp contrast with both Greek and Etruscan painting in the extent to which it followed the principles of Hellenism. The Greek painter was truly an artist, his intent basically, if not solely, aesthetic; and as the Greek artists and thinkers felt that nothing in the world was as beautiful or as interesting as man, all the Greek paintings which we know are essentially studies of the human body — or of a few noble animals, such as the horse — in repose or action; still lifes and landscapes appeared quite late, in Egypt and above all in Asia Minor. This orientation explains why Greek painting was, on the whole, subordinated to sculpture, in the round and relief, which was always considered the major art.

## The practical uses of Roman painting

Greek painting had been greatly admired by cultivated Romans who held it in higher esteem than their national production. The people of taste, toward the end of the Republican period and during the Empire, tried by all means to acquire paintings by the great Hellenic painters for their homes, and when they could not get original works they had copies made; later we will see the consequences for wall decoration of this craze. But these connoisseurs hardly dared admit their passion, which public opinion would have judged ill. The general public considered the arts as useless and dangerous unless they were justified by moral or practical uses. This "Boeotian," or unimaginative, attitude ultimately had happy consequences, since without it the conservatism of cultivated people would have stifled all the spontaneity of Italic creativity, and the studios would have been limited to the endless reproduction of Greek works of the Classical period. Happily, these were much too abstract to serve the publicizing intentions which interested the politicians and the Roman man in the street. What was needed was a means

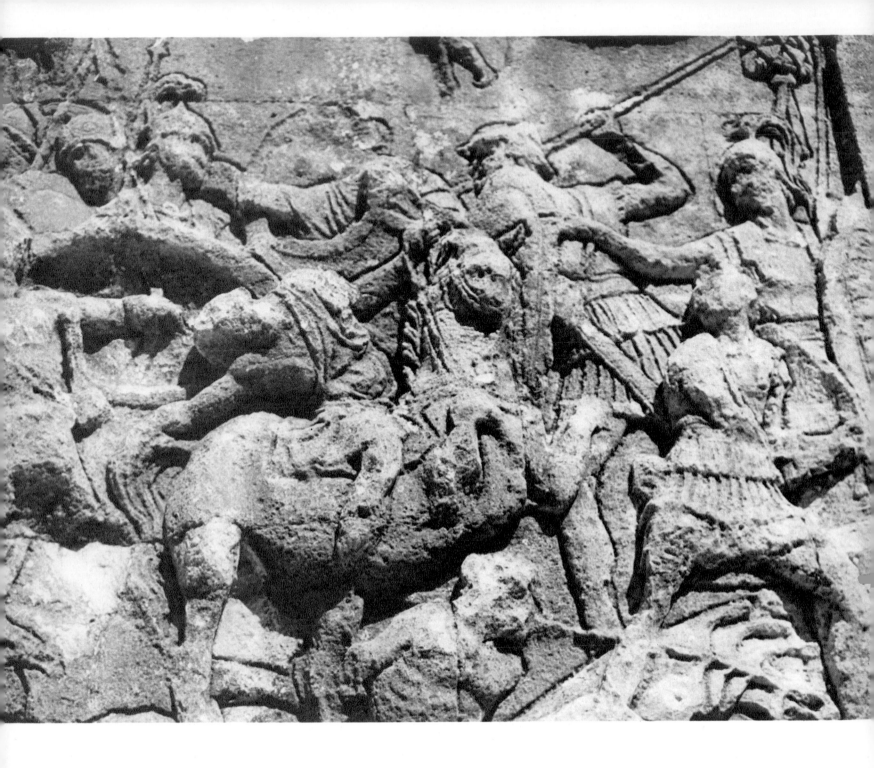

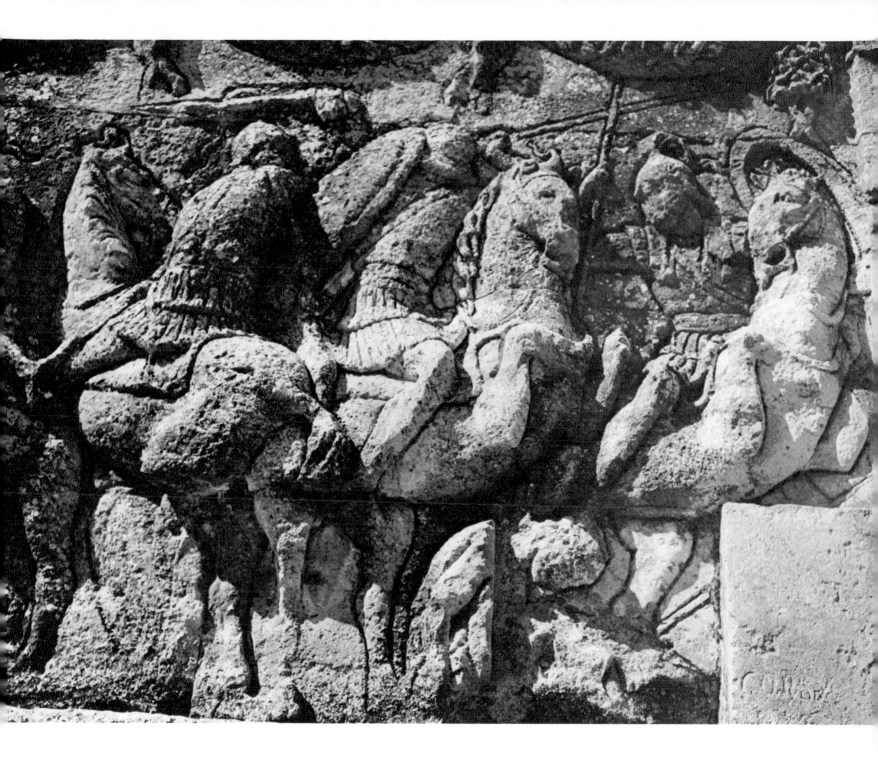

II  Details of the decoration of the Mausoleum of the Julii at St. Rémy de Provence, the ancient Glanum.  At left is a scene inspired by the death of Troilos at the hand of Achilles, but adapted to the portrayal of contemporary events.  The cavalry battle at right is derived directly from the monument of Servilius Pulex, known from the coin reproduced in plate III.

of informing the citizen of the exploits of the armies and
their chiefs, on the occasions of their triumphs or at elec-
tions. The painter entrusted with such a task could, from
time to time, when he had to commemorate some great
feat, draw inspiration from some work by Apelles, his
followers, or his rivals, devoted to the glorification of the
era of Alexander the Great and to the wars of his heirs,
the *Diadochi* [the Macedonian generals who divided his
empire]. We have been able to reconstruct, by availing
ourselves of a bas-relief from the Mausoleum of the Julii
at St. Rémy de Provence (pl. II) and a coin of the *gens*
Servilia (pl. III), a scene representing an equestrian duel
between a famous Roman champion of the period of Han-
nibal and one of the Gaulish knights who enlisted himself
in the service of Carthage. In this instance, the absence of
background and the choice of poses clearly reveal an almost
servile imitation of a Greek fourth-century model. But
Greek models did not suffice for certain subjects. Pliny [1]
mentions a painting commissioned by the financier Hostilius
Mancinus depicting the bold attack to which Carthage
yielded in 147 B.C. The artist was forced to represent
at least the approximate topography of the city and the
circumstances of the battle; the Greek pictorial repertory
could not help him in this task, and the elements of
classical composition would not have enabled him to make
the unfolding events comprehensible to the Romans. In
order to achieve his aims it was necessary for him to aban-
don the logical principles which the Greeks respected
religiously and substitute specifics: he had to juxtapose
episodes which succeeded each other in time; to introduce
geographic elements — the sea, the cliffs of Sidi Bou
Said, and the buildings, to which he could not apply
the same proportions as the combatants, and which he
therefore had to schematize; and to render exactly the
armaments of assailants and defenders, and of their ma-
chines of war, so that the action would be easily comprehen-
sible and the old veterans among the spectators would be
unable to complain about the lack of realism. His work
must therefore have resembled the fresco from the Esqui-
line very much, with its naïveté allied to verisimilitude.

During the second and first centuries B.C. the great
number of Roman victories from one end of the Mediterra-
nean world to the other stimulated a flood of commissions
for painters of battles. Unfortunately we know nothing
about these artists; their names, their ethnic origins, and

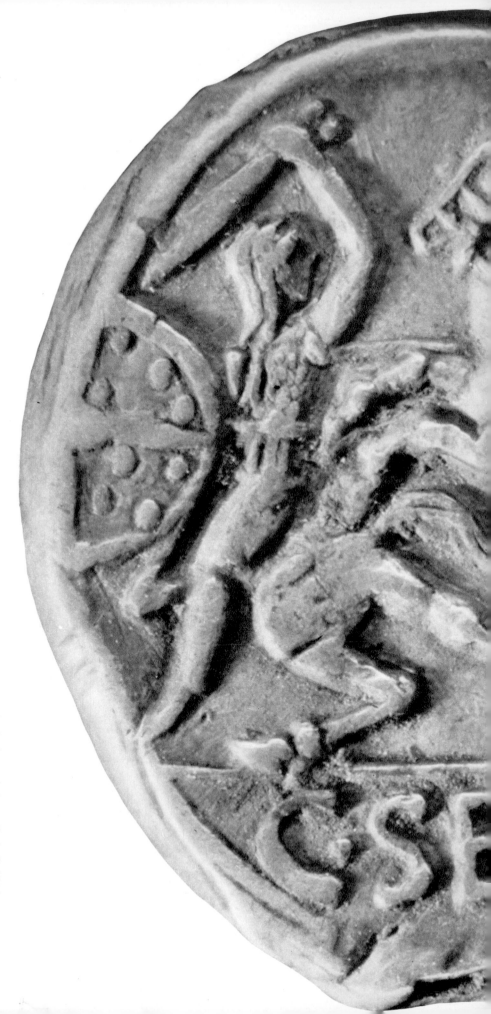

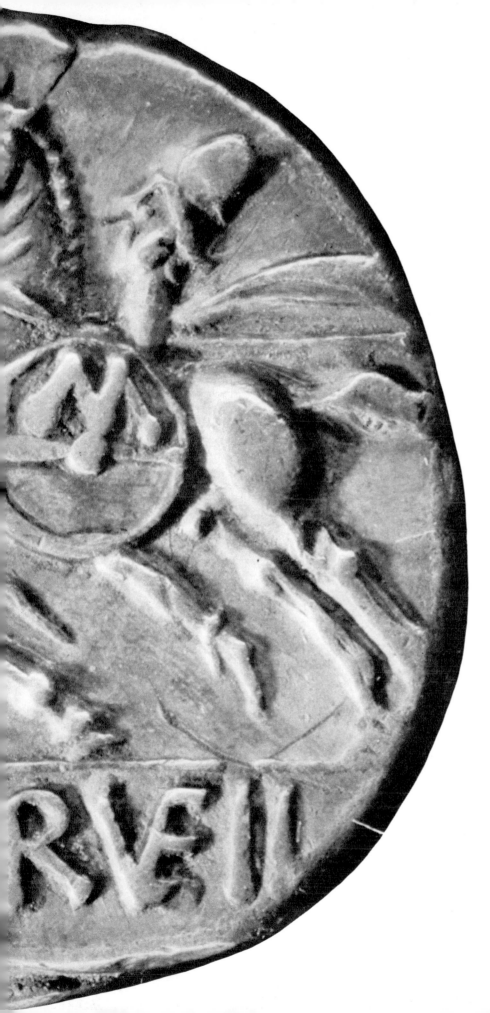

their works have perished completely. A few passing allusions by historians describing the triumphal ceremonies of which their works were a part give some indication of their subjects. The reverse of coins struck during this period by the scions of noble families, anxious to revive the glory of their ancestors, "miniaturized" such pictures from time to time (pl. Va). These hints and allusions are too few and meager to enable us to follow the evolution of this art.

### Triumphal and historical painting

For the very end of the Republic we have a very important document of this genre. This is a fresco also discovered on the Esquiline, in a *columbarium* (now in the Museo delle Terme); it depicts the legend of Rome's origins, which had assumed the aspect of a sacred story since it justified the election of the king by the people. It was this king who was destined by Providence to rule the universe. The episodes — the best preserved depicts the construction of a city — follow one another according to the principle of the continuous roll. But the technique is much less naïve than that of the "Fabian" work, and the proportion between the people and the framework of the scene is nearly correct. "The gracefulness of the design" — R. Bianchi-Bandinelli has written — "is mid-Hellenistic in origin." The artist is primarily interested in movement, in the force of energy; the scenes of the infancy of Romulus reflect the affectation of Alexandrian pastoral painting. Unfortunately, when Roman art departed from coarseness it only fell into banality. Happily the taste for the concrete restrained this inclination: the masons who supposedly built Alba, or the "Square Rome" of the first king, are, after all, the builders of the Theatre of Pompey or of the Forum of Caesar.

Around this time a new interest, born of their practical spirit, turned Roman artists — or rather their patrons —

*III Coin of the* gens *Servilia, struck in 94 B.C., depicting a combat between Servilius Pulex and a Gaulish horseman during the Second Punic War. The work reproduced here must have been a bas relief, one also used as a model by the sculptor of the Mausoleum of the Julii at St. Rémy. It is a transformation of the great battle scenes created in fourth-century Greece: in sculpture by Lysippos and his school, and in painting by the painters of historical events, like Philoxenos of Eretria.*

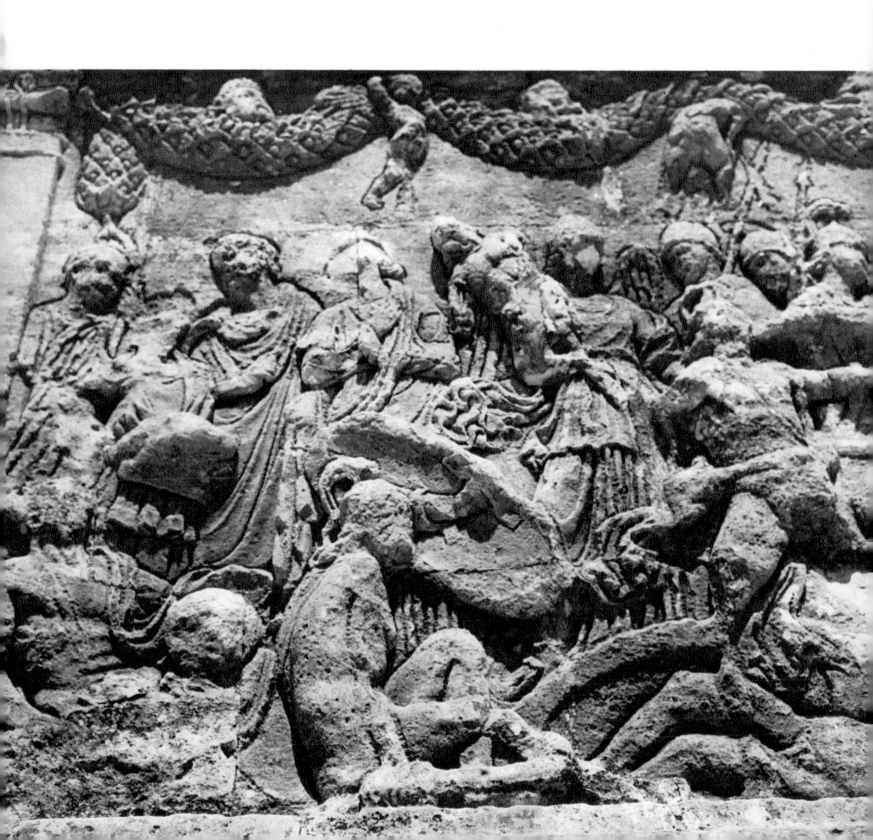

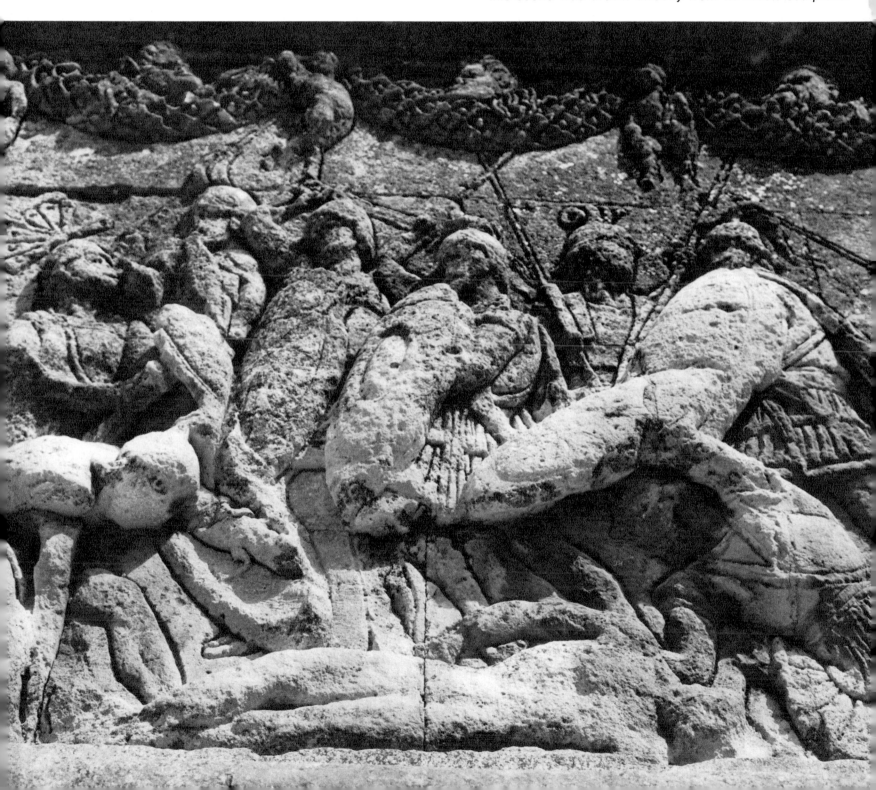

IV Decoration on the base of the Mausoleum of the Julii at St. Rémy de Provence, the ancient Glanum. The battle scene at right was inspired by the struggle over the corpse of Patroclos, but the figures carry arms of the first century B.C. At left two men and a draped woman listen to a winged woman reading from a book; this scene was drawn directly from Etruscan sculpture.

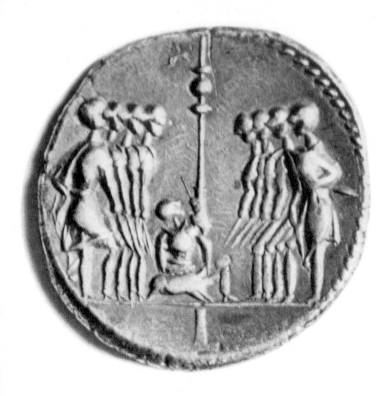

along a new path. These paintings upon which one depended for the perpetuation of national and family glories were very fragile; as early as the period of Caesar very little remained of those exhibited one or two centuries earlier. Would it not be possible to use a less ephemeral technique to the same ends?

## The transposition of painting into relief

Since the beginning of the first century B.C. stone relief had been adopted as the medium of expression for the dominant ideological tendencies, along with coins and painting. Thus a frieze found at the foot of the Capitoline, on the Via della Consolazione (pl. VIII), depicts armor and trophies in an arrangement borrowed from Asia Minor, but in a style which expresses the politico-religious doctrines on which the dictatorial power of Sulla was established. Toward the middle of the century, the decoration of a base or an altar which was erected on the Campus Martius, near the Circus Flaminius, linked some apparently conventional marine mythological figures to some scenes of contemporary political life. An analogous amalgam was fashioned in the following generation by the "master of the Ara Pacis" (pl. XI); that artist glorified Augustus in a sculptural epic connecting the imperial regime to the legendary history of the supernatural origins of the Roman people. A little earlier — around 30 or 20 B.C. — Cartilius Poplicola, a person of note in Ostia, commissioned a tomb on which the exploits of his military career were represented in a remarkably naïve style, one very close to

that of commercial signs. On the other hand, during the same period a middle-class family in a small Greco-Celtic city near Marseilles, Glanum (now St. Rémy de Provence), had the base of their mausoleum decorated with large bas-reliefs of a noble type in which mythological and literary allusions are inextricably wedded to contemporary events.

Thus, in every respect relief sculpture tended in part at least to displace painting, which had served for two centuries as the favored means of expressing the national and imperial consciousness of Rome. The substitution was never complete: the existence of triumphal paintings is attested until the third century A.D. at least, and if their importance is not evident at first sight it is because they have disappeared no less completely than their Republican predecessors. But it is still possible to imagine them exactly, just because of the influence they exercised upon reliefs.

## The « continuous style » of Roman pictorial reliefs

From the day when stone sculpture was required to play the same role which painting had previously played, it was forced to achieve the same effects as those peculiar to pictorial art. Like the painters, the sculptors wanted to represent all the phases of an unfolding action by juxtaposing the various episodes in a sort of film. Moreover, there was at least a tentative precedent in Hellenistic art: one of the friezes of the Great Altar of Pergamon depicts the various episodes of the legend of Telephus, which bears a great resemblance to that of Romulus. But the Romans were to give great dignity to this convention by the creation of the gigantic spiral column, the shaft of which was not only a hundred feet high but entirely covered by a helical frieze. The first of these monuments is the Column of Trajan, the precedent for which has eluded the ingenuity of historians of art; the fact that it was doubtless created by an architect originally from Damascus, Apollodoros, should not prevent its being considered authentically Roman. The endeavor was repeated once again in Rome by Commodus in honor of his father, Marcus Aurelius, who died in 180 A.D., and two hundred years passed by before it was used again, this time in Constantinople by Theodosius the Great and his son Arcadius. To date, the most satisfactory explanation for the principle of the spiral column is that it reproduces on a colossal scale a *volumen*, an illustrated scroll which one unrolled around a spindle in order to view it from one end to the other. The continuous style was also used on the panels which decorate the triumphal arches; for example, the Arch of Septimius Severus in the Roman Forum

*V  Far left: Coin depicting an oath-taking, struck by the Italic Confederation during the Social War (91-89 B.C.).  Like other coins of this period or later, it reproduces in miniature a painting or bas relief.  From the point of view of art history, its interest lies mainly in the rendering of the perspective so that it recedes in depth, attesting the progress already made by the beginning of the first century B.C. in the area of spatial expression.  Center: Obverse of same coin.*

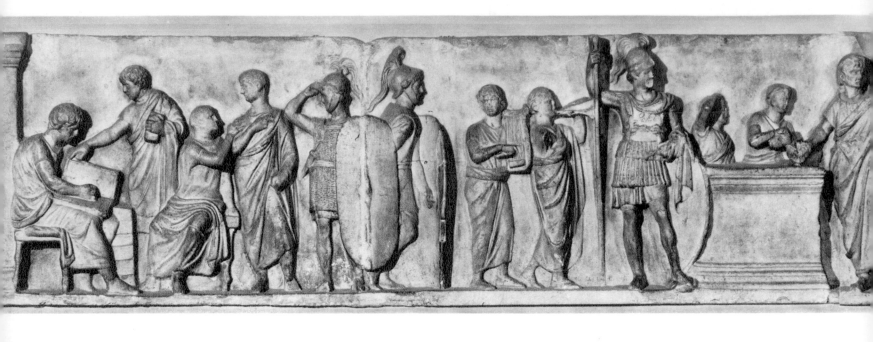

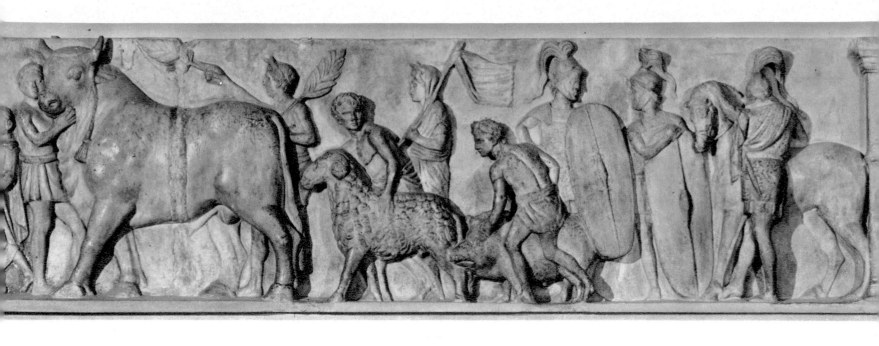

VI "Frieze of Domitius Ahenobarbus," in the Louvre.
This frieze decorated the sides of a base or an altar on
the Campus Martius; the other sides of the monument,
now in the Museum in Munich, were decorated with
reliefs showing the marriage of Poseidon and Amphitrite.
For a long time this monument was thought to have
been dedicated by a member of the family of the Domitii
Ahenobarbi, but this attribution has been abandoned
and the work is now dated about 60 B.C. In any case,
it is a unique example of historical sculpture of the Re-
publican period, closely related to painting. The scene
depicts the return of young men to military service, and
the ceremonial sacrifice called the suovetaurilia, offered
to Mars at the outset of a campaign.

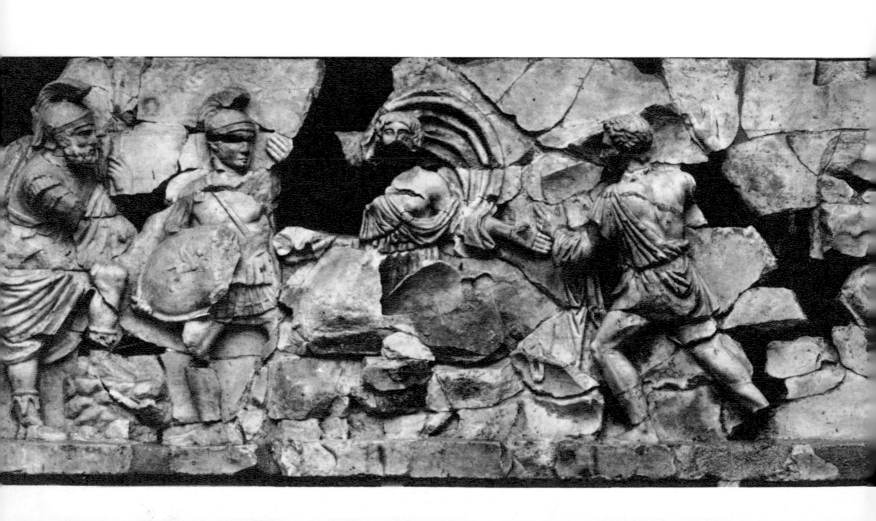

VII  Frieze from the Basilica Aemilia in the Roman Forum, depicting the legendary origins of Rome.  The detail reproduced illustrates the myth of Tarpeia, the young girl who was buried up to the waist by the shields which the Sabines threw at her to crush her.  The female figures at right are part of a marriage scene that belongs to another episode.  The date is disputed; the beginning of Augustus' reign according to H. Kähler; more likely c. 60 B.C., as G. F. Carettoni has demonstrated.

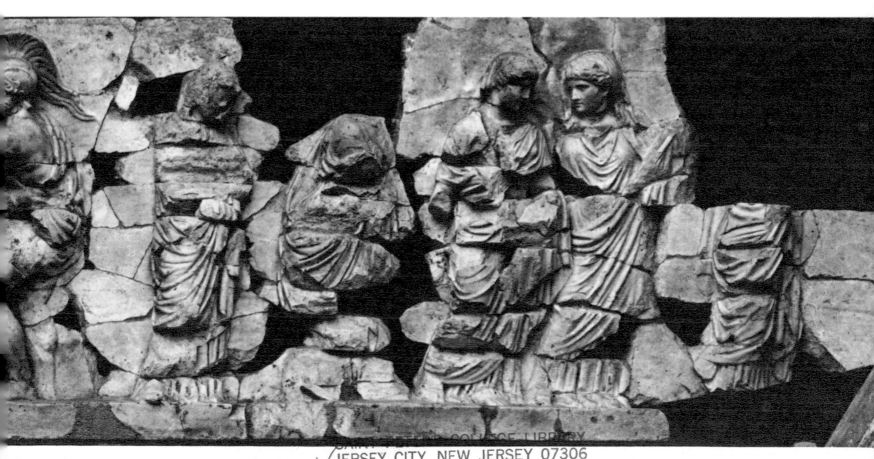

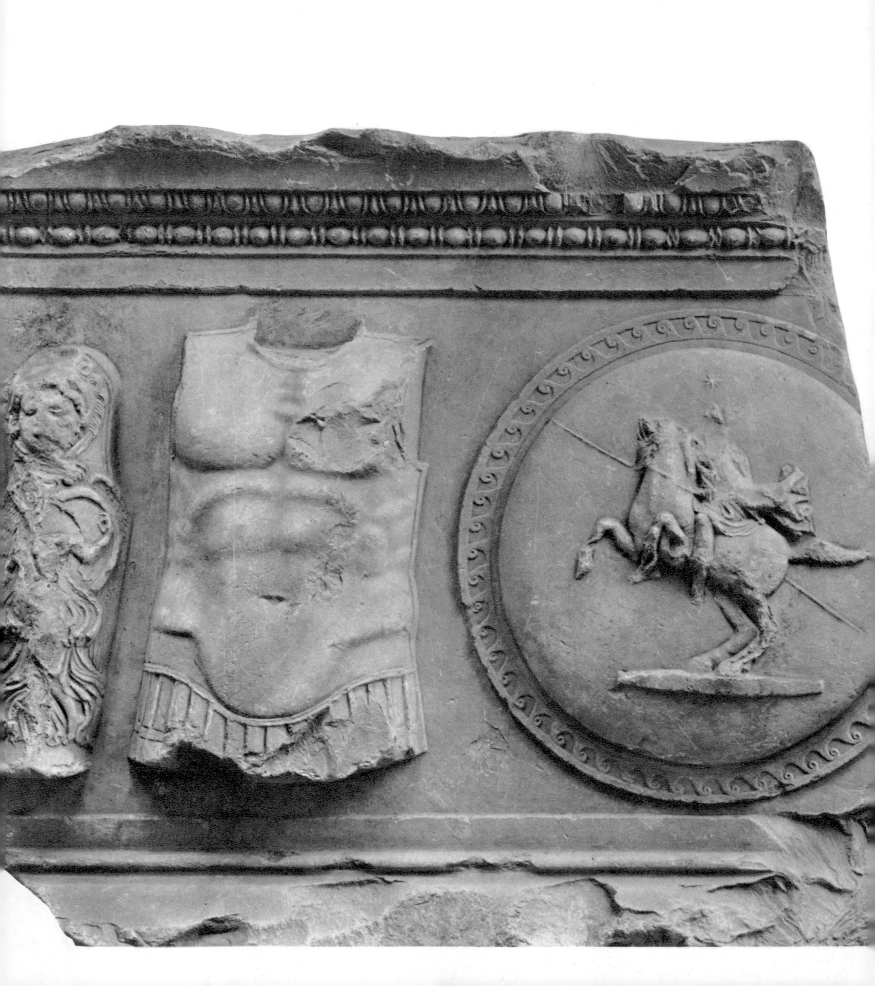

has four panels illustrating the war led by this emperor against the Parthians. Each of these panels is subdivided into two registers, both depicting the same site but at two different stages of the narrative. We know that these reliefs were modeled upon paintings. The historian Herodian tells us that he had seen the pictures representing the Parthian war and it was after having seen them that he recounts their events. His account is in perfect agreement with the version on the panels of the Arch. However, it differs from the infinitely more likely account of another contemporary historian, Dio Cassius. In truth the war had few victories and was concluded with a resounding repulse; thus the forces of propaganda had without scruple recast the story by interposing several episodes to deflect the shame which fell on the Imperial army for its defeat. It is this latter version which Herodian and the sculptors of the arch in the Forum preserve for us.

The continuous style not only appears on official monuments; it is also found on the sarcophagi which appear in Rome in the first years of the second century A.D. Many of these marble caskets portray Greek myths; others highlight the life of the deceased and glorify his virtues; some juxtapose, usually on their principal side, two or three successive scenes.

The connection of this form of expression with pictorial art is confirmed by illuminated manuscripts: the earliest preserved examples, the Vatican Virgil and the Ambrosian Iliad, belong to the fourth and fifth centuries A.D.

## Reliefs with aerial perspective

The continuous style, although alien to Classical Greek art, did not pose any particular problems to sculptors. But the sculptors, always pursuing a course set by the painters, wanted to master not only time but space. With regard to the latter the Greeks had adopted a simple solution in their reliefs.[2] All figures, usually in profile, were placed in one plane — a strip without depth parallel to the picture plane — in which they moved against a neutral ground in artificial isolation. Vases show that the painters at first had adopted an analogous formula; but, beginning with the middle of the fifth century, they became more and more interested in depicting subjects frontally or from the rear, in order to permit a study of foreshortening. When these figures were in a reciprocal relationship, engaged in combat, for example, the sense of the movement developed perpendicularly or obliquely with regard to the background, so that henceforth the action took place in a three-dimensional field. Polygnotos of Thasos, who was active between 470 and 460 B.C., was the first to represent more than backgrounds. The natural tendency of all draughtsmen is to represent the background behind the first plane; this method was used

*VIII Triumphal frieze from the Capitol, in the Museo Nuovo Capitolino. The very ornate armor commemorates a victory won in Asia. The work dates, according to M. E. Bertoldi, to the second century B.C.; in our view, to the reign of Sulla (thus c. 80 B.C.). Stylistically it belongs to the Neo-Attic school.*

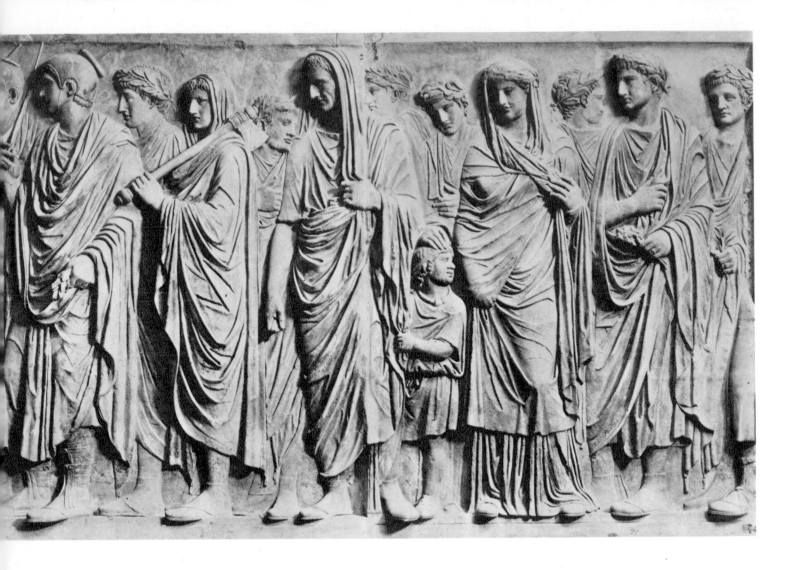

by certain potters, and we will see that it was often revived by the Romans. The method of Polygnotos is hardly much more advanced; it consists in indicating a background sloping down toward the bottom, which logically justifies stratification. The rules of mathematical perspective were only discovered toward 400 B.C. by Apollodoros of Athens, at the same time that the use of shadows to suggest plasticity came into use. However, even after these discoveries were made, the Hellenic artist showed little interest in exploring the matter further. One of the most complex compositions to come down to us is the Battle of Alexander and Darius III at the Issus, known by the mosaic copy found in the House of the Faun in Pompeii (pl. XVI) of an original painting dating from the very end of the fourth century B.C. In this work warriors are shown grouped on a relatively narrow platform, as in a scene from the theatre; the presence of masses of people in the rear is suggested by the high Macedonian lances, which also serve to fill the upper part of the field. This effect, used again by Velasquez in The Surrender at Breda, will, as we shall see, be repeated often in Roman art. The resemblance to a theatrical scene is emphasized by the simplicity of the landscape background, which is reduced to a tree with branches.

In order to find an ancient composition in which people move within a limitless landscape treated according to the rules of perspective, it is necessary to wait until the middle of the first century B.C. The Odyssey Landscapes, discovered in a house on the Esquiline, are the best examples of this type, from the point of view of technique, to come down to us from antiquity. In all likelihood, they are copies of Alexandrian works, the originals of which predate them by a century. In general one can state, although the documents establishing this thesis absolutely are missing, that the technical advances made at the beginning of the fourth century were followed up by others, notably in Greco-Macedonian Egypt, and that the Romans only inherited these attainments.

This thesis is only one aspect of a more general doctrine expounded in a most brilliant fashion by R. Bianchi-Bandinelli.[3] According to this scholar the whole of Roman art until the first century A.D., aside from the popular trend, is nothing more than a continuation of Hellenistic art in the service of Rome. We will analyze this thesis more closely in the following chapter, but it is necessary to bring it up now in order to find out if the official art of the great emperors and the Julio-Claudian princes, and especially triumphal art, is really only a continuation of that of the *Diadochi* and Greco-Macedonian royalty, or if it expresses not only in its content but in its form the national conscience of the people-king.

## The stuccos

In our view the answer to this question lies in the following observation: technical progress shows itself in those sectors which give expression to a clearly Roman ideology. Within the area of our documentation, the sector in which we can best follow this enrichment where public art is concerned is relief sculpture. We contend — and this is not a new observation but one originating with Wickhoff [4] — that the artists of bas-reliefs had considerably augmented their possibilities, notably by using forms of expression advanced by painters and by borrowing from popular art. But it has not been stressed enough that during the same time other arts coming entirely from the Greek world, and therefore appreciated by the Romans, were stagnating because their existence was dependent upon a foreign psychology. This is especially the case with stucco decoration. There are in Roman museums, and even in a few cases in their original sites, quantities of large compositions created in this material to decorate ceilings — much more rarely walls — of houses, sanctuaries, and tombs. The rise of this medium extended over two centuries at least, from 50 B.C. until 180 A.D. But during this long period, neither the subject matter, nor the style, nor the methods of composition perceptibly evolved. The only changes which had occurred were compositional ones imposed by the demands of architecture. The stuccos do indeed express an ideology, but one alien to the mainstream of Roman thought. The stuccos from the Farnesina, for example, have a Dionysian subject, but under the Julio-Claudians, Bacchism was a suspect religion, contrary to official morality. The Basilica under Porta Maggiore, a truly pagan church, its walls revetted with stuccos symbolizing the faith of its adherents, belonged, as F. Cumont and J. Carcopino have shown, to a neo-pythagorean sect which briefly seduced the young Octavius [5] but which this same Octavius severely persecuted when he became emperor; moreover, his successors also dealt harshly with this sect. The stagnation of stucco technique seems then to go hand in hand with objection to the ideology of its users. In contrast, marble relief, ennobled first by Augustus and subsequently by his heirs, who entrusted artists with the task of translating their political conceptions into plastic forms, benefited from all the discoveries of the most gifted artists of the time.

These discoveries were reached after slow and patient research on how to transpose into stone the spatial depth that had been achieved by Greek painters. Thus these reliefs really became "paintings in stone." The first endeavors in this direction had already been made by Etruscan sculptors, between the third and the first century B.C., in cinerary urns, thousands of which have been recovered from subterranean tombs. The figures decorating these small monuments move in three dimensions; but the artist has obtained this result by detaching the images from the mass of the block, like so many independent figurines. This

*IX Ara Pacis: procession. Dedicated in 13 B.C., finished and consecrated in 9 B.C., the Ara Pacis is the most characteristic monument of Augustan classicism. This part of the frieze depicts, from the left, the flamens (priests) in round caps, the attendant with hatchet who will perform the sacrificial rites, then the imperial family led by Agrippa, recognizable by his height and his veiled head. Behind him are his son Caius Caesar and his wife Julia, the daughter of Augustus.*

*X Frieze from the tomb of Cartilius Poplicola in Ostia. Cartilius was a leading citizen of Ostia who governed the city during the troubled period of the Second Triumvirate. The monument can be dated between 30 and 20 B.C.; it depicts, in the naïve style of popular art, some military events difficult to identify, in which the deceased must have taken part.*

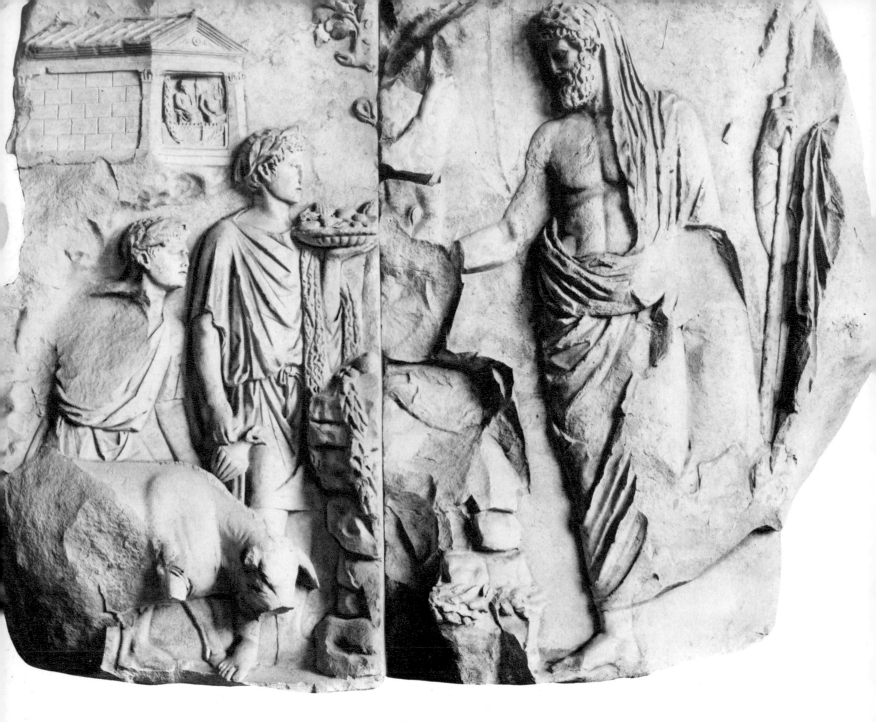

method was no doubt inspired by the statuary groups made up of a number of figures which Greek art had produced from the fourth century on. Lysippos had depicted Alexander in this way when he sculpted him as the victor of the battle at the Granicus surrounded by at least twenty-five of his courtesans. "Such groups with many figures were novelties, at least in sculpture.... Only the example of frescoes gave Lysippos the authority to attempt within his own means a version of the mosaic of the battle of Arbela."[6] Brought to Rome by Metellus, this work was exhibited by Augustus in the Portico of Octavia and must often have served Roman artists as inspiration. During the second century the sculptors of Pergamon further reduced the gulf between their medium and that of painting in the rough clay models of battles in which the numerous combatants were depicted in half life size. From the high

reliefs of Etruscan urns to these models — which were transposed into relief by Roman sculptors, most notably in the sarcophagi of the second century A.D. — the transition is almost imperceptible. But neither the one nor the

---

*XI Ara Pacis: the Sacrifice of Aeneas. The scene shown here is one that Virgil made famous: Aeneas has just discovered the sow with thirty piglets, the apparition which indicated the end of his journey, and he is about to sacrifice it. The sculptor has placed the scene in a picturesque setting inspired by Alexandrian sculpture.*

*XII Ara Pacis: vine scrolls. This magnificent plant decoration, inspired by Pergamene art, as T. Krauss has demonstrated, is an example of the "inhabited vine scroll" where little animals are sheltered in the coils of the greenery.*

26

other achieved a pictorial perspective: they placed the figures in a real space and did not try to create a fictitious space as the painters did.

The oldest sculptured monument on which an imaginary space appears is the Mausoleum of the Julii at St. Rémy de Provence, the ancient city of Glanum. The artists who decorated this tomb between the years 30 and 20 B.C. had been trained in North Italian ateliers, where the Etruscan tradition survived. One can therefore suppose that the Tuscan sculptors were able to transpose pictorial represen-

in the following chapter that it is at this moment that wall painting develops along completely original lines in order to express the state of mind of the Latin aristocracy, which continued not only as the ruling class of the Mediterranean world but as its intellectual elite.

The confrontation and subsequent synthesis of these diverse elements gives birth during the last quarter of the first century B.C. to Augustan classicism. The anonymous artist who dominates this period is the master of the Ara Pacis, whose earliest work, in our opinion, is the interior

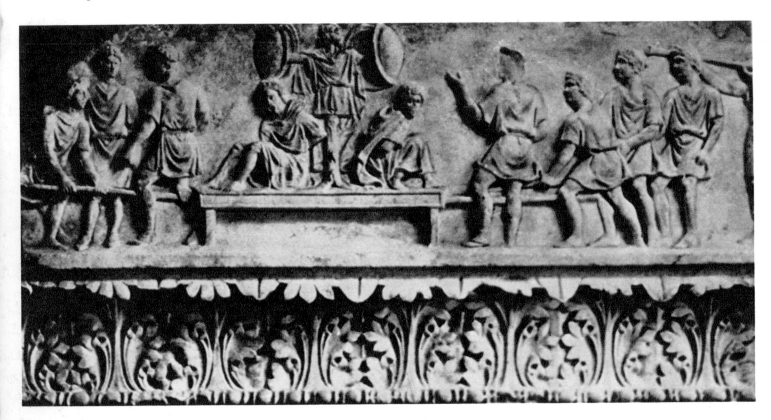

tations of space into stone by the end of the second century B.C. or at the beginning of the first century B.C. This hypothesis is confirmed by a study of coins struck during this period. The most remarkable is a denarius issued by the Italian insurgents (pl. V) during the so-called Social War *circa* 90 B.C.; it shows two armies, aligned face to face in order to take an oath of allegiance, in a receding perspective which very effectively gives the impression of spatial depth. In addition, one must take note of other contemporary works or works produced by the next generation, such as a coin commemorating the capture of Jugurtha by Sulla,[7] and the relief from Ostia [8] which shows fishermen extricating a statue of Hercules from their nets, which employ the simple method of superimposed planes to suggest the third dimension. One can thus distinguish from this period onward not only a sophisticated trend but also one using simpler means. This dualism, which persists throughout antiquity, singularly complicates the task of the art historian.

The first half of the first century B.C. was a very important period for the development of Roman art. During this time Rome unified the diverse cultural currents of Italy and at the same time attracted to Italy the productive forces of the Greek world which Rome had ruined. We shall see

frieze of the Temple of Apollo (pl. XIII) in the Circus Flaminius (*circa* 20 B.C.) and whose latest is the decoration of the Arch of Tiberius in the Roman Forum (16 A.D.), known only from the silver cups from Boscoreale which reproduce it.[9] This master, whom we believe to have been an Italian, interests himself hardly at all in the representation of space in relief. When he does attempt it, as for example in the Ara Pacis panel showing the Sacrifice of Aeneas (pl. XI), he does so in the manner of the Alexandrian landscapists: he furnishes the background of his stage with the conventional picturesque elements — trees, little temples — and by the use of simple tricks he avoids dealing with the problem of the relationship of the different planes. Thus the Temple of the Penates seems to be on a mountainous escarpment, which in a way accounts for its small dimensions. An analogous solution was adopted for the presentation of the Capitol in the scene of the sacrifice of the bull on the Arch of Tiberius; but in this later work the oblique representation of the animal — which recalls the foreshortening effects in Greek painting at the time of Alexander the Great — and the placing of the temple at the same oblique angle suggest spatial depth.

The influence of the master of the Ara Pacis lasted for

half a century at the least; it left its mark especially on the Ara Pietatis dedicated by Claudius.[10] However, this work assigns great importance to architectural landscape, especially temples. Its effects can be compared to some extent to those of the Pompeian painter of the fresco of Jason and Pelias (pl. XXXVII); but the sculptor absolutely disdains any illusion of reality in the relative proportions of

triumphal procession. In our opinion this is an early work by the master of the Ara Pacis, c. 20 B.C. It is characteristic of this artist to treat themes similar to those of popular art and in a style strongly tempered by Neo-Attic influences.

*XIV Pediment of the tomb of Lusius Storax at Chieti. Lusius Storax, a rich freedman, presides over a gladiatorial contest. A typical example of plebeian art, according to R. Bianchi-Bandinelli. Middle of the first century A.D. The majority of the figures face the spectator, as in Late Antique monuments.*

*XIII Frieze from the interior of the Temple of Apollo in the Circus Flaminius (near the Theatre of Marcellus):*

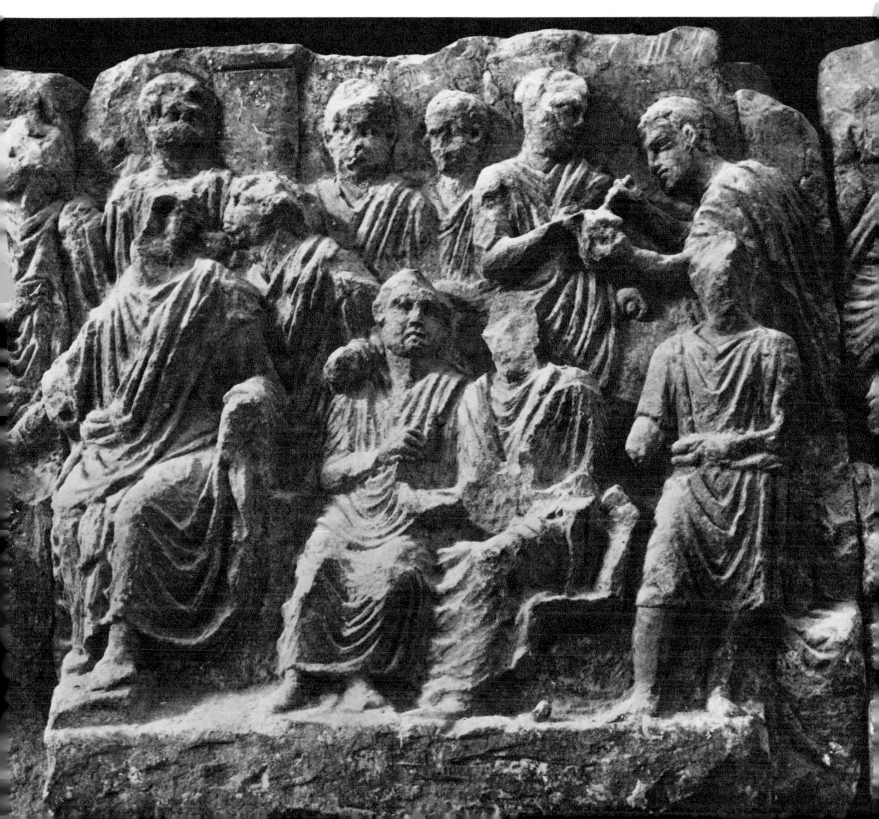

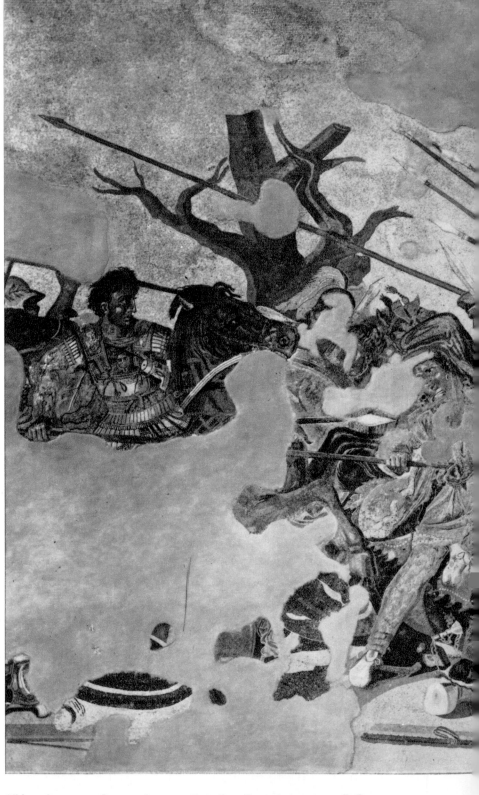

XV   Amazon Sarcophagus, detail.   Fourth century B.C. Florence.   This unique Etruscan sarcophagus reproduces one of the great Greek paintings of battle scenes, a genre that is chiefly known to us through this sarcophagus and the Alexander Mosaic from the House of the Faun in Pompeii.   The genre appeared during the first half of the fourth century with Aristides of Thebes, and this sarcophagus is generally thought to date from approximately that period.   Instead of depicting the fig-

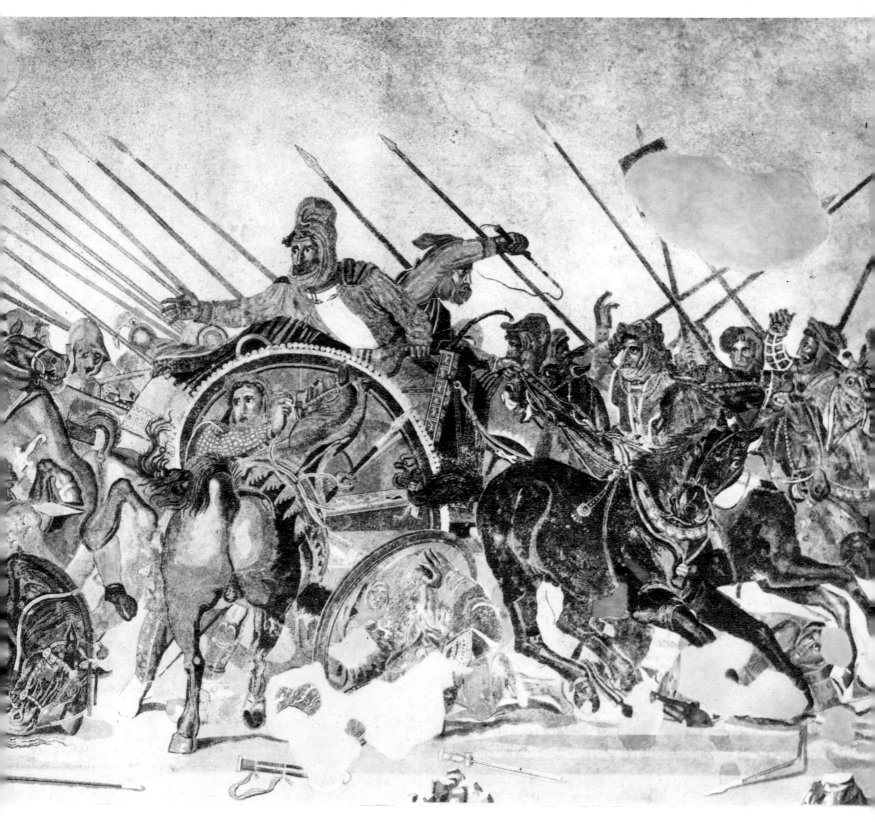

ures in profile, in one plane, as in reliefs, the painter preferred to show them foreshortened, either in full face or in three-quarters view.

XVI Battle of the Issus (the "Alexander Mosaic"), Naples Museum. This mosaic, discovered in 1830 in the House of the Faun in Pompeii, where it decorated an exedra in the first peristyle, is a skillful transposition of a great painting. Moreover, it is the best documentation we have of Greek historical painting, which is known to have existed from the beginning of the fourth century B.C. According to the most widely accepted opinion, the original painting was the work of Philoxenos of Eretria, who was active during the last years of the fourth century. This work exercised much influence in Italy; one can find it, for example, transposed, sometimes in a rather naïve way, onto Etruscan funerary urns. It certainly served as a model for numerous painters called upon to represent the great events of Roman history.

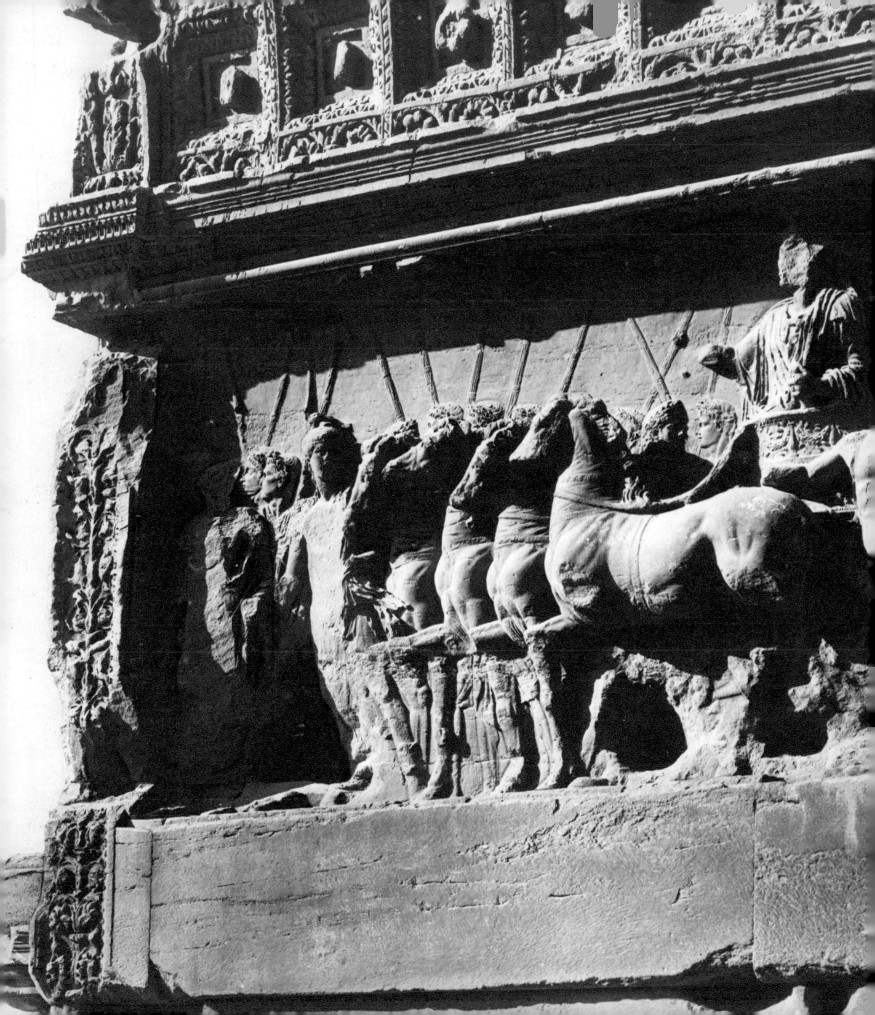

landscape and buildings; this course, and also the miniaturistic tendency which made him detail the decoration of the pediments, proves that this artist was under the influence of popular art. That popular art was still very much alive is attested to by the numerous funerary monuments in the Italian cities, such as the relief of Aquila, characterized by the "diffraction of space" in a number of planes and even of "supports" assigned to various figures. One will find this procedure in the area of courtly art as well, for instance in the work of the goldsmith; it appears especially in cameos, the production of which reached its zenith at this time, and in *caelatura*, or metal chasing. An example of the last appears on the cuirass of the statue of Augustus from Primaporta — a transposition into marble of a bronze original executed toward 20 B.C. One should not forget that there are many degrees and steps between courtly or official art and popular art: these are most notably represented by the monuments dedicated to the ruler by the people of the lower classes, like the altars of the Lares during the Augustan era, and much later by the altar of the Temple of Vespasian in Pompeii.

Therefore, one can state that the illusion of space has a Greek origin, that it was adopted by the Romans and transposed by them to the medium of relief, an area which was interesting to only a small elite, and that even they were ready to renounce it when the difficulties it entailed were too great. One cannot neglect the existence, attested in Southern Gaul, of a baroque current in sculpture strongly opposed to the classicism of the capital, which established the connection between the Hellenistic baroque adopted by the Etruscans and the baroque of the second century A.D. The arch at Orange, erected during the years 25-26 A.D., is its most distinguished example. The decoration of the lateral façades of this monument consists of some architectonic compositions with details that seem to "recede behind the wall," borrowings evidently from the phase of Pompeian painting known as the Second Style. The large friezes of the attic display scenes of battle inspired by Pergamene sculpture. Thus we have a transposition here not from paintings but from statuary groups. The artist nevertheless had to resolve the arduous problems of perspective.

It is during the Flavian period that we find Roman reliefs in which spatial perspective is most nearly perfectly realized, especially the panels of the interior passage of the Arch of Titus in the Velia at the foot of the Palatine, which was erected shortly after the death of the Emperor and dedicated in 81 A.D.; the subject is Titus' triumph over the Jews (pl. XVII). Instead of filing perpendicularly toward the spectator, the procession seems to emerge from the background at the right of the relief and to move obliquely toward the left: thus one no longer has the im-

*XVII Relief from the passageway through the Arch of Titus, built after the death of this emperor in 81 A.D. Here we have the most remarkable example of the transposition to relief of the compositional methods and perspective of painting. The scene shows the triumph of Titus over the Jews. For a detailed analysis see p. 33.*

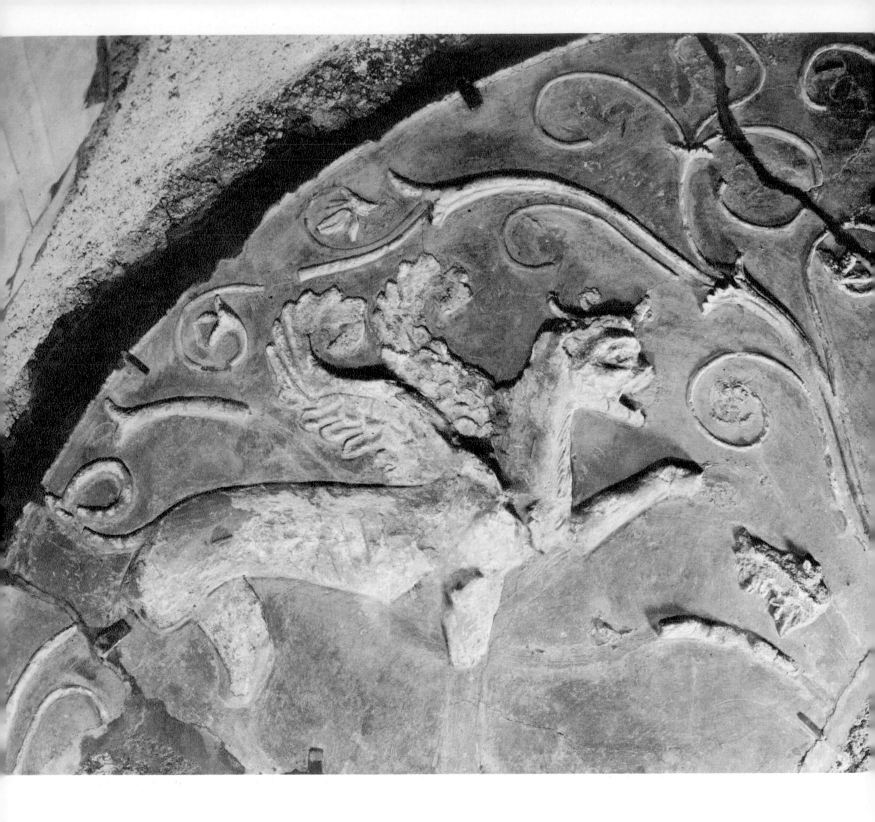

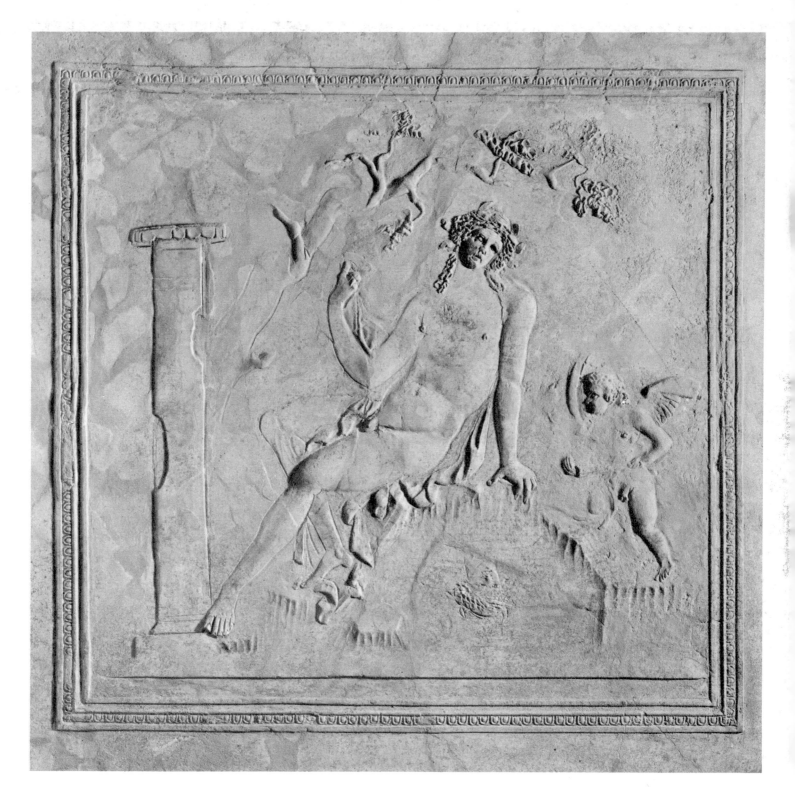

XVIII Detail of the stucco decoration of the House of the Griffins on the Palatine. This house, covered over by the Domus Flavia, or Palace of Domitian, dates back to about 80 B.C., and its decoration belongs to the very first phase of the Second Style. One sees here one of a pair of facing griffins which gave the house its name; this very ancient motif of oriental origin had frequently been borrowed by Roman art.

XIX Castellammare di Stabiae. This little stucco picture portrays Narcissus. The decorative repertory of stuccoists had been fixed since the Hellenistic period and hardly varied during the Imperial period. One finds in this work of the Flavian era all the elements of a picturesque style set in Alexandria since the second century B.C. — tree, sacred column, etc. The composition is determined by a rigid geometric scheme, Narcissus' body exactly delineating the diagonal from one corner of the frame to the other. The reflection of his face in the water is an example of the transposition of a strictly pictorial effect to a plastic medium.

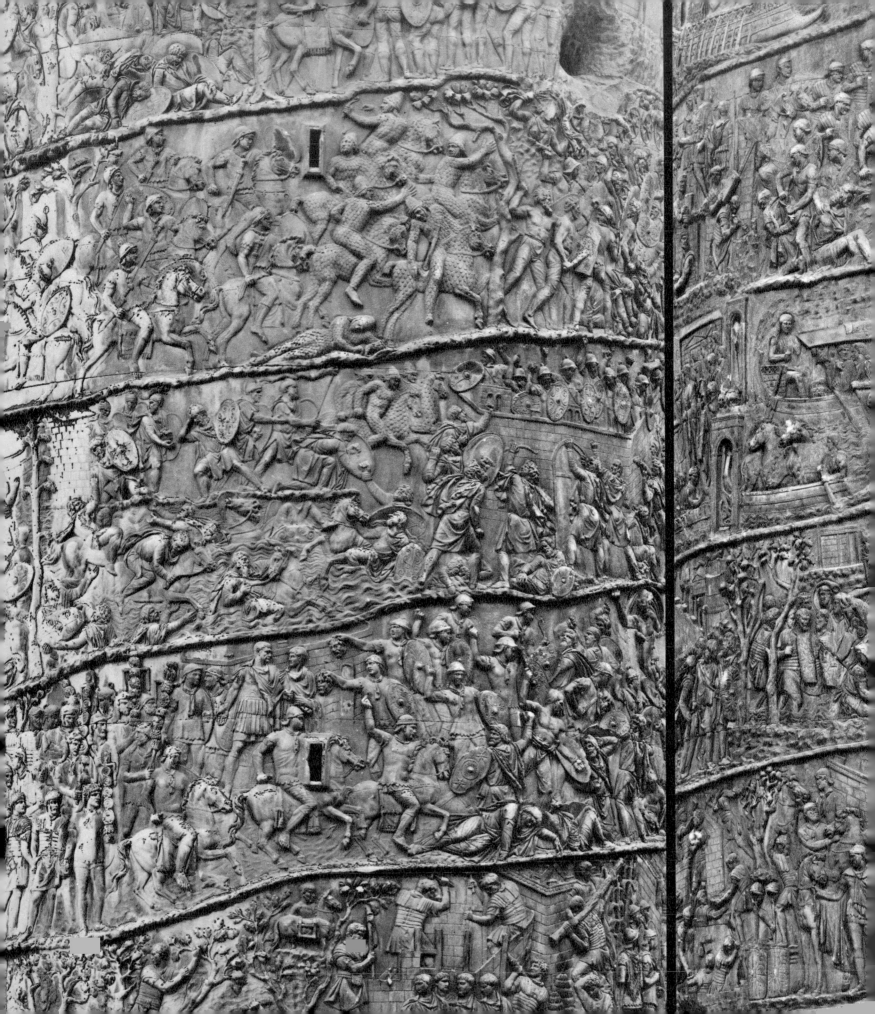

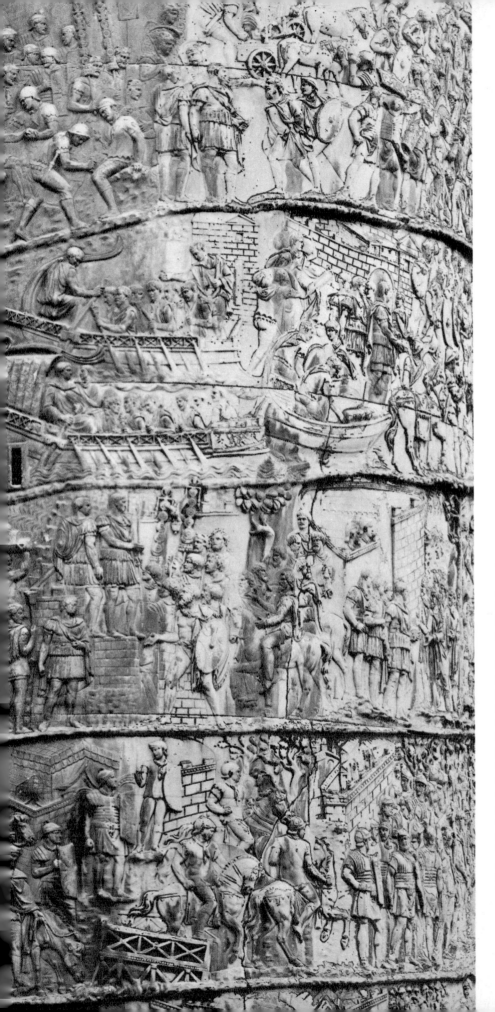

XX Scenes from the Column of Trajan. In carrying out the enormous program which was entrusted to him, the artist charged with designing the frieze of this column — whom most art historians identify with Trajan's architect, Apollodoros of Damascus — was inspired by both the Classical tradition and Roman historical painting. To the first he owed his humanism (the human figure is idealized and exalted from one end of the frieze to the other) and his sense of equilibrium and harmony, which are evident even in the most violent scenes. From the second he borrowed a taste for the picturesque and the lively; a sense of nature — all the more remarkable since the framework is hardly amenable to it; and finally a certain number of conventions and methods such as the superimposition of spatial planes and the representation of figures on a much larger scale than that of their setting. From Roman historical painting he also adopted the continuous style, which consists of representing one episode after another, as in a film. But the genius of the artist dominates these diverse elements and makes one forget those which are artificial or awkward.

37

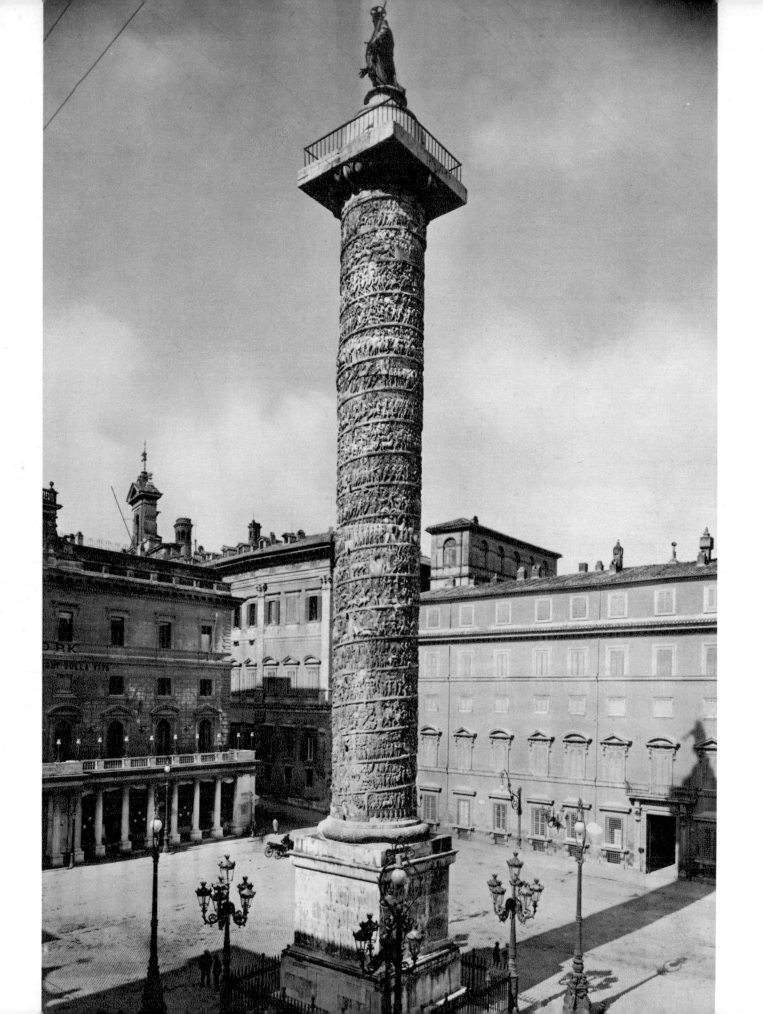

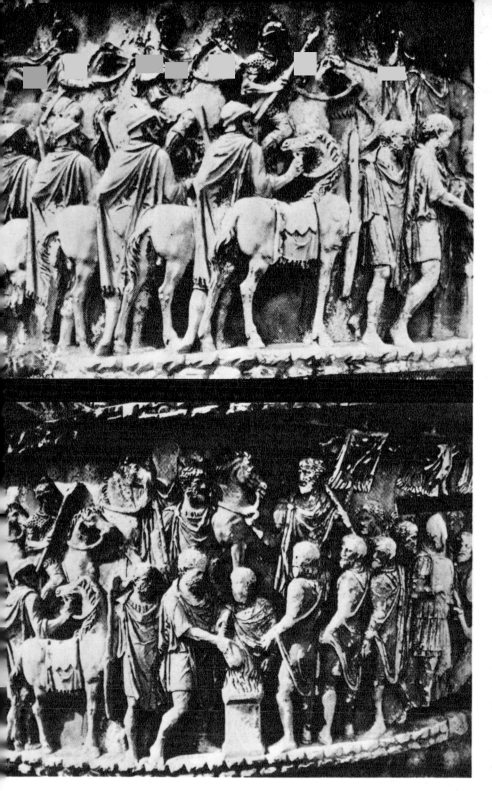

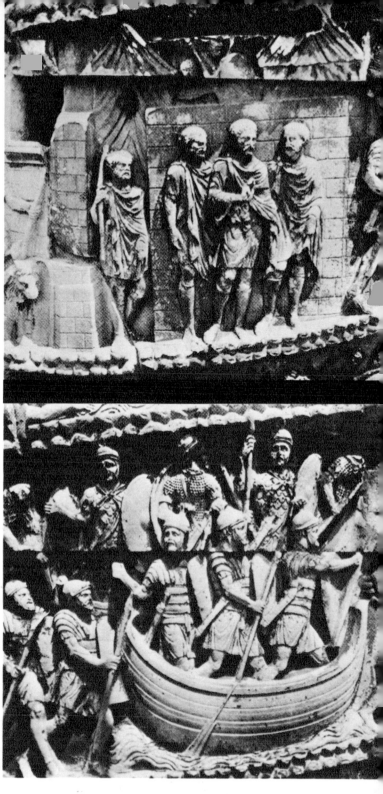

XXI  Column of Marcus Aurelius.  The great triumphal columns with helical friezes are the most spectacular and original creations of Roman art.  By providing triumphal sculpture based on historical painting with this extraordinary framework, Roman artists assured the success of the continuous style, creating an optical illusion analogous to the cinema.

XXII  Details from the Column of Marcus Aurelius.  The column, erected in 180 A.D. in memory of Marcus Aurelius, although decorated in accordance with the same principle as that of Trajan, reveals completely different artistic tendencies.  In the sacrificial episode (the two scenes above, at left), the presentation of the backs of the dismounted riders in the first plane indicates the influence of a pictorial prototype.  The group consisting of the Emperor and two of his councilors (above, at right) inclines toward frontality and heraldic symmetry. The scene of a river crossing (below, at right) shows schematizations for such natural phenomena as water and indicates that all concern for illusionism has disappeared.

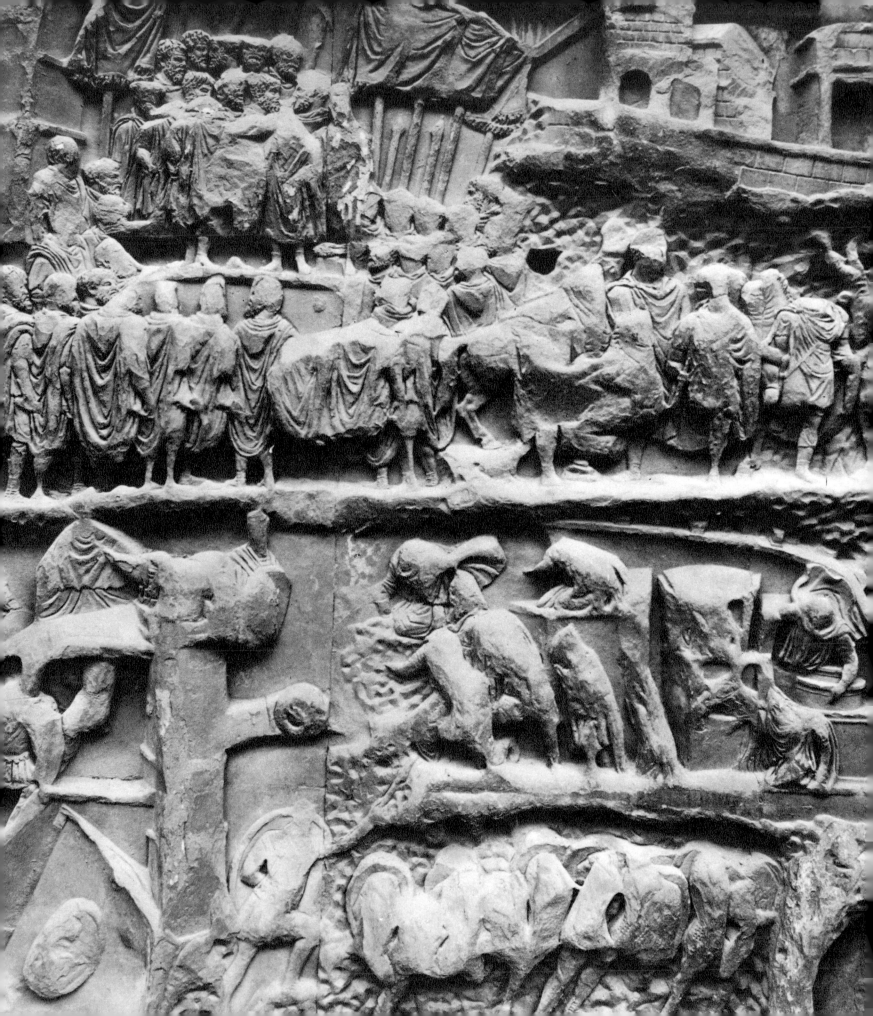

pression of seeing something performed on a narrow stage, closed at the rear by an impenetrable wall, but sees instead an action that develops in an unlimited spatial depth. From a psychological point of view, this obliteration of the background is analogous to the elimination of the wall in wall painting, which we will study in the next chapter. Whereas in Greek Classical reliefs the heads of the figures are in the highest relief, in the Arch of Titus the sculptor has reserved high up a large free zone in which only the torso of the emperor and that of the Victory who accompanies him in the chariot are detached from the background. The fasces of the lictors, which radiate over the heads of the horses of the quadriga, are the only other forms in this zone, and it is the suggestion of sky there which further augments the pictorial quality of the composition. F. Wickhoff in 1895 was the first to emphasize the importance of these effects. According to him, the decoration of the Arch of Titus represented the most typical and perfect Roman relief. R. Bianchi-Bandinelli observes that "the individual figures move in a free space, and the degree of relief — which decreases from the horses, which are almost in the round, to the heads and the lances in the background — creates the illusion of a truly atmospheric space; moreover, even the very mass of the figures does not move along a straight line but along a curved and convex one, easily apprehended in the processional relief in which the first figures at the left are seen in frontal and three-quarters view, those at the center in profile, and the last ones at the right from the back while they enter the 'Porta Triumphalis.' The spectator is grazed and almost jostled by the cortege."[11] The Italian scholar shows that this manner of engaging the spectator in the action of the image reappears in the reliefs on the Column of Marcus Aurelius (pl. XXII), which we will later discuss. In the reliefs of the Arch of Titus he discerns the personal invention of an ingenious master, and he considers it as a first step in the direction of the Late Antique with its aim to communicate with the spectator, and in a way, surround him.

This participation by the spectator was already demanded by wall paintings a century and a half before the erection of the Arch of Titus. The difference is that the paintings invited the spectator to enter into the composition, while the figures on the Arch of Titus and on the Column of Marcus Aurelius come to him. In the Late Antique, the relationship between image and spectator is achieved solely by an exchange of glances, there being no change of place.

The style of the reliefs on the Arch of Titus is not the only style current during the Flavian period. In 1937 some marble plaques carved during the reign of Domitian, depicting the arrival of Vespasian in Italy at the end of the Civil War in 69 and the departure of Domitian to take

XXIII   *Panel from the Arch of Septimius Severus in the Roman Forum: the siege of a city. The sculptor of this arch, which was completed in 205 A.D., made a much more energetic use of the methods of his predecessors. One of these is the depiction of the same site in two successive phases of the action.*

command of the armies, were found under the Palazzo della Cancelleria in Rome.[12] The composition differs completely from that showing the Triumph of Titus, although there also a free zone is maintained over the heads of the figures; the movement is parallel to the neutral ground of the relief.

The pictorial expression of space is therefore encountered on some Roman reliefs in various periods and is not

*XXIV   Relief of Marcus Aurelius, in the Palazzo dei Conservatori in Rome.   From an arch of triumph dedicated at the Capitol in 176 A.D. to commemorate the Germanic wars.   The three reliefs preserved from this arch, along with those on the Column of Marcus Aurelius, are the clearest expression of the baroque tendency which became dominant at the end of the second century.   The sculptor has made maximum use of the play of light, giving his work a quality that is more pictorial than plastic.*

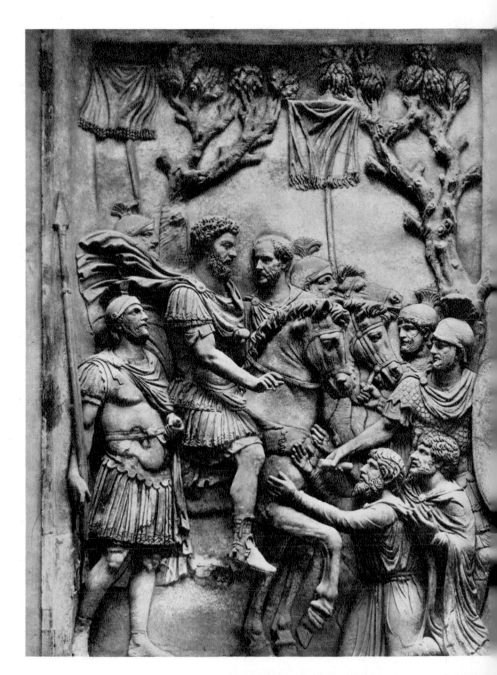

characteristic of any one period. These reliefs are very probably transpositions from paintings; all of these reliefs are devoted to triumphal ceremonies, and it is extremely probable that they reproduce some of the famous triumphal paintings whose existence is attested during the empire but none of which has survived.

In the end it was not until the reign of Domitian — an epoch when Roman artists attained the highest technical mastery in all areas — that a sculptor more gifted than all the others found a way to completely transpose into marble the effects of spatial perspective discovered by Greek painters.

The most brilliant successor to the artist of the Cancelleria reliefs was the sculptor of the relief on the Column of Trajan (pl. XX), who resorted to very different methods. We do not agree with R. Bianchi-Bandinelli in attributing to the same artist both the helical frieze on the Column and the very large rectangular frieze (pl. XXV) which decorated the Forum of Trajan before being reused on the Arch of Constantine. The sculptor of the frieze, in our opinion, is one of the many Anatolian artists who came to establish themselves in Italy at the beginning of the second century and who worked in those ateliers which began to

*XXV   The great Trajanic frieze reused on the Arch of Constantine.   This gigantic relief originally adorned the Forum of Trajan.   It depicts his victory over the Dacians; but whereas the Column of Trajan reproduces historical events with relative fidelity, this frieze depicts the war in a purely symbolic fashion — in the guise of a personal combat between Trajan and Decebalus which never took place.   It is, in fact, an adaptation of the monuments of the Pergamene kings; here one sees for the first time on an Imperial monument the dominance of the baroque tendency, which will assert itself more and more during the course of the second century A.D.*

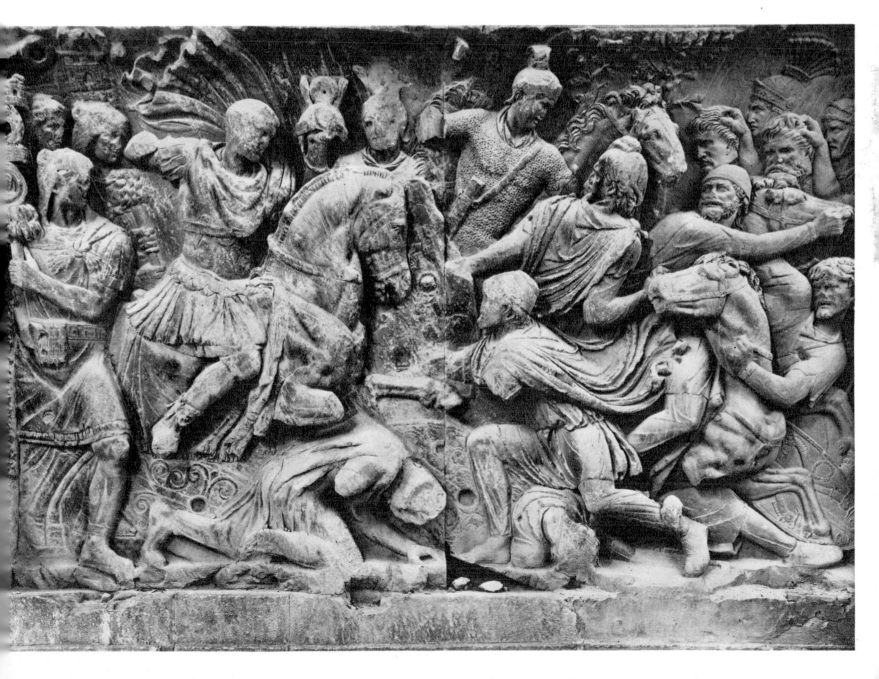

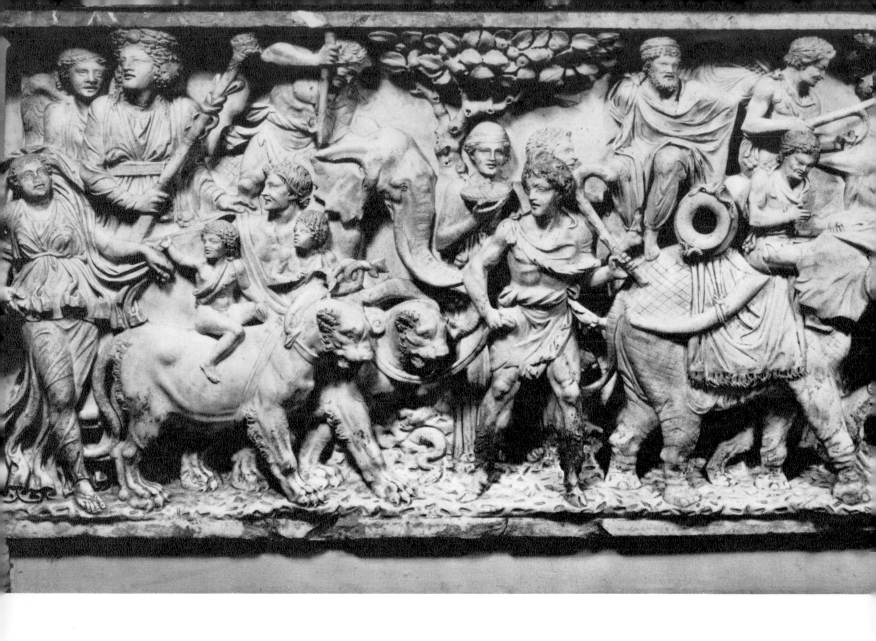

44

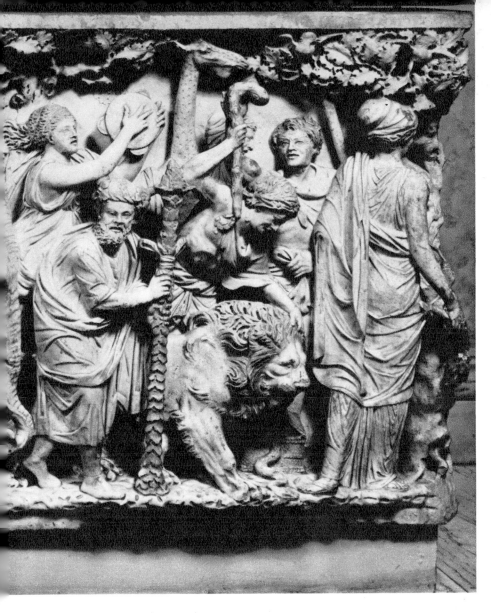

supply rich Romans with marble sarcophagi decorated in the Asiatic style. In contrast, the creator of the Column frieze, although occasionally making use of conventions drawn from the Pergamene repertory, seems to us to be the continuer of a clearly Italic tradition.

We have already emphasized the common attributes of his work and that of the "Fabian" fresco from the Esquiline (pl. I). This tradition is responsible, in particular, for the use of the continuous style, which we have already explained, and for the fact that the frieze developed into nothing less than a petrified film strip. But it is also from the Column that the system of landscape notation comes; perspective is abandoned in favor of a superimposition of planes; two scales of proportion are used at the same time, one for the figures and the other, much reduced, for the buildings and nature. The artist's talent, nevertheless, allowed him to omit that which was childish in these methods, and to conjure up with a few very simple sketches the savage majesty of the rivers, the mountains, and the forests of a still virgin Eastern Europe. On the Column of Marcus Aurelius (180 A.D.), later by two thirds of a century than that of Trajan, the schematic character of the landscape is strongly emphasized; one now sees the image depicted with really conventional marks, analogous to those of cartography. In a scene which shows the emperor talking across a river to some barbarians, the course of the water is represented by a sort of vertical ribbon. One finds exactly the same method used to suggest the Nile on a mosaic which paved the office of the Egyptian shippers in Ostia.[13] This attests to a tendency to abandon the illusionistic representation of nature, such as had been achieved by Hellenistic artists, for a system of abstract notations, at once symbolic and ornamental. This tendency manifests itself, above all, in the panels of the Arch of Septimius Severus in the Roman Forum (pl. XXIII) which reproduce, as we have already said, paintings exhibited after the emperor's triumph over the Parthians. The landscape is reduced to some sand, a few rocks, and the ribbons of flowing water; the cities become ideograms, three or four structures surrounded by a wall.

However a relief from an arch of Marcus Aurelius, only a few years earlier than the Column,[14] still shows a composition conceived more along the lines of the reliefs on the Arch of Titus: a procession emerges from the background at the left; it advances to the first plane, where the prince stops a moment to light the incense on a censer; then he turns his back as he withdraws toward the right. Few antique works, even paintings, caught movement so

XXVI *Dionysian sarcophagus of the period of Commodus (180-192 A.D.), in the Walters Art Gallery, Baltimore. The baroque tendency so marked in Roman art toward the end of the second century is strongly affirmed by a group of sarcophagi depicting Bacchus' triumphal return from India: although inspired by myths which had enjoyed great popularity during the Hellenistic era, the theme seems to have been created in this form in the second century A.D. Appearing toward the middle of that century, it was revived frequently until the end of the third.*

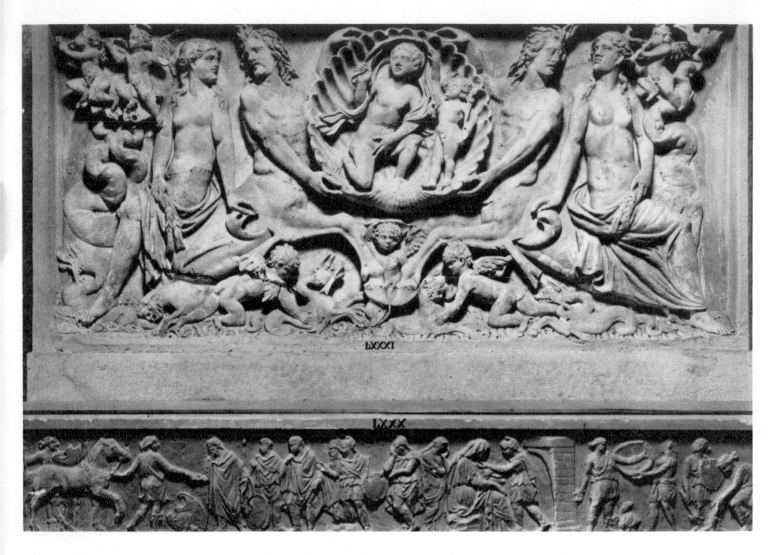

successfully, and not even the most skillful sculptors of the Renaissance achieved a more successful expression of space in relief. It is disconcerting at first to learn that the artist of these panels worked with the same crews who carved the Column; the certainty of this fact absolutely scuttles the notion that the Romans' renunciation of illusionism was caused by some lack of skill. One must never forget that the Romans' official art always had a practical aim, serving as a vehicle of propaganda and as a psychological prod; their paintings and reliefs are closer to our posters than to our paintings. It was not necessary that they be beautiful, rather that they be comprehensible, persuasive, and effective. There was always the tendency to summon the spectator: our poster artists well know the power of a hand extended toward the passerby, of a face which fixes him with a stare. From this same purpose comes the preference for simple forms, easy to grasp at a glance, which convey a precise idea to the mind. Thus the panels on the Severan Arch in the Forum (pl. XXIII) serve a specifically public aim in their simultaneous depiction of the same site *before and after* the intervention of the Roman army. All this was not new in Roman triumphal art, but toward the end of the second century it was asserted with a brutal vigor. It is easy to understand why the German invasion, which had overturned the defenses of the empire under Marcus Aurelius, was endangering Mediterranean civilization and leaving behind it after effects which would, during the course of a century, overturn the established order in the political, social, economic, intellectual, and religious areas.

In response, a brutal revolutionary action was called for: Septimius Severus and after him the Pannonian emperors, the Tetrarchs, and Constantine, did not hesitate to implement one, and because of it they succeeded in slowing down briefly the collapse of civilization. Art was mobilized, as were all the known psychological means; and these simple but extraordinarily powerful monuments, which seem barbaric to us in comparison with the works of more propitious centuries, impress us even today with their efficacy. The rivals for power did not hesitate at first to use analogous means: the Christians put a completely simplified painting, freed of conventions, in the service of their propaganda. After the peace of the church the two currents converged, and together they gave birth to Medieval art.

---

*XXVII  Sarcophagus in the Villa Borghese, c. 230 A.D. During the third century new methods of composition appear in sculpture as well as in painting; renouncing illusionism, the artist arranges the figures as on a coat of arms, stressing the central image: in this case, a lady coiffed in the style of the Severan empresses and deified In the guise of Venus.*

## The originality of Roman mural decoration

The most important Roman paintings to have come down to us are the frescoes which decorated the buildings of two Campanian cities, Herculaneum and Pompeii, which were buried during the eruption of Vesuvius on August 23 and 24, 79 A.D. The excavation of their ruins began in 1719. Over the years since then, the initial, primitive methods of retrieval have been supplanted by improved techniques, but the task is not yet completed. Meanwhile the hoard of Pompeian and Herculanean paintings preserved either *in situ* or in the museum in Naples is already immense.

It is, moreover, complemented by other works of the same type, found either in Rome itself, especially on the Palatine, or in other cities of Italy. The earliest of these documents go back to the end of the second century B.C. Pompeian painting — as we shall call it in order to simplify matters — extends, therefore, over little more than two centuries, precisely those during which lived the most illustrious men of the Latin civilization, the creators of the Empire and of classical literature. It constitutes the most important body of archaeological remains which this period has bequeathed to us.

If all the paintings in our museums were to be completely destroyed, and future archaeologists studying our painting had at their disposal only the decoration on our walls and ceilings, the image they would develop would be utterly impoverished and false. Let us not be led into the same kind of error with regard to Roman painting, reconstructing it entirely from the wall decorations of two cities. The very abundance of these murals proves that they were in part decoration and therefore executed by artisans rather than by artists. It is also quite certain that the Romans considered wall painting an inferior genre (pl. **XXXIX**). For one thing, they had easel paintings and produced them in greater numbers than frescoes. Furthermore, the murals often strove to imitate easel paintings, for the same reason that causes people today to hang reproductions of old masters in their apartments if they cannot afford originals. The historian of painting seems at first sight to have fared less well than the historian of sculpture, who at least has the consolation of being able from time to time to compare an original with innumerable more or less adroit replicas.

So much for regret over what has vanished. Let us now move on to the total effect of a painted wall that has survived in a Pompeian house of the middle of the first century B.C., specifically the east wall of the *oecus corinthus* — a pleasure room in the Greek style — in the House of the Labyrinth, located between the street of Mercury

and the street of the Faun, in the extreme north of Pompeii (pl. XXXI). In front of the wall stand some mutilated shafts, remnants of a colonnade; they are gray stone coated with stucco. Behind them are other columns, raised on a rose marble base, supporting the two halves of an intentionally severed pediment. In the photograph, they seem scarcely less real than the portico in the foreground, yet they are simply painted on the plaster of the wall, together with the pediment which they support, some large urns, and an altar, which seems to be placed between them on the base. In the middleground is a low dark red wall, past which we see a round, columned pavilion. This elegant structure is enveloped by porticoes that recede into limitless space.

The whole composition is conceived in such a way as to allow the eye to pass unconsciously from the real into the imaginary; the piece has no boundaries. The low wall behind the porch with the broken pediment, which screens the lower portion of the pavilion, comes closest to being a boundary, yet this wall is what one least notices, lying as it does between the rich decoration in front and the monumental whole in the distance, which it shields without covering. We are on the threshold of a sacred precinct here: the altar, the large amphorae, which doubtless contain the lustral water, the frightening masks placed over the screen wall, the crown suspended within the circular kiosk, all these create a religious atmosphere, the more affecting because no living creature inhabits this immense temple, where one sees neither gods, nor priests, nor worshippers.

This fresco from the House of the Labyrinth is not the whimsical creation of an isolated artist. It belongs to a particular type, the development of which we can follow from

*XXIX   Herculaneum; vestibule of the House of the Samnite.   The Oscan, or Samnite, language was spoken in Herculaneum and Pompeii until 80 B.C.   This house dates from the second century B.C. and is a typical example of the decoration of the First Style, which is also found in the Greek world, as at Delos.   The decorator has tried to suggest a costly construction by employing polychrome stucco to imitate precious marbles.   One sees here a part of the "isodome" structure which constitutes the middle zone of the wall; above the area shown in our picture is the upper cornice with its row of billets — very narrow denticules, typical of the Hellenistic era.*

*XXX   Fresco from Boscoreale, in the Naples Museum. This painting from the celebrated Villa of P. Fannius Synistor depicts the famous theme of the door.   The trompe l'oeil decoration breaks down into three planes: the make-believe colonnade in front of the wall, the wall itself pierced at the center by the door which leads to the other world, and a perspective view of as much of the world beyond it as can be seen over the wall. The masks placed on a balustrade, which will be met with in a later phase, in the House of Augustus on the Palatine (pl. XXXVI), are the guardians of the beyond. The little frieze over the door illustrates the Hunt for the Calydonian Boar, a funerary theme which occurs frequently in the Hellenistic art of Italy.   This painting belongs to phase I B of Beyen's classification, c. 60 B.C.*

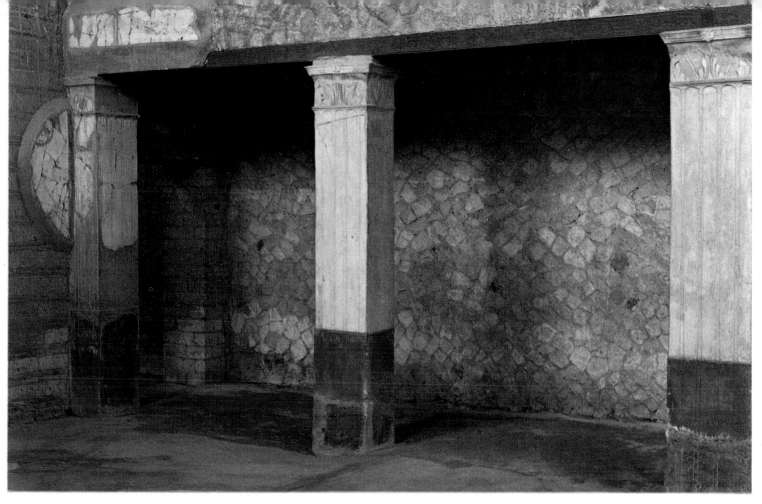

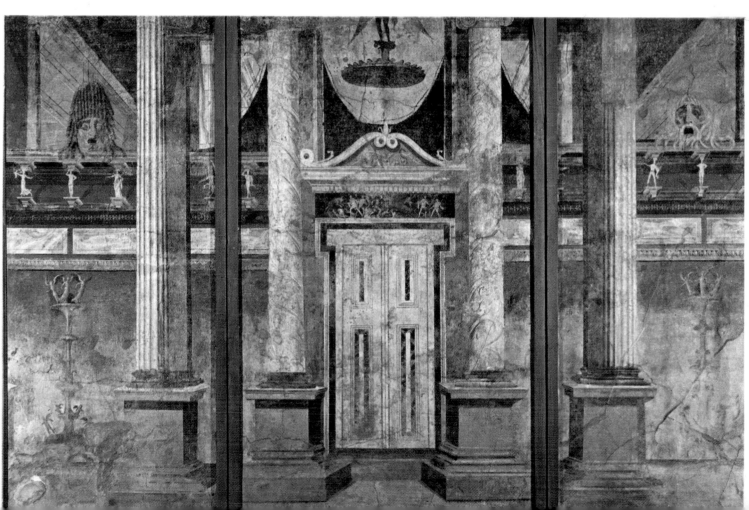

80 B.C. until about 15 B.C., according to the most likely chronology. This evolution, which we will trace later on, attests to constant progress within the exploration of the imaginary; the painters of the First Style had simply used the techniques of *trompe-l'oeil*, inherited from naturalistic Greek painting, in order to embellish the wall with those architectural details which the proprietor could not afford, such as revetments of precious marbles and noble colonnades. The idea of "opening up the wall" appeared later. Perhaps it was initially intended to suggest the existence of imaginary parks, of paths, and porticoes, ventilating in an illusory way the too narrow rooms of an urban house. Thus one sees on the wall of the House of the Empress Livia at Primaporta, in the north of Rome, a charming garden of greenery inhabited by birds. But this need for flight into nature, very real to the Romans of the first century — and often expressed by Virgil and Horace — quickly grew into a need for purely psychological escape into an unreal paradise. This flight is well illustrated by the paintings in the House of the Labyrinth, and by those contemporary with them, *circa* 50 B.C., in the celebrated "Villa of the Mysteries"; there the point of view is reversed in the famous "Dionysian room" (pls. XXXII, XXXIII), for the supernatural beings of another world invade the room and mingle with the living. This sort of thing shocked the staid people, those who simultaneously were working to organize the real world and to build a new order out of the chaos of the civil wars. Vitruvius, the military engineer for Caesar, became an architect in the service of the Augustan reconstruction, and he severely condemned the excesses of the imagination in a chapter (L. V, Ch. 7) of his celebrated treatise on architecture published about 25 B.C. If he does not speak of the "flight over the wall," he does fulminate against that which one can call the surrealist tendency, well represented, for example, by the "House of Livia" on the Palatine (pl. XXXIV):

"But those subjects which used to take reality for their model are discredited by today's moral decadence. For one paints monsters on the walls rather than pictures of definite objects: in place of columns, there are fluted reeds with coiled leaves and volutes; instead of pediments, some species of little pavilions; and one finds even candelabras which bear the images of little buildings, on the pediments of which there are light flowers having tendrils for roots, where, contrary to all good sense, figures perch; there are also some shafts terminating in half-figures, some of which have the heads of men and others of beasts. None of this exists, it will never exist and has never existed." But both the "surrealism" here condemned and the escapism evidently stemmed from the same state of mind, one which turned away from a concept of nature that is intelligible and that is disciplined by the reason in which classicism found its inspiration. This state of mind effectively disappeared some ten years after the publication

of Vitruvius' work. Then one sees the birth of what is called the Third Style, characterized by a suppression of the *trompe-l'oeil* effects and of the openings in the wall. This again forms a limited space, being confined to a single plane; the wall is divided into panels symmetrically arranged around a large central picture of a landscape or a mythological subject; one such painting is Pan and the Nymphs (pl. XXXVIII) of *circa* 20 B.C. Analysis of this composition shows us an extremely precise geometric scheme: horizontally it consists of three zones, of which only the middle one has figures; each figure is separated from the others and enclosed in a sort of vertical frame determined by the element of landscape against which the figure stands out clearly; the whole painting is thus constructed by juxtaposing five rectangles, each of which encloses a figure or an element of decoration; this gives the scene an equilibrium and a serenity which well fit the spirit of this quiet idyll. The immobile figures, in serious and meditative poses, are borrowed from the repertory of Greek classical painting; one would easily recognize elsewhere the draped woman, in profile, playing the lyre, the nude male, who is shown seated and in full face, and the pair of listening nymphs. The Roman painter was inspired by an early fourth-century B.C. picture, of which he modified only the balance by further developing the landscape decoration. Therefore, in every respect this work is classical. It fits perfectly into the general current of Augustan art and could be compared for example, with the mythological reliefs of the Ara Pacis (pl. XI).

But this classical conception was too remote from the state of mind of a great number of Romans at the beginning of the Christian era for it to endure. One takes this into account when appraising another, but much later, painting of the Third Style, The Rescue of Andromeda, from the House of the Priest Amandus (*circa* 40-50 A.D.) (pl. XLI); instead of concentrating on the figures (as the Athenian painter Nikias had done toward the beginning of the fourth century B.C. in a famous painting of the same myth, of which there are numerous copies in Pompeii), the Italian muralist has painted an extraordinarily turbulent landscape around the violet granite rock to which the young

---

*XXXI Pompeii; House of the Labyrinth. This plate, for which the commentary will be found on pp. 47-8, shows us the development of the theme of the "disappearance of the wall" in phase II C of the Second Style (according to Beyen), c. 50 B.C. The principle of the composition is the same as that in the preceding plate, the illusionistic effect being further augmented by the real colonnade in the first plane. Behind it, the painted wall decoration begins with a colonnade with a broken pediment framing an altar in front of a wall. Since this wall rises only to mid-height of the scene, it allows us to look beyond to a circular pavilion (tholos), a type of funerary architecture found in Pompeii itself (the Mausoleum of the Istacidi), at St. Rémy de Provence (the Mausoleum of the Julii), and in the rock-cut tombs of Petra in Jordan, as well as elsewhere. The tomb seen in this fresco stands in the middle of a vast portico of which the pediment in the first plane is the propylaea.*

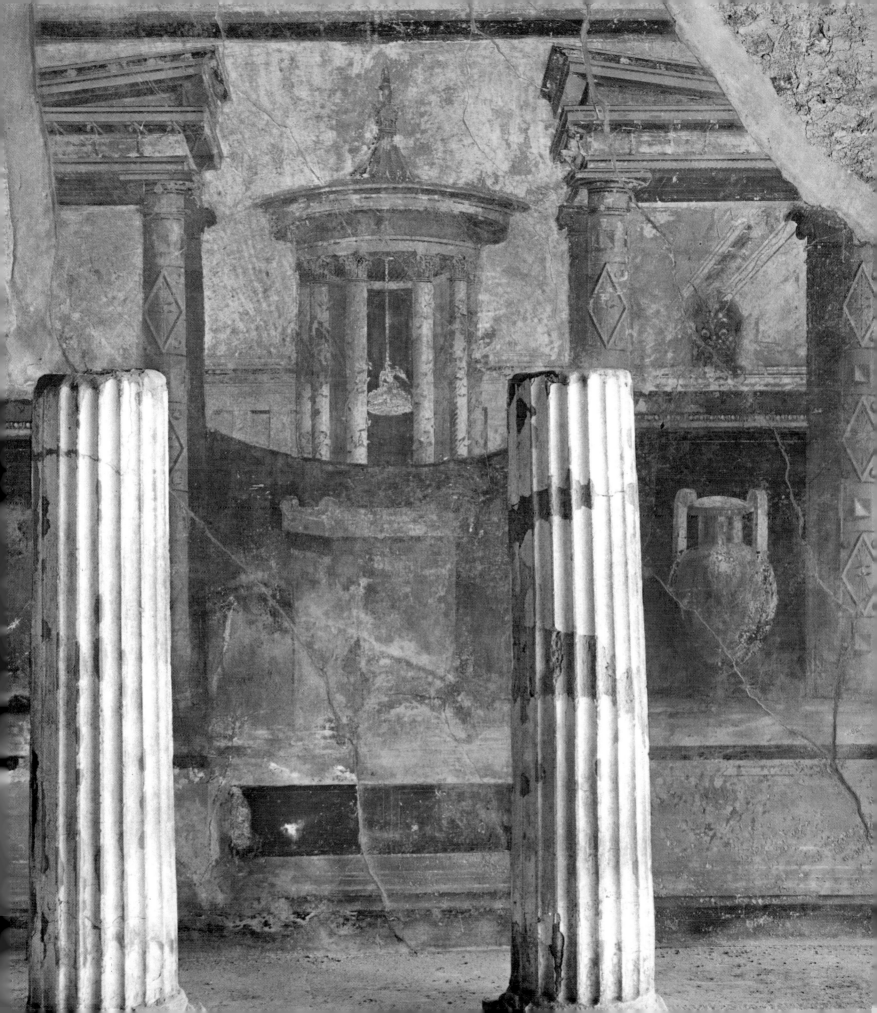

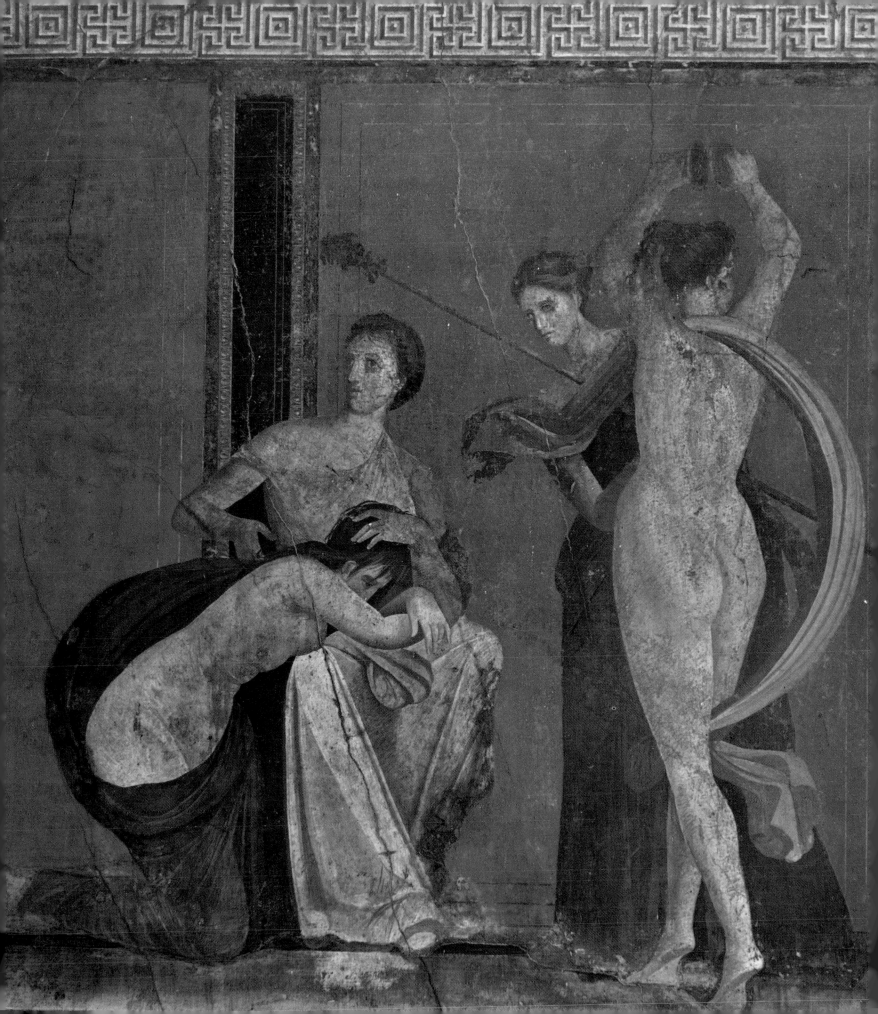

girl is chained. In so doing, he has revived the tragic and mysterious atmosphere of this somber drama, an atmosphere which Nikias had completely dissipated. The work can, perhaps, be compared to an engraving by Gustave Doré, and it is not at all absurd to qualify it as romantic.

The House of M. Lucretius Fronto brings us to the last phase of the Third Style (*circa* 50-60 A.D.); we shall restrain ourselves for the moment from proving that it shows a tendency, still timid, to "reopen the wall." The central panel of the *tablinum*, in the middle of which is a picture of the Triumph of Bacchus (pl. XLIV), is flanked by two "windows" each revealing a curved portico with slender colonnettes which is supposed to continue behind the panel. In the upper zone of the decoration there are architectural motifs of the same type. One is still far from the deep perspectives of the Second Style, but the work clearly marks a trend toward a formula freed from classical constraints.

It is the expansion of this formula which characterizes the Fourth Style. It is not difficult to discuss this period of Pompeian painting because of the great abundance of

*sacred objects, the main one being a phallus, and a winged female demon brandishing a whip. According to some, this demon is flagellating the initiate with bared torso whom one sees kneeling. According to others (especially F. Matz,* Dionysiakè Teletè, *1965), the initiate adopted this position only because she must not see the phallus; the menacing gesture of the demon, personifying ignorance, is meant for the priestess who reveals the sacred objects. The dancing Bacchante symbolizes the joy achieved through the revelation; perhaps she represents the initiate herself; the figure, one of the most beautiful feminine nudes which antique painting has bequeathed to us, was inspired by a Greek model of the middle of the fourth century B.C., a time when artists were especially interested in foreshortening and in the expression of movement.*

*XXXIII Boscoreale; Historical frieze. Contemporary with the frieze from the Villa of the Mysteries (c. 50 B.C.), this painting with life-size figures is notable for the trompe l'oeil columns, ornamented with bosses, in front of the area in which the figures move. According to the most likely interpretation, the woman seated at right is the Macedonian queen Phila, widow of Demetrios Poliorcetes; the adolescent wearing a Macedonian military uniform is her son, the young king Antigonus Gonatas; the old man leaning on his staff is the Stoic philosopher Menedemos of Eretria, teacher of Antigonus. The group thus represents the royal family of Macedonia c. 270 B.C.*

*XXXII Pompeii; Villa of the Mysteries. The great Dionysian frieze. The group reproduced here appears at the very end of the frieze. Immediately to its left there is a woman discovering a winnowing basket containing*

XXXIV The main room of the house on the Palatine said to have belonged to Livia. The "House of Livia" — which should not be confused with the imperial villa at Primaporta, which certainly belonged to Augustus' wife — is found near the top of the two peaks, called Germalus and Palatium, which form the Palatine. Its discovery in 1860 by the Chevalier Rosa was subsidized by Napoleon III. The house was at first identified with the house of the Claudii where Livia gave birth to Tiberius, and then, by G. Lugli, with the house of Hortensius later inhabited by Augustus; in the wake of the most recent discoveries (see infra pl. XXXVI) G. F. Carettoni leans toward the latter identification; the house might well have been included in the Augustan property but would not have been used by the Emperor. One sees here the decoration of the main room which belongs to phase II C of the Second Style, c. 30-20 B.C. This phase is distinguished from its antecedents by the appearance in the center of the wall of an aedicula containing a picture imitative of a classical Greek model — here, a rendering of the Io and Argus by Nikias; other copies of smaller paintings, showing religious scenes, are at the upper part of the panels framing the aedicula. The scenes opening onto the world beyond the wall are relegated to the far sides; in this case they are urban landscapes in which figures move about. The diminished importance of "crossing over the wall," the disappearance of the fantastic character of the landscapes revealed "on the other side of the wall," the appearance of copies of paintings, all mark this as a transitional phase between the Second Style and the Third. See supra p. 50.

XXXV "House of Livia": Room of the Winged Figures. The most interesting feature of this décor consists of the panels in the upper zone; in each of them two winged figures — Victories, Griffins, etc. — face each other in heraldic fashion along the length of a kind of stylized tree. Here we have the very ancient motif of the tree of life which appeared in Mesopotamian art from the third millennium onward. The winged creatures are perched on the branches of this tree. The whole effect corresponds perfectly with Vitruvius' description of the "extravagances" encountered in the art of this time (see p. 50).

works and the variety of tendencies to which it attests. Richness and diversity suffice to vouch for the artistic vitality of the Campanian cities during the fifteen or twenty years that precede their catastrophic destruction.

Just at this time, however, Pliny the Elder — who was to die a victim of his sense of duty and of his scientific spirit by going to the aid of the victims with the fleet which he commanded — did not hesitate to deplore the decadence of painting; but this did not prevent him from citing several contemporary painters, including Fabullus, Nero's painter.

It is from him that we will seek understanding of what the Fourth Style consists of. The Golden House, the fabulous palace extending from the Palatine to the Caelian, built by Nero after the fire of 63, was, according to the picturesque expression of Pliny, the prison of the art of Fabullus, all of whose work was in effect entombed along with the ruins of the palace itself, under the Baths of Trajan. But this burial preserved for posterity that which was kept from the view of its contemporaries. Thanks to it, Fabullus became the teacher of the painters of the Cinquecento, who eagerly went down into the "Grottoes of the Caelian" to copy the frescoes discovered there around 1574. Giovanni da Udine's decoration of the Grand Loggia of the Vatican was directly inspired by them.

The décor of the Golden House is striking first of all because of its airiness and elegance (pl. XLVI). The thin

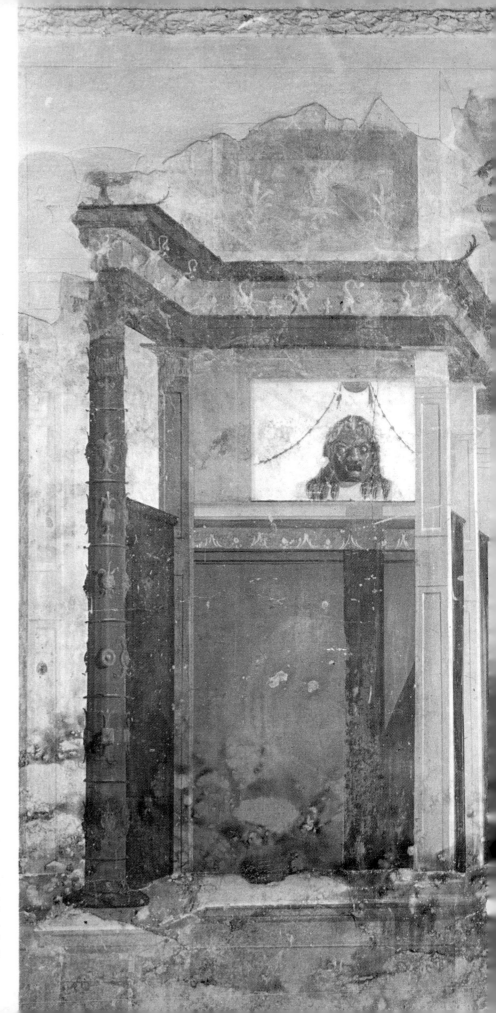

*XXXVI   G. F. Carettoni's new excavations on the Palatine: Room of the Masks.   During the past few years, G. F. Carettoni, Superintendent of the Forum and the Palatine, has excavated buildings with several stories on the south side of the Palatine.   They are at a level lower than that of the podium of a temple identified by G. Lugli as the sanctuary of Apollo Actius, which was established by Augustus in 27 B.C. on a site next to his house; the exploration of this podium by Carettoni brought to light some decisive evidence supporting Lugli's identification.   But Carettoni thinks that Augustus' real home was comprised of the buildings he has explored, not the "House of Livia."   The decoration here reproduced belongs to the same phase, II C of the Second Style, as does that from the "House of Livia," as the presence of the center aedicula with a painting (in this case a sacred landscape) demonstrates.   The theme of this painting is, moreover, almost identical with that of a painting in the so-called triclinium in the "House of Livia."   They both depict rural sanctuaries in which the divinity is not represented by a statue, but by a column or by a sacred stone in the shape of a spindle or club. The atmosphere of fantasy is much more marked in this room than in the "House of Livia"; it is created for the most part by the frightening masks, placed as in the villa at Boscoreale (see pl. XXX) on a balustrade that separates the real world from the one "beyond the wall": one finds, too, a "dissolution of form" and a use of almost surrealistic colors, similar to those which will turn up later at Stabiae.   It would seem, therefore, that the decoration of the Room of the Masks must be dated slightly earlier than that of the "House of Livia": c. 30 B.C.*

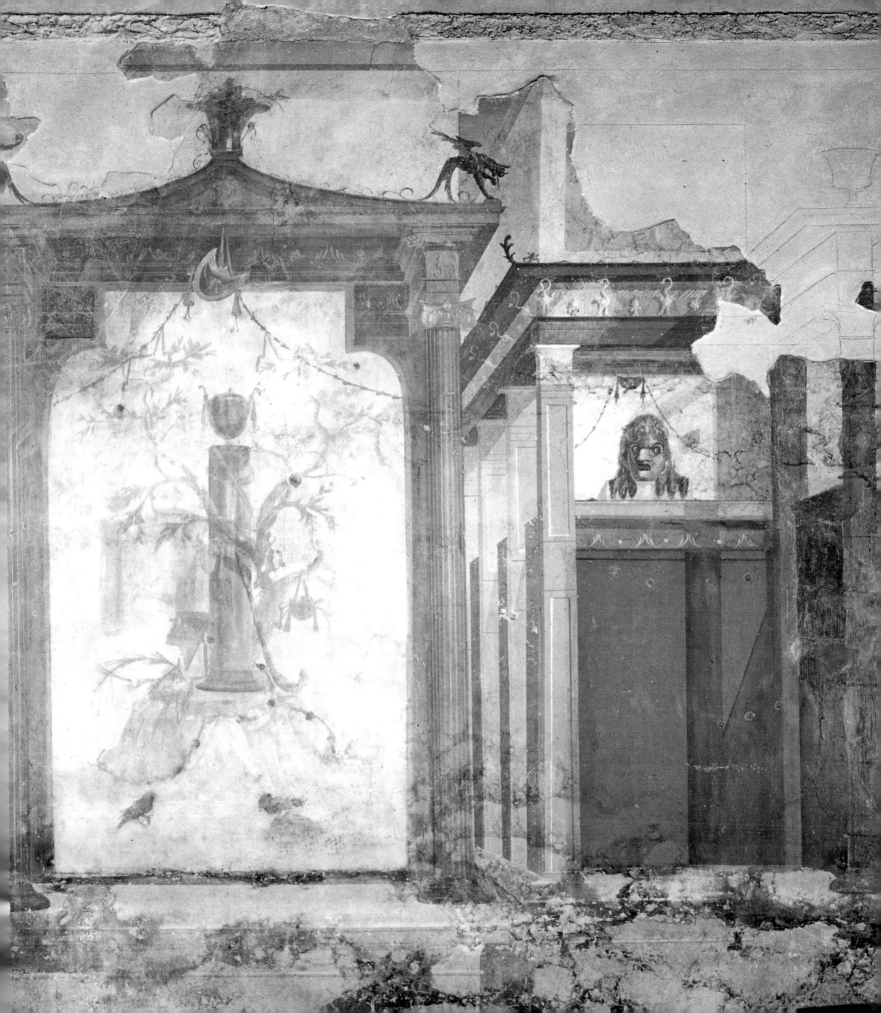

pergolas painted in red and gold, the royal colors, stand out from the white ground of the wall; they frame false windows which open onto views of architectural perspectives receding into the distance. Thus one returns to the principle of the open wall, to the escape into the dream world. The relationship of the Fourth Style to the Second Style is so striking that one of the profoundest interpreters of Roman painting, L. Curtius, was persuaded that it followed the Second without interruption, and that the Third Style was only a parallel, contemporaneous trend. Precise datings established during the last quarter century do not support this theory. But the only explanation that one can conceive of is that some limited convergence of inspiration brought the two styles into being separated by about a century.

The Fourth Style is not simply a new edition of the Second or an imitation. The graceful architecture of the Golden House, still very similar to that of the Third Style, has however been retained simply as an element of decoration, and it cannot be mistaken for the solid colonnades, the look of reality, which we found in the House of the Labyrinth; even later on, when one again finds solid columns, stairways, and real doors, the motifs most prevalent during the Caesarian epoch, such as the round pavilion, do not reappear. What is more, the fantastic landscapes are no longer deserted (pl. XLVI), as had usually been the case earlier. In the corridors of the Golden House human figures, almost life size, rise from the décor (pl. XLVII).

These apparitions naturally make one think of actors emerging from a stage set; indeed several works in the Fourth Style, painted in the time of Nero, definitely conjure up a theatre during a performance. This is true, for instance, of the frescoes in the House of Pinarius Cerialis, a Pompeian jeweler specializing in the production of cameos and intaglios, which the Romans frequently used as seals

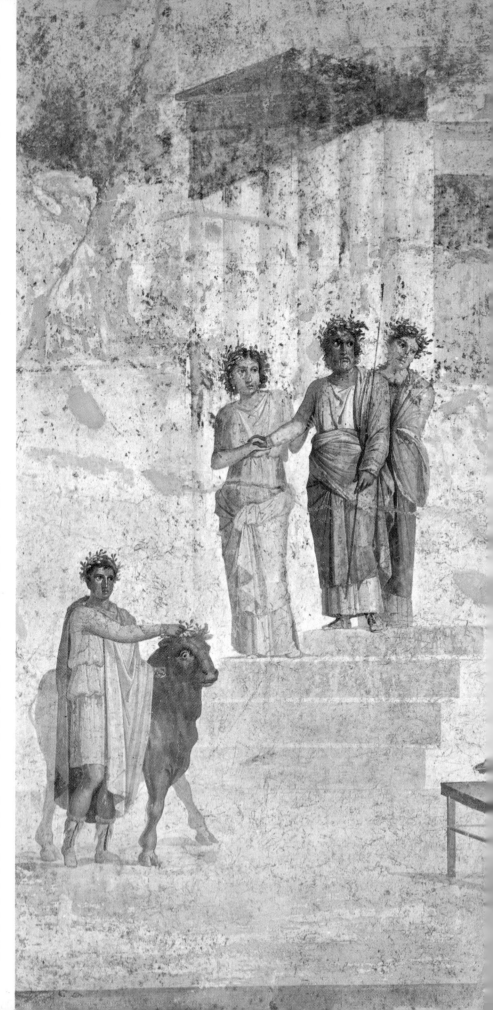

*XXXVII   The Meeting of Jason and Pelias.   This painting, from the "House of the Fatal Loves," now in the Naples Museum, is a typical example of the Augustan classicism of the Third Style.   See p. 102.   The geometrical construction is particularly evident, each group coinciding with one of the three verticals which punctuate the painting; furthermore, Jason, Pelias, and the priest with the sacrificial bull are inscribed within an equilateral triangle.   Note the tendency toward tripartite frontal composition in the group of the old king and his daughters and compare it with the Isis Ceremony (pl. XLII).*

*XXXVIII   Pan and the Nymphs.   This painting from the same house as the preceding and also now in the Naples Museum, was done in the classicizing period of the Third Style, and dates c. 1-30 A.D.   See the commentary, p. 50.   The figures, especially that of Pan and the nymph with the cithara, are borrowed from the repertory of classical Greek painting.   However, the treatment of the trees is impressionistic and the rocks are relatively angular and twisted; these elements were undoubtedly borrowed from Greek landscapes from the end of the Hellenistic period — typified by the scenes from the* Odyssey *on the Esquiline — and they indicate the "romantic" tendency which was to follow.*

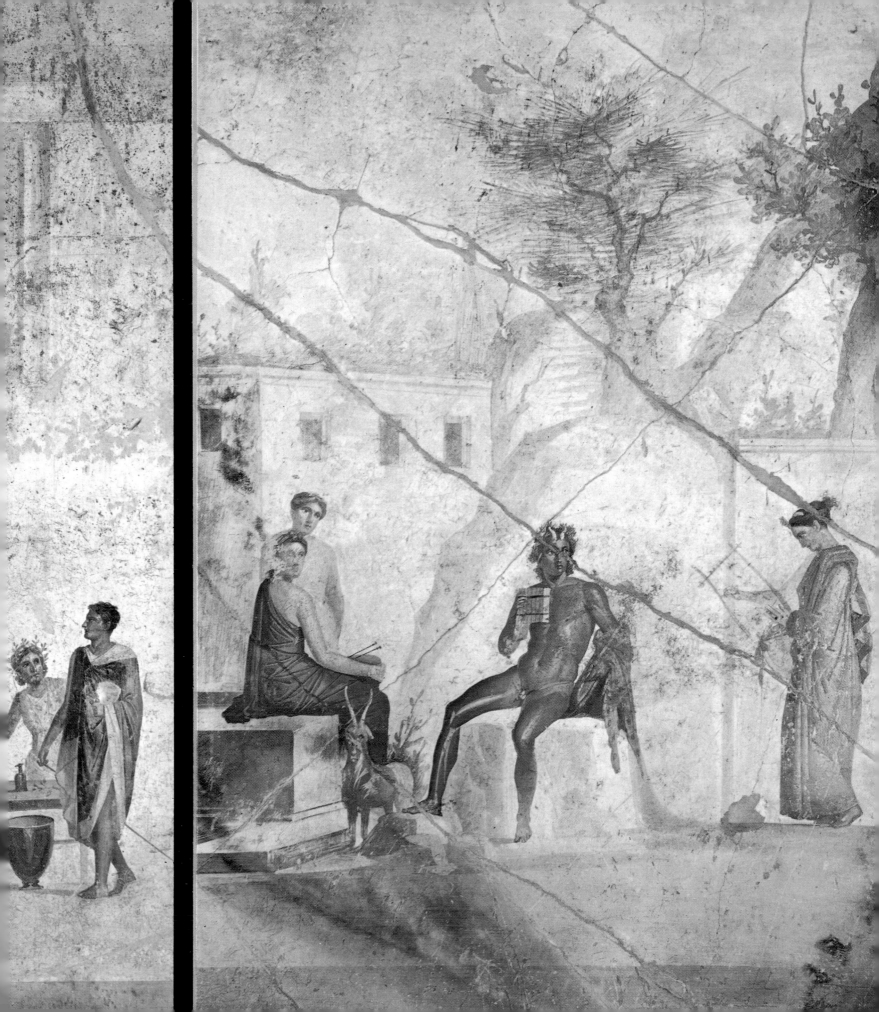

(pl. XLVIII). The rich colonnades of the "scaenae frons" in one fresco (pl. XLIX) provide the setting for the shepherd Attis, who is being guided toward the nymphs of the river Sangarios; later Cybele, his acknowledged lover, cruelly avenged this infidelity. In the House of Apollo (pl. L), the sun god, seated on a dais, tries a curious case involving two goddesses; they are the Evening Star and the Morning Star disputing the ownership of the planet Venus. The artists, in order to make the inspiration for these scenes more explicit, did not omit the backdrop curtain and the chandelier. The pictures reflect, in our opinion, the profound cultural influence exerted by Nero upon his subjects. The passion which this prince had for the theatre is well known; he went so far as to appear on the stage himself. He even chose it as the setting for great political ceremonies, such as that held when Tiridates, the king of Armenia, came to pay him solemn homage. In the Theatre of Pompey, landscaped for the occasion in such a way as to evoke the whole universe. Nero played the Sun King, a role identical with that of the Apollo-judge shown in the Pompeian house; certain details of the décor of the latter also relate to the Apollo Actius of the Palatine, whose temple was the dynastic sanctuary of the Julio-Claudian family.

Nero, therefore, seems to be the real inventor of the Fourth Style, at least in its most characteristic forms. This imperial dreamer who lost the power to distinguish between his illusions and reality — did he not imagine when told of the revolt of the Gauls and the defection of his armies that the rebels could be pacified by his songs? — could encourage only an art of escape, a fantastic illusionism depicting this universe under the sole governance of aesthetics, a perfect universe, that is, which he believed himself called upon to create for the happiness of men.

Whereas the frescoes with the figures in the *Domus Aurea* have their origins in theatrical compositions — as we have found in Pompeii not only in the House of Apollo and of Pinarius Cerialis, but also in the House of Joseph II, and in public buildings such as the market and the *Palaestra* — the decoration of the "landscape room" of the Golden House gave birth to a parallel current that is much closer to the Third Style (pl. XLVI). The light architectural structures, representing doors opening onto infinity, are connected to each other by large panels. The room thus seems bounded by a sort of pergola that opens to the air, the intercolumniations of which would be closed by tapestries; in the middle of the walls, panels are defined, showing either figures in flight, singly and in pairs, or

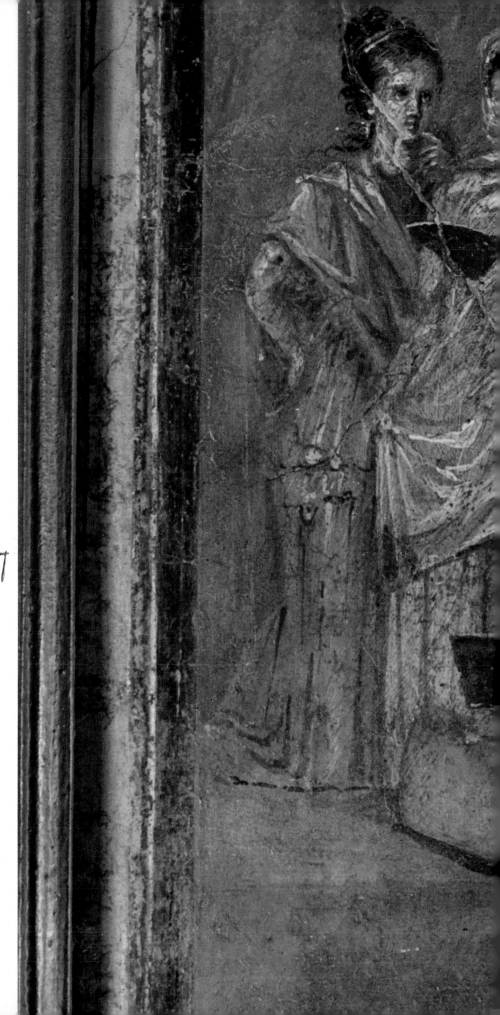

*XXXIX This work, now in the Naples Museum, came from the old excavations in Herculaneum; it depicts a woman painting a picture. Amateurs preferred easel painting to mural painting, and the works of celebrated masters brought very high prices. A considerable number of these painters were women; Pliny (Natural History, XXV, II, 40) records: Timarete, daughter of Micon, Irene, daughter and pupil of Cratinos, Calypso, Aristarete, daughter and pupil of Nearke, Olympias, and Iaia of Cyzicus, a painter famous for her skill, who came to Rome at the time of Varro.*

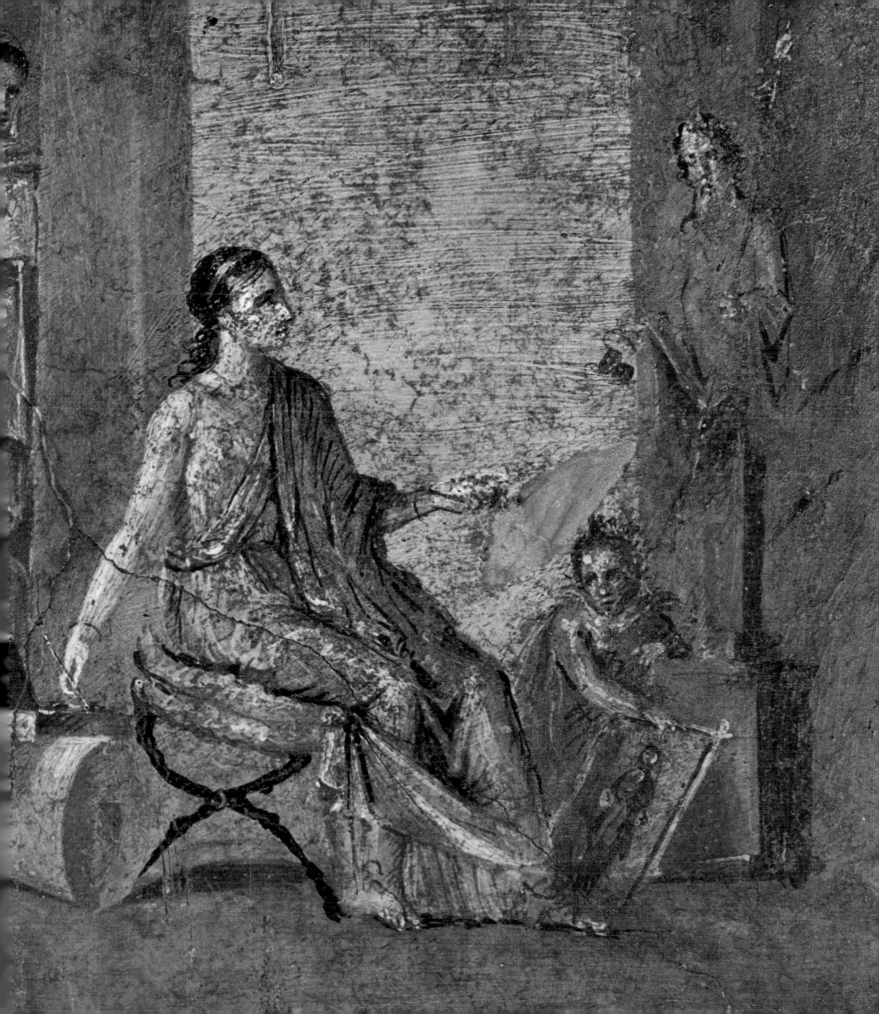

landscapes or mythological scenes. These panels which constitute the principal zone of decoration, are often framed above and below by friezes. The same thing is done in the Grand Salon of the House of the Vettii, where the celebrated frieze depicting cupids practicing various trades is placed as a predella below the large panels (pl. LI); the central one depicts embracing Bacchantes and Maenads.

The two types of décor just discussed here are the fundamental ones; but one would find it difficult to convey within a few pages the great richness and variety of the combinations which the painters of the Fourth Style evolved. It would be necessary to analyze not only the decorations on the middle zone of the wall but especially those on the upper zone, which were often designed to give the impression of large windows or of loges open to the exterior. Moreover, the painters of the second half of the first century A.D. generally cared much less than their predecessors about the logical coherence of these compositions. They had a tendency to treat each sector, each element, of the decoration individually, and with baroque fantasy and exuberance. In doing this, they began to lose sight of the fundamental psychological principle of their art: the necessity of persuading the spectator of the existence of an imaginary world beyond the wall. These works fragment one's attention, scattering it among amusing and picturesque details, or, when the spectator's attention is again concentrated, attract it to the paintings placed in the center of the panels. Therefore, little by little a conception close to that of the Third Style returns, in which the architectural composition serves only to frame the copy of the painting which occupies its center.

This evolution is more and more marked in the last phase of Pompeian painting, which corresponds to the reign of Vespasian (70-79). The new ruler, scion of a modest family from Reate, was the complete opposite of Nero: down-to-earth, realistic, and rigid. Although there still were many people in the Empire who missed the magnificence of the preceding regime, the active propagandizing by the adversaries of the Neronian ideal bore fruit. Nor is it surprising to witness a classicizing reaction in the arts. Nevertheless, neither in this era nor later, under Hadrian for example,

XL   Herculaneum; House of the Bicentenary.   Daedalus and Pasiphae.   The decoration is characteristic of the middle of the Third Style, c. 40 A.D.   All trompe l'oeil effects and simulation of architecture have disappeared from the wall, which is now made up of panels separated from each other by vertical bands filled with elegant "inhabited vine scrolls."   Attention is focused on the center panel with its rendering of the myth of Daedalus and Pasiphae, one that often inspired Pompeian painters: see pl. LII for a classic interpretation of it by a Flavian (late first century) artist working in the Fourth Style.   Here the scene takes place not in a palace or in Daedalus' workshop, but in a stormy landscape, such as the painters of the middle phase of the Third Style favored.   From a herd of heifers Pasiphae chooses a model for Daedalus, portrayed here as a Roman artisan; compare his idealized characterization in pl. LII.

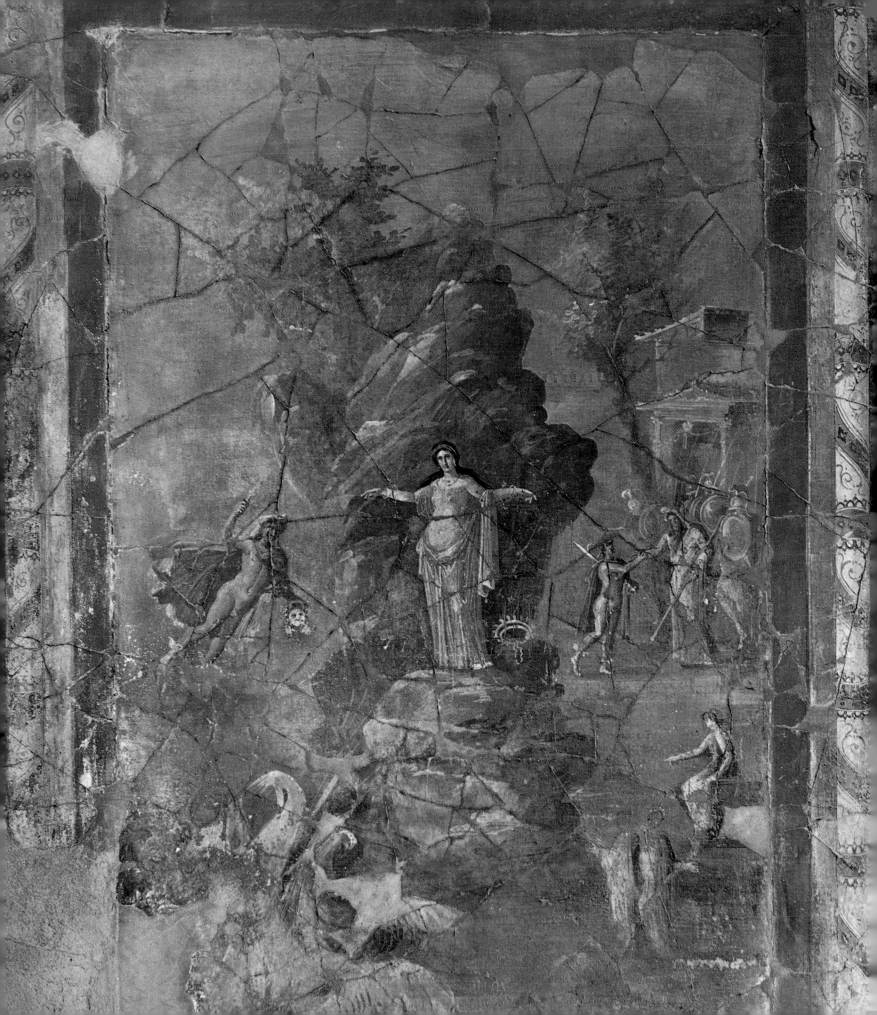

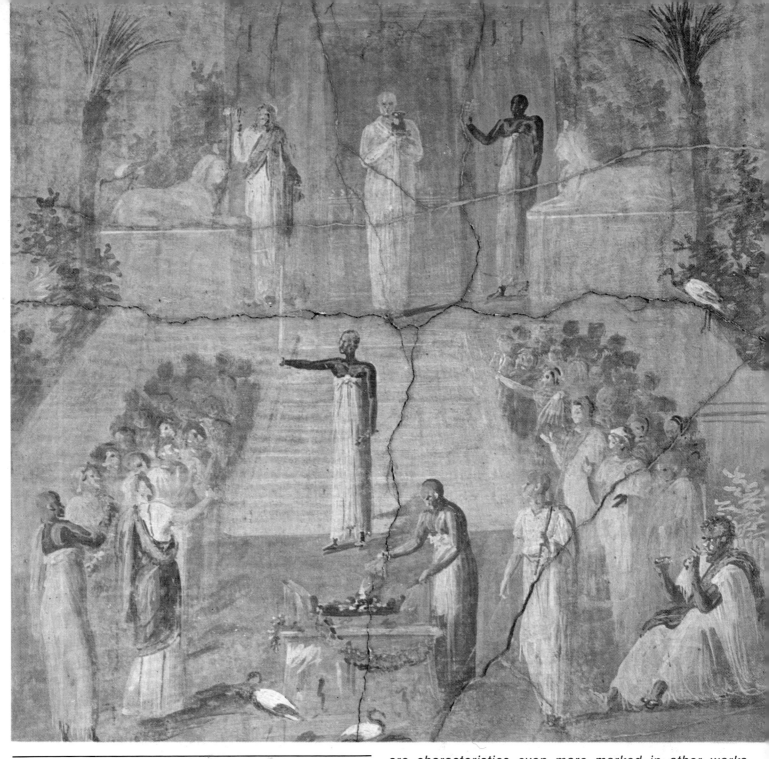

XLI House of the Priest Amandus: the Deliverance of Andromeda. A characteristic work of the "romantic" phase of the Third Style, c. 40-50 A.D. For the commentary on this painting, see p. 50. The originality of this picture is all the more notable since this subject had often been treated in Pompeii, but in a version formulated by Nikias. The main characteristics of this work are: the importance assigned to the landscape, in which the figures are almost lost; the simultaneous depiction of successive episodes (note the meeting of Perseus and Andromeda's father at upper right); and the violent contrast of colors. The lack of interest in exploring either psychological or plastic effects, and also the taste for informal and savage natural settings

are characteristics even more marked in other works in the same vein, such as the Abduction of Hylas (K. Schefold, Vergessenes Pompeji, pl. 11 b).

XLII Herculaneum; Ceremony of the Cult of Isis. A painting illustrative of the romantic tendency of the Third Style, c. 50 A.D. See the commentary on p. 101. The balanced composition of this painting is not unlike that of the Meeting of Jason and Pelias (pl. XXXVII), but the spirit of the work is completely different. The pervasiveness of the somber light, the expression of the overall movement through the gestures of a few key figures, who stand out clearly from the undifferentiated masses, occur again in the famous painting of the Trojan Horse, which has other significant similarities to the paintings in the House of Amandus.

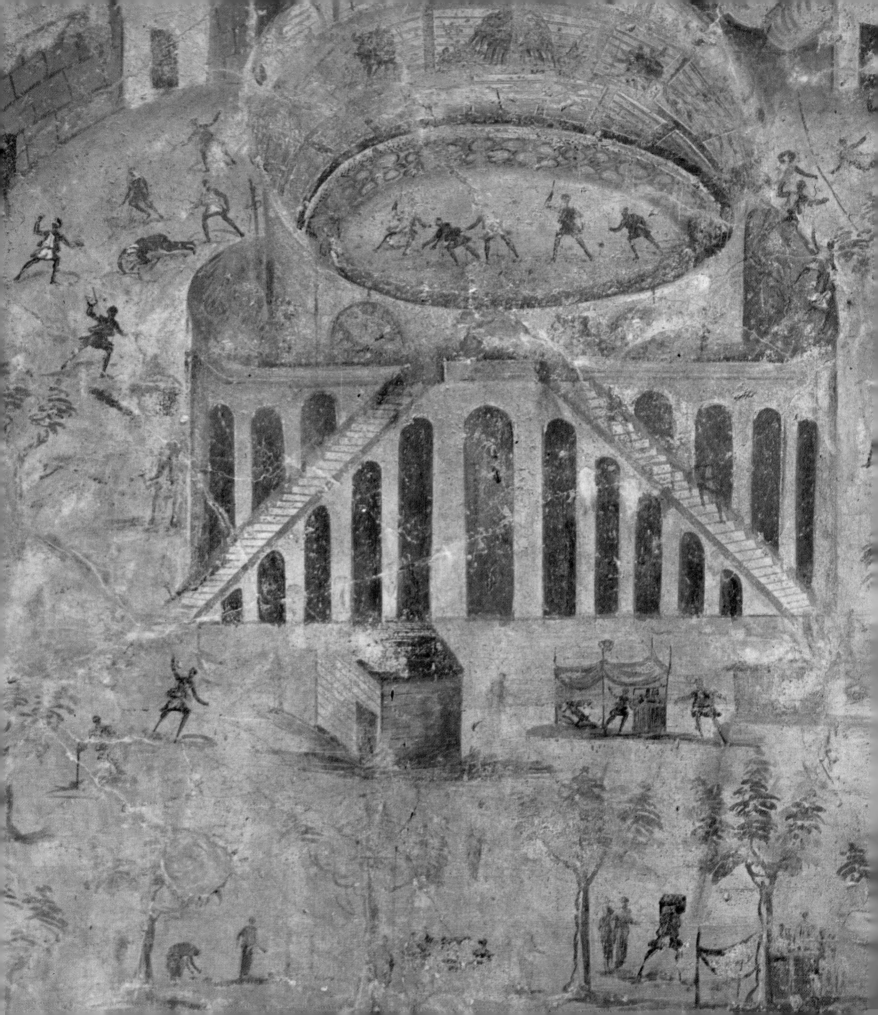

can one talk of a new classicism, comparable to that found under Augustus; that period had seen the *creation* of a style, one which used the fundamental principles of all classicism — rationalism, idealized naturalism, order and measure in expression — but used them in new formulae: in sum, the Augustan Third Style, like the decoration of the Ara Pacis, is completely original in respect to the works of the past. In contrast, the classicizing reactions which periodically mark the development of Roman art from Vespasian to Constantine are incapable of creativity and thus imitate earlier masterpieces. We do not see the rise of a Fifth Style in Pompeii. The painters either continue the less romantic current of the Fourth Style, that of the panels, as may be seen in the House of Loreius Tiburtinus (pl. LV), or they copy the compositions of an earlier period. It is completely characteristic that in this case they adopt the Third Style as a model, and more rarely the First, but never the Second. This choice indicates that we are not guilty of anachronistic illusion when we state that the development of Roman painting is marked by the alternation and opposition of two currents of contrary aesthetic inspiration.

One can therefore say that the decadence of Roman wall painting began a few years before the destruction of the Campanian cities. It was only made more evident by what was to follow. The painted decoration of the Ostian houses lets us follow this decline; consider, for instance, the House of the Muses, which dates from Hadrian's reign (pl. LXV). There we again find a composition very close to the Fourth Style with its panels. The wall is divided into large monochromatic fields, in the middle of which there is a figure. Between these panels some openings still reveal graceful architecture receding into the distance, but the clumsiness with which the perspective is treated betrays the indifference of the painter, who evidently no longer believes in the existence of a supernatural world beyond the wall. Architecture and apertures are nothing but conventions that have been passed on to him by tradition and that he makes use of to give order and rhythm to his composition. His interest is concentrated on the figures

---

*XLIII   The Riot in the Amphitheatre, from Pompeii; now in the Naples Museum.   This painting is extremely important for the history of Pompeian painting; it is the only representation of a contemporary event which happens to be well documented and dated: the bloody riot involving the people of Pompeii and Nocera in the amphitheatre of Pompeii took place in 59 A.D.   The painting, which reveals some of the chief characteristics of popular art (such as bird's-eye perspective), can give us some idea of the historical paintings of triumphal art.   But in addition, it clearly is linked to the romantic phase of the Third Style shown in the preceding plates, especially by the scale of the figures in relation to their surroundings, by the comprehensive conception of the individual event, and by the attempt at expression of a collective psychology.   Thanks to this painting we have good reason to argue for the continuation of the Third Style into the early years of the reign of Nero.*

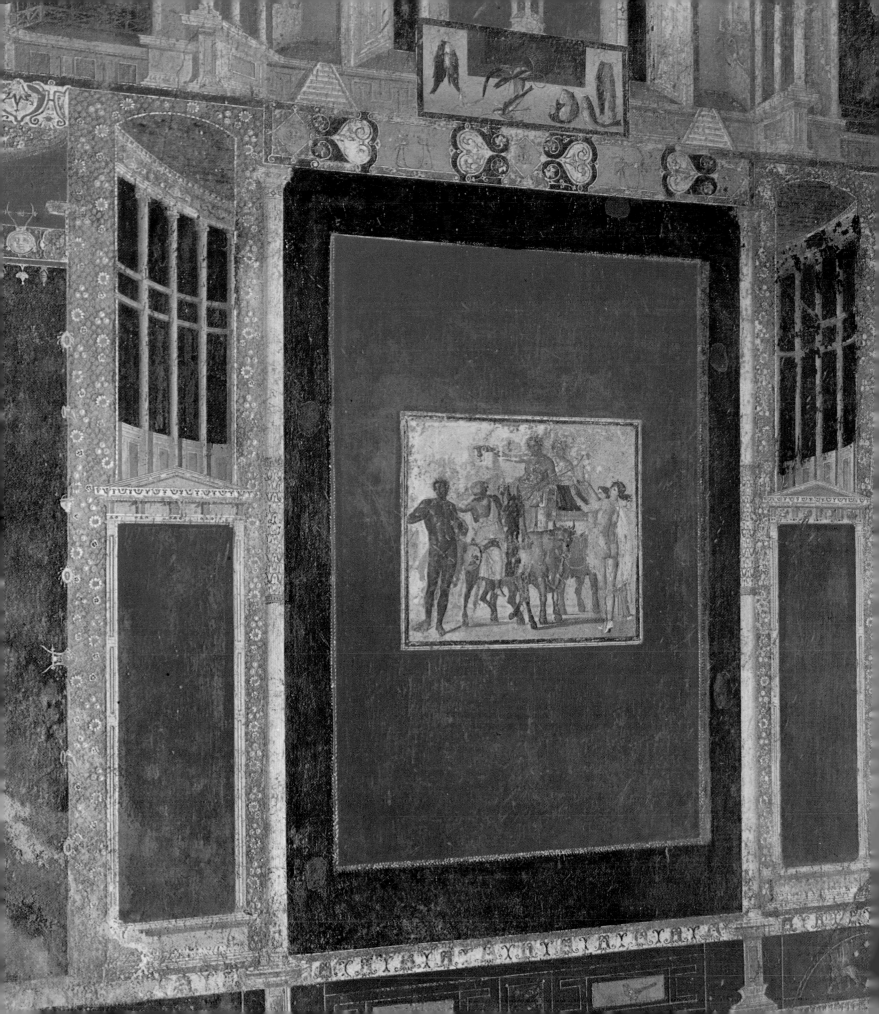

which occupy the center of the panels. In the second half of the second century the useless souvenirs of the past are logically given up as mere encumbrances: openings and architecture disappear completely. Only the panels remain, and they are separated from each other by thick colored bands; these do not aim at imitating architectural elements; their function is only to delimit the fields in which the figures are set forth against a neutral ground or in the middle of a décor reduced to the minimum necessary for comprehension of the scene. This "outline style," as it is called, developed during the beginning of the third century in pagan art as well as in the first works of Christian art.

This rapid and summary survey of the history of Roman wall painting enables us to define its essential quality and its originality. During two periods, one toward the middle of the first century B.C. and the other a little more than a hundred years later, Roman painters tried to suggest the existence beyond the wall of an imaginary world to which this wall, become transparent, reveals the approaches. There were two reactionary periods — the first in the very last years of the first century B.C. and the second after the fall of Nero in 60 A.D. — during which the principle of the transparent wall was renounced. After the destruction of Pompeii this principle was no longer understood and no subsequent attempts were made to revive it.

One must emphasize the originality of the Roman artists' development of the transparent wall. As far as we know, there is no equivalent attempt in the entire history of wall decoration, whatever the place or time. In all other cultures, the artist charged with decorating a wall opted for one of two formulae available: either he completed the work of the builder by embellishing the wall or contrariwise by concealing the material of which it was made; or

XLIV  *Tablinum of M. Lucretius Fronto.  The House of M. Lucretius Fronto is a characteristic example of the transition which ushered in the Fourth Style, and can be dated to c. 60 A.D., before the earthquake of 63. The wall, which had closed up as the Second Style ended, now tends to open again on both sides of the central panel and in the upper zone.  The main picture no longer has the elongated shape that it had when it first appeared in the latter phases of the Second Style. The subject here is the Triumph of Bacchus.  This motif will appear frequently — although with very different treatment — in Roman art during the second century, and as often in relief as in mosaic, but it seldom appears earlier.  The composition of this work has certain elements that surely are of Hellenic origin — specifically, the opposition of the two nudes which frame the group.  Note that the Satyr is depicted frontally and the Maenad from the back, and compare the latter with the dancing Bacchante in the Villa of the Mysteries (pl. XXXII).  However, the frontal presentation of the chariot occurs again in such a work of popular art as the Venus Pompeiana from the shop of Verecundus (pl. LXIV).  Since this seems to be an Italic invention, we do not believe that the painting shown here reproduces a Hellenistic model.*

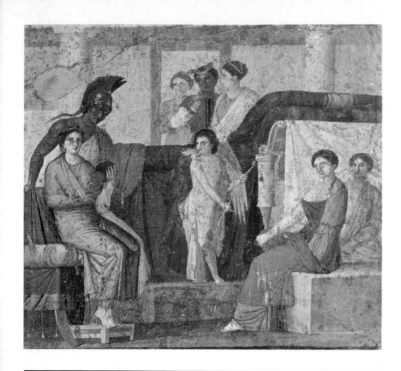

XLV   The House of M. Lucretius Fronto: the Loves of Mars and Venus.   This was one of the favorite subjects of Pompeian painters and it was often exploited for its eroticism.   That is not the case here.   Certainly the presence in the background of Mercury accompanied by two goddesses makes one think of the spicy episode in the Odyssey when the lovers were surprised by Hephaistos, but here the absolutely proper poses of the principals and the demeanor of the witnesses give the scene a quite different meaning.   The balanced arrangement of the composition on both sides of the central axis formed by the figures of Mercury and Amor, the use of architectural coulisses, the bond established between the figures and the elements of the décor which enframe them, all of these recall the methods used in the first phase of the Third Style.   The romantic phase is past, and we see here a return to the psychological humanism of Greek painting.

XLVI   Golden House of Nero: the Room of the Land-scapes.   The decoration is by Fabullus, who must be considered as the innovator of the panel series of the Fourth Style; 66 A.D.   See the commentary on p. 58. The decorative system is still very close to that of the House of M. Lucretius Fronto (pl. XLIV).   Nevertheless, the openings have taken on a greater importance. The delicate tonalities with white and gold predominating, the elegance and the lightness of the motifs, which contrast with the excesses of the Fourth Pompeian Style, are characteristic of Fabullus' manner. The subjects of the panels in the upper zone, Nereids and sea monsters alternating with Gorgons, perhaps have a symbolic value: they conjure up the limits of the universe, the geographic limits imposed by the oceans, the cosmic limits consisting of the "superior waters."   The landscapes in the middle of the walls symbolize the real world.   The whole of the Golden House was conceived as a microcosm, a sort of miniature of the perfect universe that Nero believed himself called to give birth to.

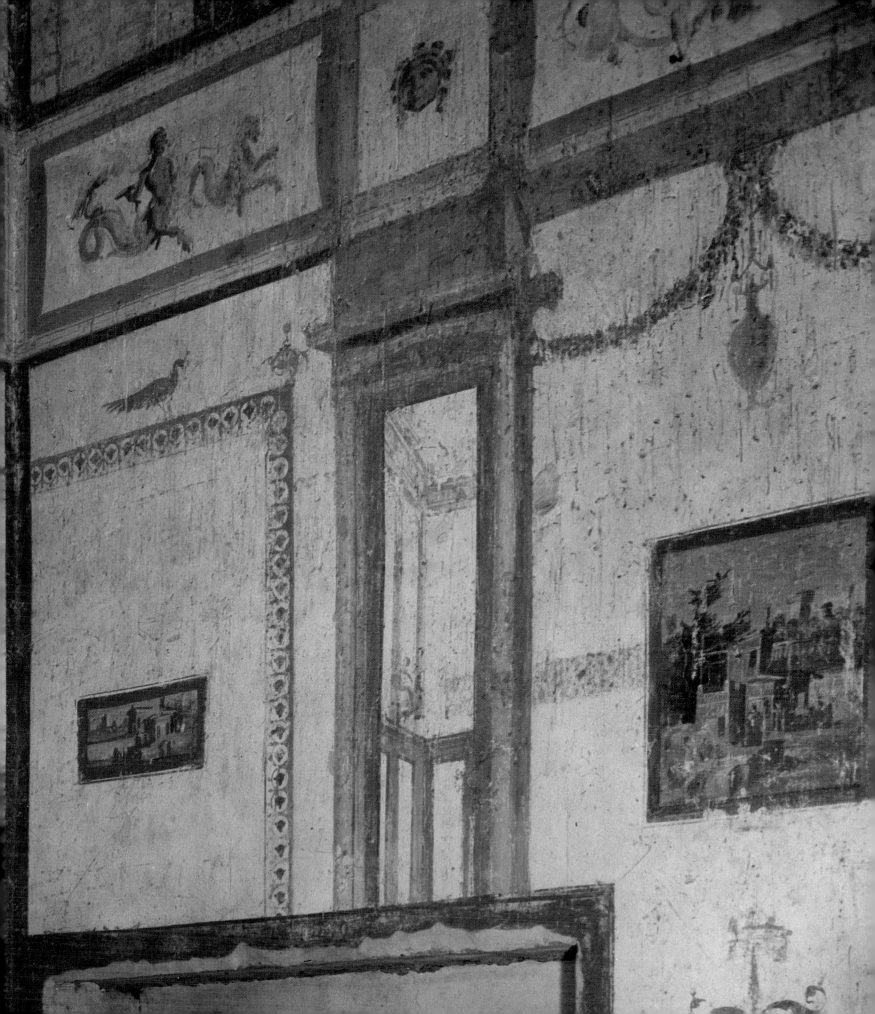

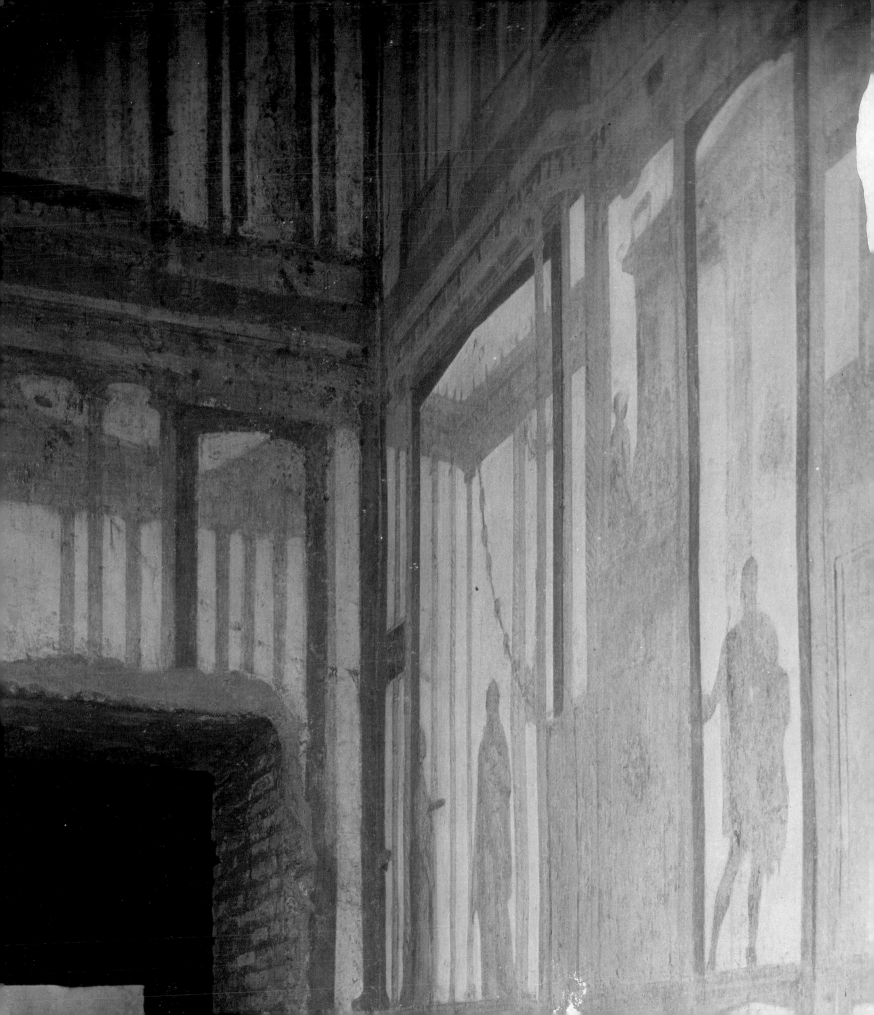

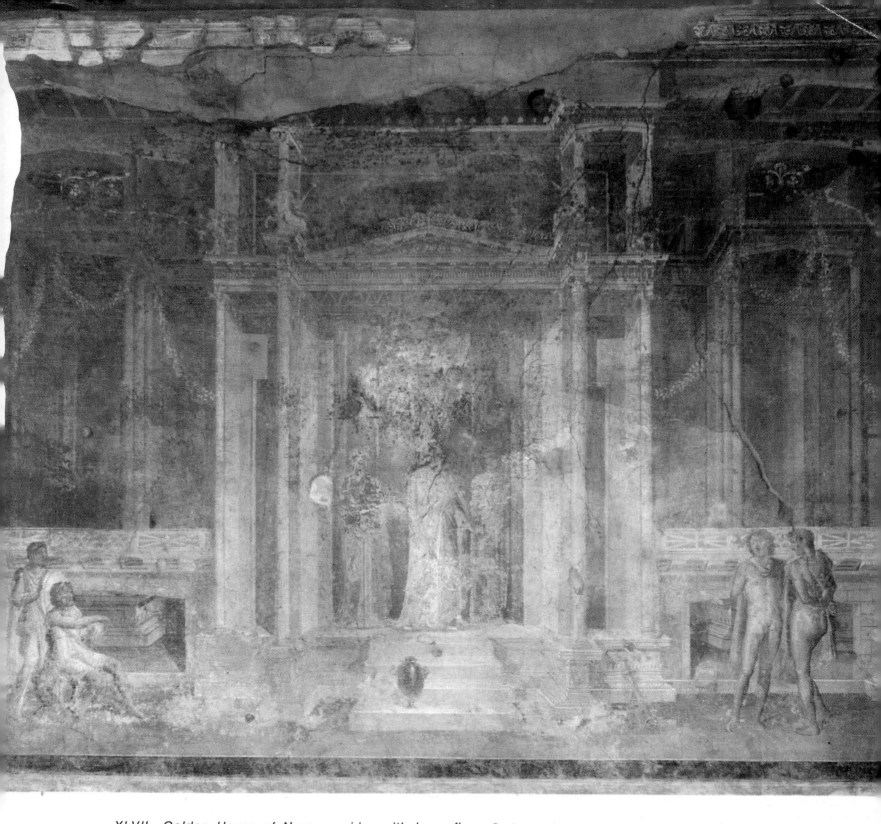

XLVII  Golden House of Nero: corridor with large figures.  By Fabullus, 66 A.D.  This decoration can be considered as the point of departure for the theatrical series of the Fourth Style.  The wall again becomes entirely transparent, as in the Second Style, and reveals a fantastic world: it is the perfect universe, entirely ruled by the laws of aesthetics of which Nero dreamt.  The harbingers of this world come toward us.

XLVIII  House of Pinarius Cerialis: Iphigenia in Tauris. A typical example of the theatrical series of the Fourth Style; end of the reign of Nero, 66-69 A.D.  The architectural decoration simulates the scaenae frons of a theatre and is intended to evoke the sanctuary of Artemis in Tauris for the spectator; the general format of the composition is that of the solemn departure from a temple, such as we have already seen in the Meeting of Jason and Pelias and in the Ceremony of the Cult of Isis from Herculaneum (pls. XXXVII, XLII).  Thus one sees that the same arrangement not only can serve to translate very different situations, but also can be used in very different styles.

the wall could simply serve to hold a composition which had no relationship to it. It matters little in the latter case if it is a picture which hangs on the wall or if it is a fresco which is a part of it: the painting represents a space which has no connection with the real space of the room. The Roman painter, on the contrary, seeks to alter real space by enlarging it with a fictional space which extends symmetrically from it in relationship to the wall. In order to make the relationship of the real and the imaginary space closer, he projects into the interior of the first the elements which belong to the second: the *trompe-l'oeil* architecture which constitutes the first plane of his composition is seen as if it were before the wall.

This extraordinary attempt at suggestion has, in our opinion, no equivalent; the *trompe-l'oeil* effects of the eighteenth century, which in other respects often imitate Roman painting, are nothing but tricks with a very limited function; furthermore they correspond only to those elements which in Roman painting are supposed to be in front of the wall — they do not open perspectives behind it. The Roman attempt has scarcely any parallel except in the art of the spectacle: the theatre, and present-day cinema. The spectator has before him, beyond the plane of the stage set or screen, a world at once imaginary and real, completely different from the world represented by painting. We had wanted to explain Pompeian painting of the Second and Fourth Styles as a sort of fixed and permanent theatre; we will discuss this thesis soon, but one must now say that although it reckons with a large part of the truth, it does not explain the origin of this tendency.

How did this direction come about, and to whom must one attribute its invention? In order to deal with this question, we must cite again that great connoisseur of Roman art, Professor R. Bianchi-Bandinelli: "During the second quarter of the first century B.C.," he writes (*Storicità dell'Arte Classica*, p. 161), "there still existed a wall decoration of fictional architecture, of a noble and severe taste (generally called the 'Second Style,' and more precisely designated by Beyen as phase IA of the Second Style); the earliest example known today, thanks to Rizzo, is found in the House of the Griffins on the Palatine. As the middle of the century neared, this decoration seems to have been enriched by a decided attempt to explore the possibilities of perspective and the tricks of light and shade. One can prove that this decoration is strictly in the Hellenistic tradition; the first examples introduced into Rome must have seemed attractive with their touch of exotic fantasy and exuberance, in comparison with the sober Sullan architecture in which an adaptation of the common language of Hellenistic architecture was tried for the first time. It has already

*XLIX  House of Pinarius Cerialis: Attis and the Nymphs. The right wall of the room shown in plate XLVIII.  The compositional scheme is identical with the preceding one, but the subject of the drama here is the myth of Attis: guided by Eros, the Phrygian shepherd loved by Cybele approaches the nymphs of the river Sangarios. Cybele's punishment for this will be to strike Attis with madness, which will lead him to self-mutilation.*

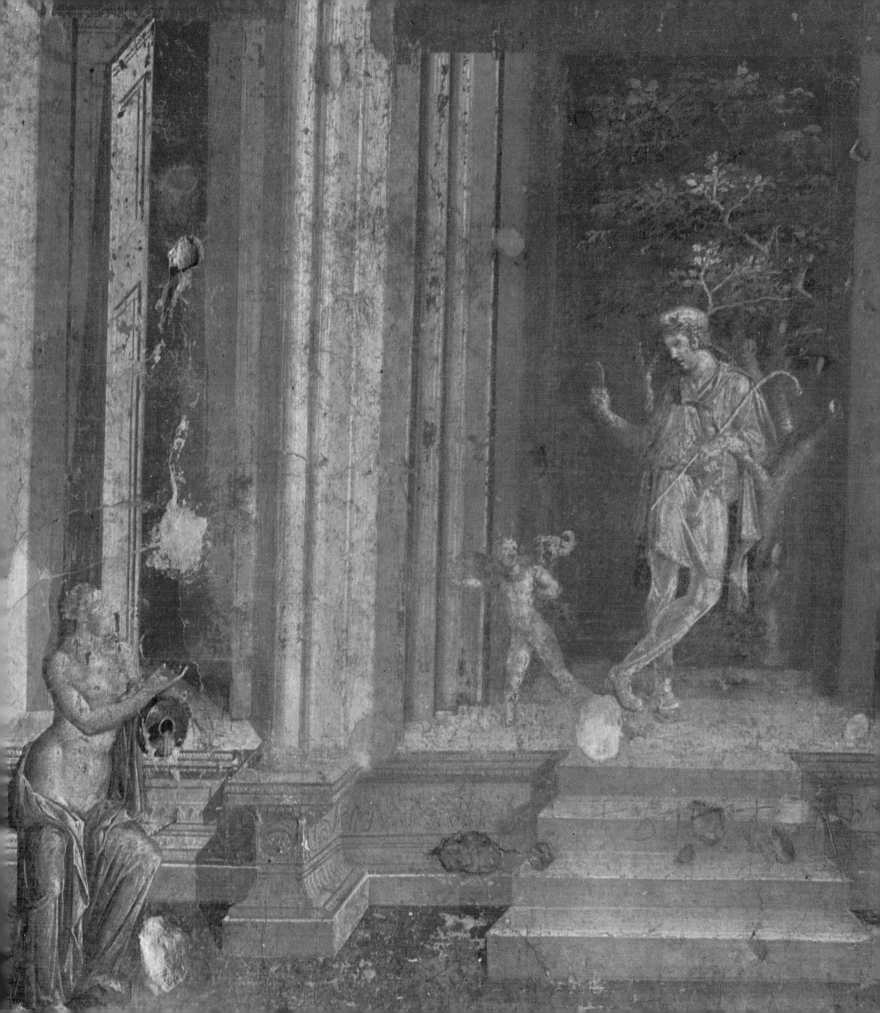

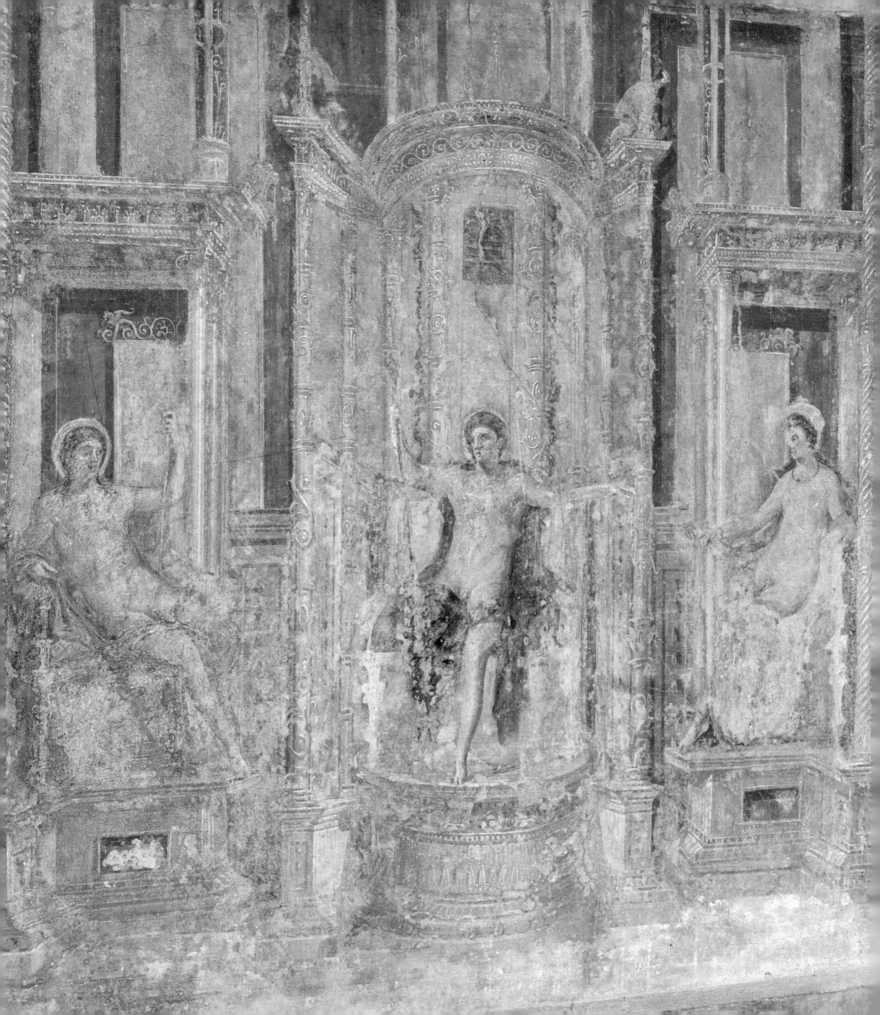

been shown and proved (thanks to Curtius) that underlying this decorative syntax is the same architectonic taste that inspired the so-called 'Weepers' sarcophagus in the museum in Istanbul or the design of an altar and of the Gymnasium of Priene. These examples, as well as some ordinary decorative details, indicate the probable source is to be found in the Greek cities of the Syrian coast or is generally Asiatic. But the tendency toward perspectives of the background must have been widespread throughout the whole of the Hellenistic world; this is proved even in the Alexandrian milieu by examples however modest.

"One of these is the door of a tomb in the necropolis of Hadra (with the inscription *tephane chreste chaire*) which is represented as a wooden gate between two pilasters, between which a simple and light garland is suspended against a blue ground indicating the open air. Another example is the enclosure of a tomb in the necropolis of Sciatbi (with the inscription *philotecne chaire*) of the first half of the third century B.C., where there is a false door surmounted by a pediment showing a drum and clappers decorated with shells, visible across a square opening crowned with a twisted alabaster cornice; note that the space above the cornice is painted blue to indicate the open air, the sky, space, and that under the denticles of the pediment there is a strong projection of light and shade. The comparison with the false door in the large *oecus* of the Villa of the Mysteries (phase I B of the Second Style), over which an apse-like structure opens onto the sky, and with that of the Villa at Boscoreale is decisive. And we should remember that on another wall at Boscoreale we still find the small wooden gate in use. Even the modesty of these Alexandrian examples increases their value as witnesses of an expanded taste and experience.

*L Pompeii; House of Apollo. Another example of the theatrical style in vogue during the last years of Nero's reign. This painting has both mythological and astrological meanings, which accords with the preoccupations of the period (see p. 58). Like the previous plate this is doubtless a sort of mime, or ballet, rather than a play: Apollo issues his verdict on the controversy between Hesperos (the evening star) and Phosphoros (the morning star).*

*LI House of the Vettii: frieze of the Cupid Apothecaries. The House of the Vettii is one of the best-preserved houses in Pompeii and one of the first to have been restored. It is decorated entirely in the Fourth Style and offers a veritable catalogue of all its diverse phases and tendencies. The frieze here reproduced is in a large room, designated rightly or wrongly as a triclinium, which was painted in the "panel style" appearing at the end of Nero's reign: this frieze is situated between the socle and the middle zone of the wall; it represents, in light colors on a dark ground — a method related to chiaroscuro — Cupids and Psyches (little girls with butterfly wings) devoting themselves to all sorts of human occupations common to everyday life. This fanciful motif may well have its origin in Alexandria. But the exactitude with which the occupations are represented — here those of a pharmacist's dispensary — shows the influence of Italic popular art. The Vettii, great merchants, belonged to that part of the middle class which toward the end of the first century A.D. expressed a certain impatience with aristocratic humanism and its irrelevance to daily life.*

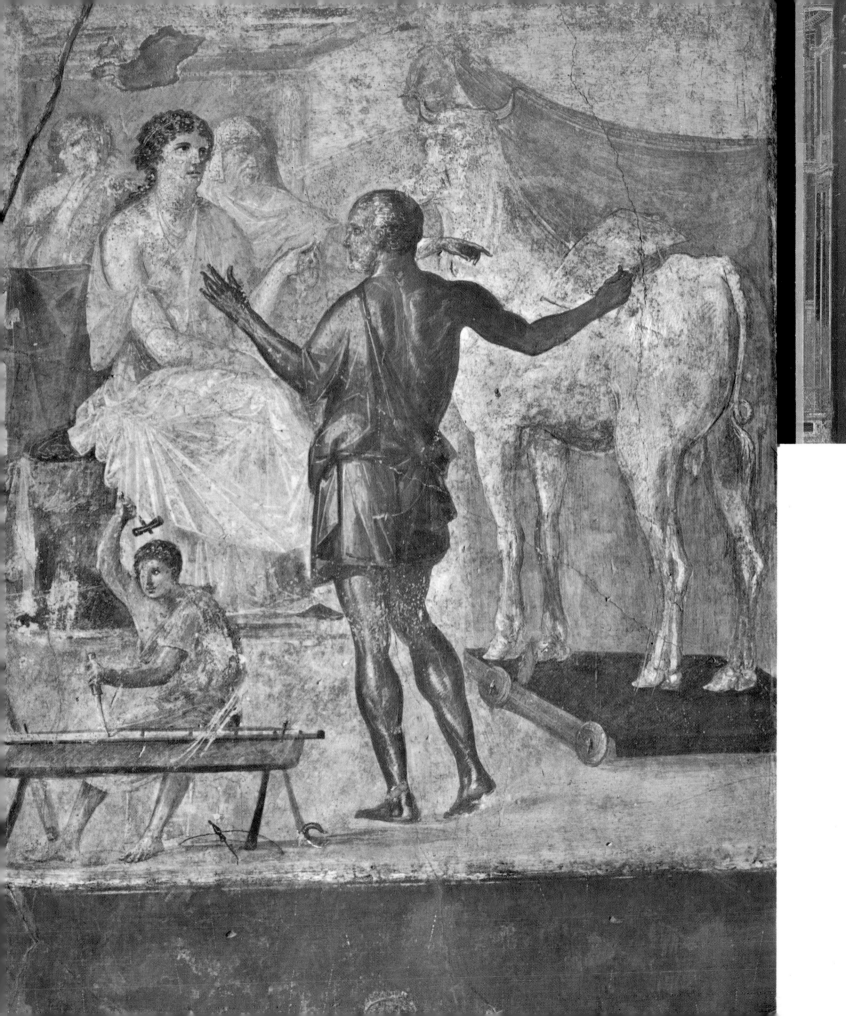

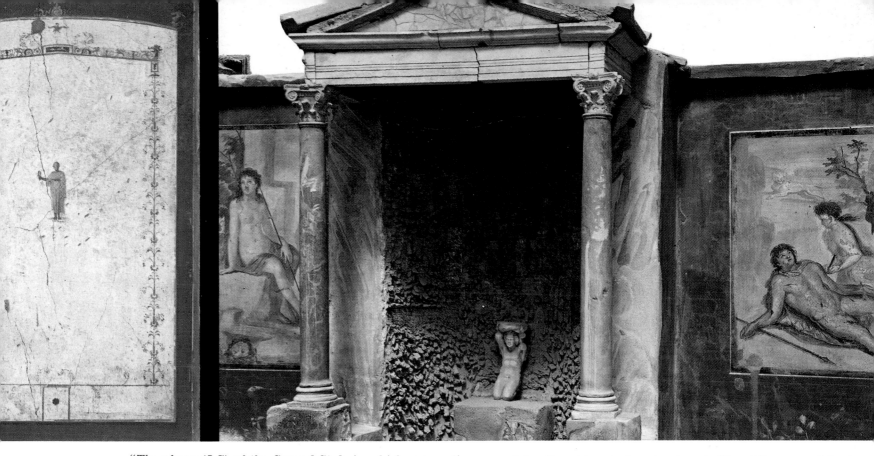

"The phase (I C) of the Second Style in which perspective plays the most decisive part, which appears in the Villa at Boscoreale and, ten years later, on a wall coming from the Gerace property in Pompeii, seems completely suffused with Hellenistic tradition, while one finds there no manifestations of any other — i.e. Roman — civilization. Where a bent toward perspective and the sense of space are concerned, which some have supposed and others have proclaimed to be typically and exclusively Roman, it is necessary to remember that the motif of the half wall opening high up to show the interior of other rooms or passages is a typical spatial theme found not only in the compositions of Pompeian paintings clearly derived from prototypes of the classical period, but also... in the Thessalian stele of Hedisto from the third century B.C."

Before discussing R. Bianchi-Bandinelli's thesis, which we chose for its clarity, distinctness, and the precision of its facts, it seems useful to draw the attention of the reader to the artificiality of the distinction, introduced by the moderns, between Greek — or Hellenistic — art and Roman art when the centuries immediately preceding and following the Christian era are concerned. This is the same as distinguishing between the European and the American art of the first two thirds of the present century. Certainly in the world contemporary with Christ, there were local artistic schools — one of the most individualistic was the

*sent by Poseidon to her husband, King Minos, and that ultimately sired by her the Minotaur — inspired Romano-Campanian painters more often than any other episode of the legend. We have already seen the interpretation of a painter of the Third Style (pl. XL). The painting in the House of the Vettii (see commentary, p. 101) is clearly more classical; the stereotypes — for example, the enthroned queen — and the expressions come from the Hellenistic tradition and are easily recognizable. Everything which gave life and originality to the painting in the House of the Bicentenary — the attitude toward nature, the study of the figure of an artisan — has disappeared here.*

*LIII House of Loreius Tiburtinus: Portrait of Loreius Tiburtinus, priest of Isis. In an overall composition of panels separated from each other by slender architectural motifs, characteristic of the Flavian Fourth Style, there is a panel with this portrait of the master of the house, a worthy Pompeian, dressed as a priest of Isis and holding the sistrum. The cult of the Egyptian goddess was very popular in Campania during the Imperial era when the area had close economic relations with Alexandria. See p. 99.*

*LIV Decoration of the Loggia of the garden of Loreius Tiburtinus. The house of Loreius originally had a charming garden, now reconstructed; its axis was traversed by a "Euripus," a marble canal bordered with statues, where an ingenious hydraulic system simulated the floods of the Nile. The "source" of this Euripus was sheltered by the chapel that appears at the center of the plate; integrated into a loggia, it was decorated with two paintings of romantic episodes: Narcissus, and the Death of Pyramus and Thisbe: these works, however mediocre, are the only ones in all of Pompeian painting to carry a signature, that of a certain Lucius.*

*LII House of the Vettii: the Ixion Room; Daedalus and Pasiphae. The Ixion Room was one of the last to be decorated in the House of the Vettii: by a Flavian artist working in the Fourth Style. The story of Daedalus fashioning a cow out of wood — a substitute to enable Pasiphae to overcome her passion for the bull that was*

one we call Neo-Attic, which had its center in Athens; but it would be a great mistake to attribute to them a consistency which they hardly possessed, and above all to suppose that each one embraced a single, precise, aesthetic doctrine; even the Neo-Attic school, which willingly drew its inspiration from the great masterpieces of the great Athenian period, seems after all at least as eclectic as neo-classic. Furthermore, this imitation of the masterpieces of the fifth

*LV House of Loreius Tiburtinus; Heraclean frieze. The House of Loreius Tiburtinus on the Via dell'Abbondanza was decorated in the Fourth Style during the Flavian era. The two superimposed friezes, of which only a part is reproduced here, tell the history of Troy. The upper, larger, frieze illustrates the taking of the city by Heracles, who was furious at the perfidy of Laomedon;*

from left to right: Laomedon enthroned, Heracles massacring the Trojan army; Heracles presiding over the marriage of the young Priam (to whom he has turned over the city) to Hecuba. Thus we have an example of a continuous frieze with an epic subject, the principle of which is the same as that of the Column of Trajan; such friezes also existed in Hellenistic art, for instance the Telephus relief on the great altar at Pergamon.

This Pompeian frieze perhaps derives from a Pergamene model, but the episodes have been chosen to emphasize moral values, conforming with a Roman ideal: the punishment of those of bad faith, the "virtues" of Heracles, the understanding of Priam and Hecuba. The smaller frieze below illustrates the Iliad: note the chiaroscuro effects, especially in the scene at right of the sleeping Trojans.

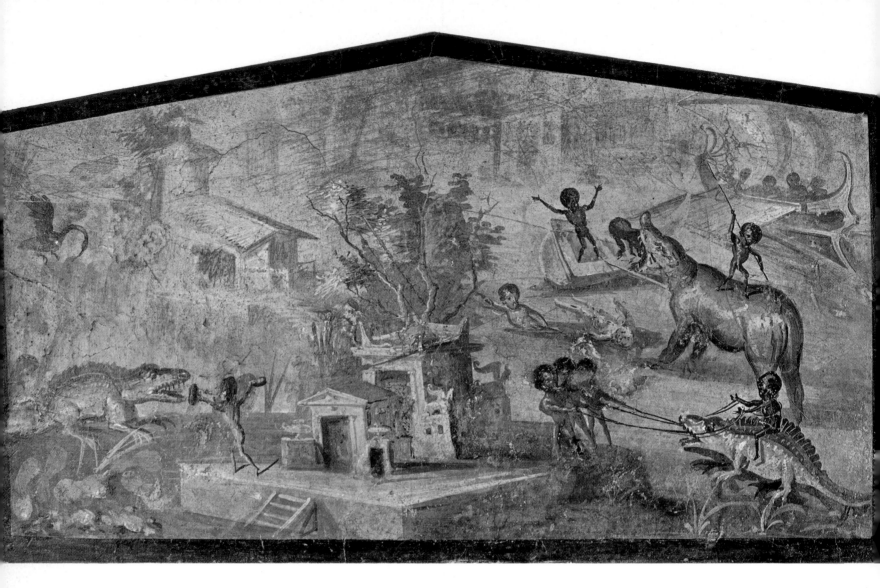

century B.C. was not a monopoly of its artists; an exact copy of one of the Caryatids of the Erechtheion has been found in the Forum of Augustus, and the base of this statue carries the signature of a purely Roman sculptor, G. Vibius Rufus. The centers of artistic activity were in fact the cities in which the artists could find commissions, that is to say, where the citizens retained political and economic power. With Sulla, Rome became the most important center, whereas most of the cities of Asia, violently affected by wars, were thoroughly decadent. Outside of Rome, the only artistic centers remaining were Athens, which had a singular position but which played scarcely any role in pictorial production, and the mysterious Alexandria, whose production is lost except for some miserable debris.

This artistic activity of Rome — and Campania merely offers a provincial reflection of it — was the achievement of people of all origins: certainly Greeks and Orientals, but also the Italians of the North and the South, who brought

to the capital the traditions which they had acquired in their native cities. All were ready to trade experiences, and above all, everyone had to submit to the directives they received from their silent partners. During this period of antiquity, each work of art had two authors; the painter and the man who commissioned him and bore the expense. Not content to choose the artist and watch him work, the patron intervened not only in the choice of subject but also in its execution, and all the more easily since the practitioner to whom he had recourse generally was the product of an eclectic training, as capable of transposing a classical model from Periclean Athens as a baroque model of Pergamene, Rhodian, or truly Etruscan origin.

Although we scarcely have a notion about the artists themselves, we know their intelligent patrons well: they were members of the aristocracy of the last century of the Republic, Cicero and his friends, Caesar, Pompey. All were imbued with Greek culture, some of them personally practiced the plastic arts, many were writers of great

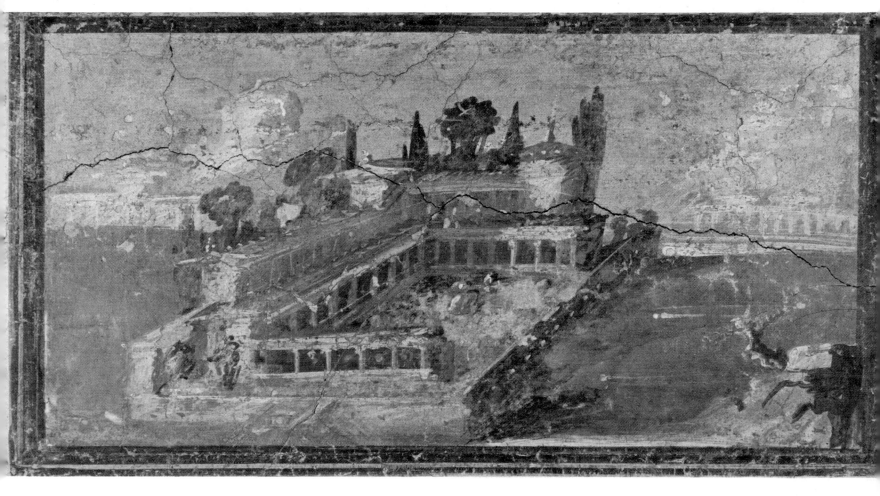

LVI   Nile Landscape.   The minor subjects of Pompeian painting might have been set in the center of side panels, they might have been placed on predellas, or they might have filled the friezes that separated the three large horizontal zones.   They were often landscapes, always more or less conventional.   This is an example of a Nile landscape inhabited by pygmies.   From very ancient times the Egyptians, and the Greeks after them, knew of the existence of these small dark people in tropical Africa, and all sorts of legends grew up about them.   Alexandrian painters depicted them, no doubt quite accurately at first, evoking the valley of the Upper Nile, as the Barberini Mosaic from Palestrina, dating from the Sullan era, testifies.   In Pompeian painting this subject becomes fantasy; the pygmies live in a village on an artificial island, the structures reminiscent of Ptolemaic Egypt.   The constantly repeated theme of their battle against crocodiles and hippopotami — elsewhere they are seen carried off by cranes — al-lows them to be depicted in grotesque, and sometimes obscene, poses.   A little of the humor of Egyptian art comes through in these compositions, which continued to be popular until the third century A.D.

LVII   Stabiae; Villa at the Seashore.   While the sacral-idyllic landscape (see pl. XXXVI) and the exotic land-scape were largely conventional, the paintings of villas and harbors were certainly inspired by contemporary reality.   This painting of the Flavian Fourth Style from Stabiae shows a dwelling consisting of two main buildings forming an L and preceded by a three-sided portico open to the sea.   This plan, analogous with that of the Villa Farnesina, was later applied to many country houses, especially in Gaul.   The large round tower must have served as a lookout.   Stylistically this little painting is a good example of the "ars compendiaria," which we have compared to impressionism, and which was always used in rendering this type of subject.

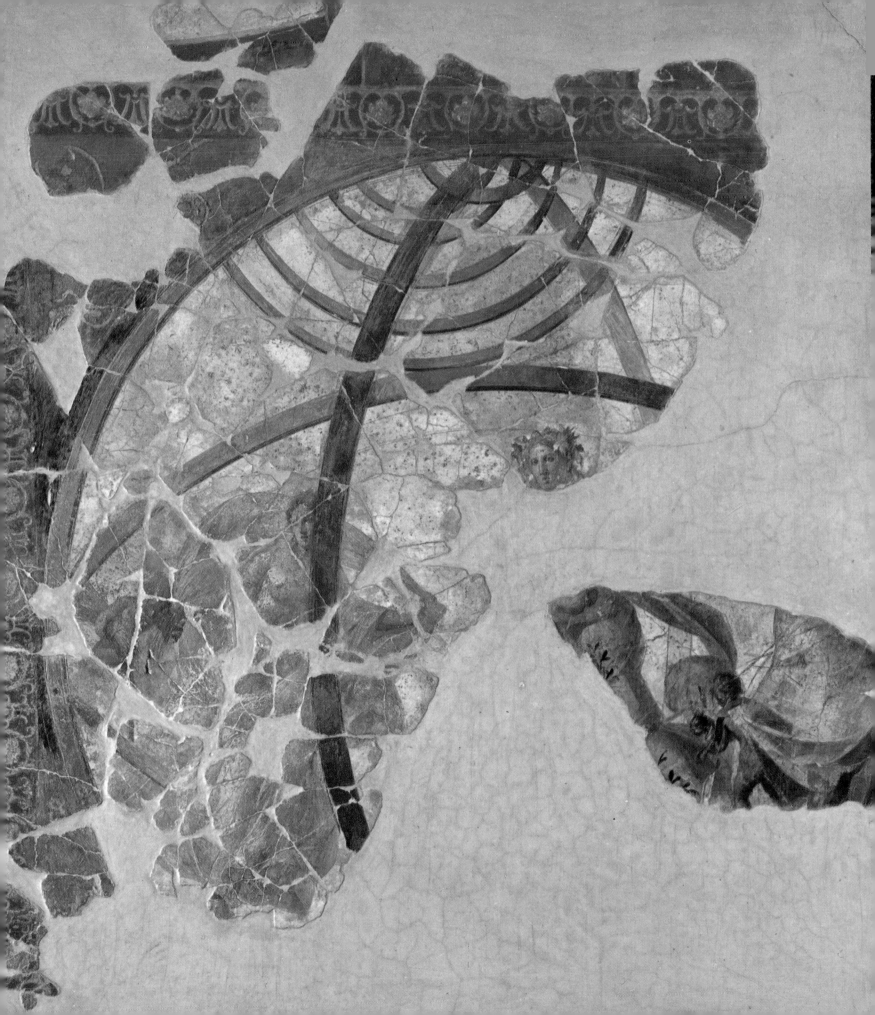

talent. They had studied the history of art as collectors, impelled equally by a desire not to be duped by some dealer and by disinterested passion. They knew enough about architecture to design the plans of their own houses and those of the monuments which they offered to the Republic with the spoils of their conquests. All that we know of the buildings which they have left behind demonstrates that their enterprise was effective and invigorating even when, with singular modesty, they pretended only to reproduce in Rome one of the marvels which they had admired in the East. The Theatre of Pompey in the Campus Martius imitated, according to Plutarch, the Theatre of Mitylene. But in this, as in all Greek theatres, the tiers were supported by an excavated flank of a hill; those of the Roman monument were, on the contrary, sustained by a system of arcades and of radiating vaults, a scheme of which this is the first example, as the researches of Italian architects show.

It is therefore improbable to conclude that these great noblemen, who were both intelligent and artistic, would be content, when the decoration of their homes was concerned, simply to commission reproductions of paintings two or three centuries old. A specific example, although of a later time, shows us how the Romans conceived the

*LVIII Stabiae; the Planisphere. This ceiling decoration reflects in a remarkable manner the astrological and cosmological preoccupations which manifested themselves from the time of Nero. Personifications of the seasons are enclosed within a ringed sphere representing the universe. Beginning with the last years of the first century, Roman art increasingly manifests the belief in a ruling Providence whose unvarying natural laws bring forth the eternal renaissance of life and its triumph over the forces of disaster, attesting a supreme and beneficent power; the Empire is the projection of this cosmic order on the human plane. These doctrines are the fruit of the scientific philosophy of the era. We have here an extraordinary example of an effort to translate them into original visual forms, ones alien indeed to the now hackneyed repertory which Greek art had created.*

*LIX Stabiae; figure of hero (perhaps Theseus). Stabiae, the Campanian town where Roman paintings of an exceptional quality had already been found, such as that of the flower-gatherer (Spring?), has yielded new treasures during the past few years; these various ensembles indicate the evolution of painting during the Flavian era better than the decorations of Pompeii and Herculaneum do. The figure seen here in a red cloak — perhaps Theseus — is the work of a master. Though classical in his means of expression, he is like the painter of the Basilica at Herculaneum in the excellence with which he renders dramatic emotion in large figures solidly constructed.*

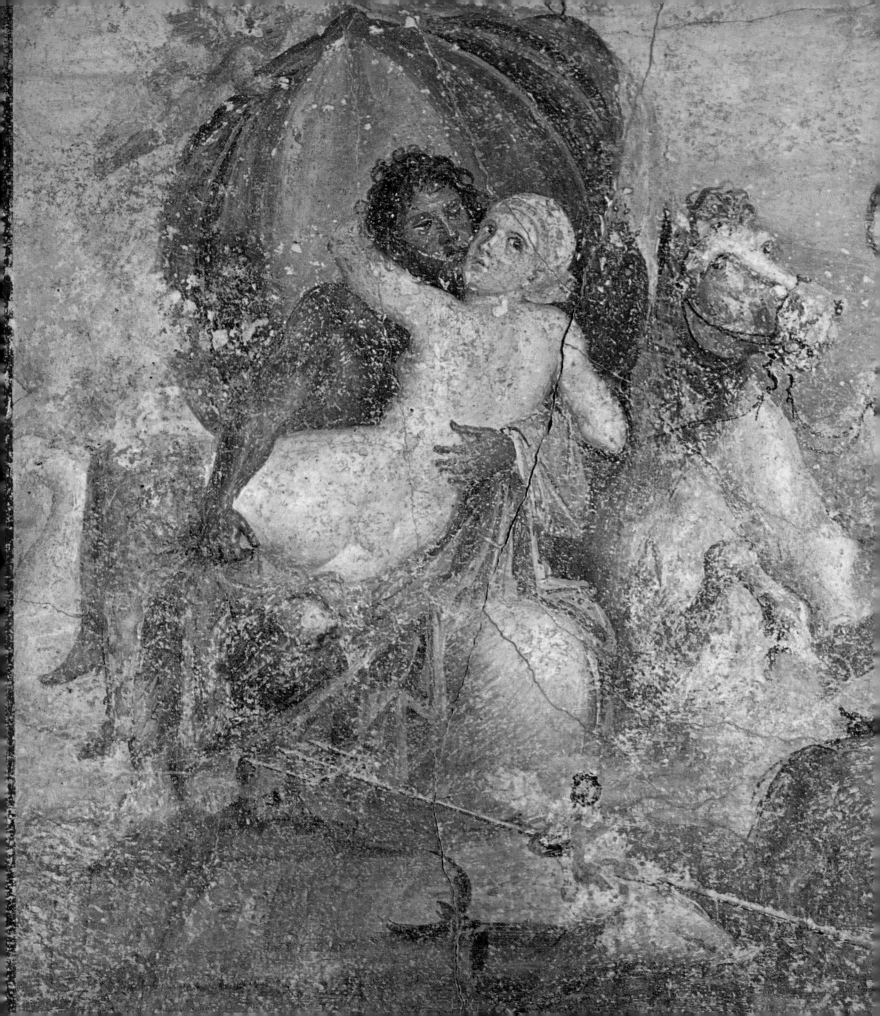

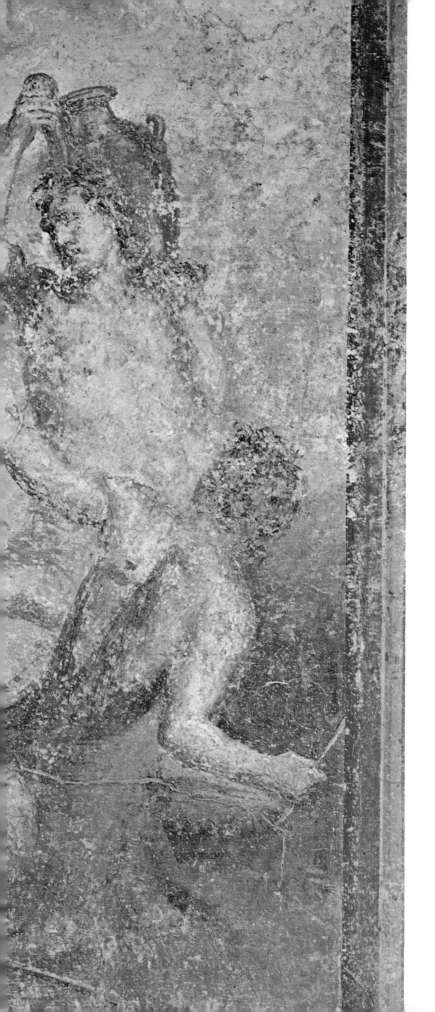

"imitation" of foreign buildings. The Emperor Hadrian, a great traveler given to exotic taste, had, according to the testimony of historians, reconstructed on his estate at Tivoli the most beautiful sights which he had visited. Today one can see there the "Serapeum" and the "Canopus," which were supposed to represent a temple and a celebrated canal close to Alexandria; the first is an enormous artificial grotto realized with all the resources of second-century A.D. architectural technology, which could have had nothing in common with a Ptolemaic sanctuary; the second is a pool bordered with baroque porticoes under which some Egyptianized statues keep strange company with copies of Phidian works. One can see from this how a Roman used either an earlier work of art or a copy of one, which he had commissioned: he inserted it like a jewel into the center of an entirely new composition conceived by him in terms of his own taste, and with no concern for the original intent of the monument or for the total effect of its original site. This notion might seem sacrilegious but it kept Roman art even in its most classic phases from descending, as did the Neoclassicism of the nineteenth century, into the dullest pedantry.

Pompeian painting offers us some good examples of the integration of ancient elements into a new synthesis; let us consider, for example, the right wall of the so-called *tablinum* in the "House of Livia" on the Palatine (pl. XXXIV). The painter has inserted three pictures into his composition; the most important one, in a central aedicula, depicts Io guarded by Argos, a work by Nikias, who was a contemporary of Praxiteles; the Roman copyist elaborated the landscape and added the figure of Hermes. On the upper part of the sides of the screen, which here represents the wall, two other pictures were apparently hung. Only one of them has been preserved, and loyal to the cause of illusionism, the decorator has shown the cupboard which protected it. The picture itself, which depicts a scene of sacrifice, appears to be a faithful enough copy of a work of the fourth century; it is evident that

---

*LX   Stabiae; Neptune Abducting a Nymph.   Among the frescoes recently discovered in Stabiae was a Triumph of Dionysos and this Abduction of a Nymph by Neptune. The compositions of both are quite close to that of the Triumph of Bacchus from the House of M. Lucretius Fronto (pl. XLIV).   Even so, the divine processions in them are not depicted with such frank frontality; instead the movement is oblique, as in the chariot scene on the Arch of Titus on the Velia (pl. XVII).   Here the movement is re-crossed: by the diagonal of the body of the young woman and by the parallel line of the torso of the Triton swimming in the first plane at right.   The veil blown up into a conch and held over the god and his companion by small cupids recalls the niche which frames Roman cult statues as well as the baroque arrangements around Hellenistic statues.   The canopies carried by angels in both Medieval and modern popular icons derive from this motif.   The Triton carrying an amphora is a stereotype that reappears frequently in the sculptured sarcophagi of the second century A.D.*

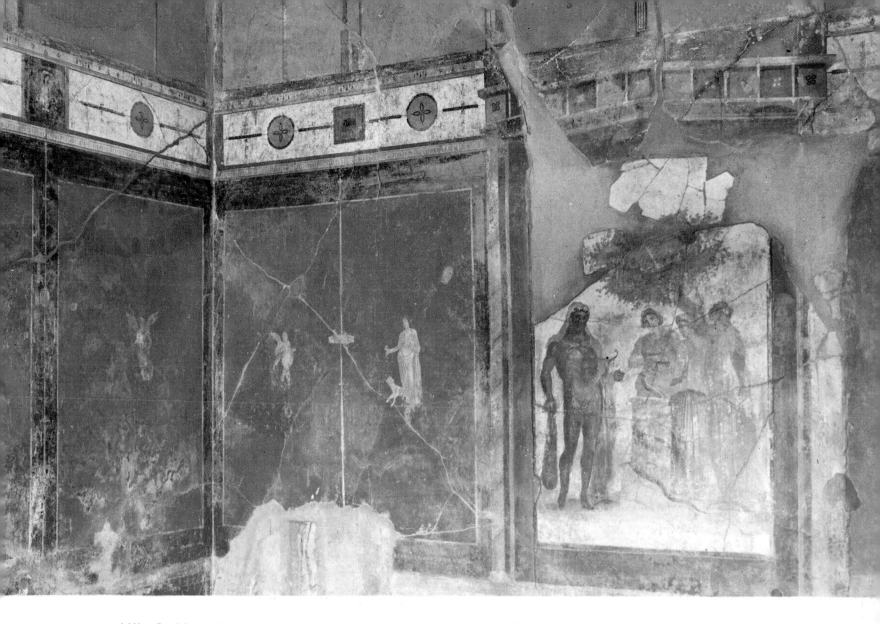

LXI  Stabiae; Lararium.  Here is a picture of one of the domestic sanctuaries which were never omitted in Campanian houses.  The small chapel attached to the wall shelters the image of Minerva, no doubt chosen because she was the patroness of artisans.  Although the gods of the lararia — the most popular were Heracles, Venus, and Mercury — did not differ outwardly from the Olympian divinities, whose adventures were related in the murals, they in fact represented old Italic beings to whom the populace remained sincerely attached and to whom they paid homage in a simple cult similar to that surrounding the saints in popular Catholicism.  The image of Minerva (not visible here) is strictly frontal; above it has been painted a veil which gives her something of the majesty of a Madonna.  Just above floor level, to the left of the column remnants, is a scene of an enormous snake; it stands on a small altar in order to devour the offerings, in particular an egg, which have been left there for this purpose.  This serpent is the incarnation of the family's ancestors, and the spirit protector of the home.  The cult of these familiar snakes has left some traces in modern Mediterranean countries; thus we find there an expression of a very enduring religiosity — the one from which we derive the chief explanation for the most original phenomenon in Roman wall painting: the theme of the disappearing wall.  It is remarkable that even in this modest décor the painter tries to guide our eyes from the tangible to the unreal; without our being aware of it, we are to look from the real chapel to the painted picture which faithfully reproduces reality.  With this illusion — that the serpent really lives in the house and comes there to find its food — the artist sets the scene for a supernatural being.

LXII  House of the Priest Amandus: Hercules in the Garden of the Hesperides (on wall adjacent to that with the Liberation of Andromeda, pl. XLI).  The theme, the conquest of immortality by the virtuous hero, is a parallel to that of Andromeda, the deliverance of persecuted innocence.  But the works differ strongly in style: in the Hercules painting the figures outweigh the landscape, and they are emphatically three-dimensional.  These characteristics are typical of Greek fourth-century painting, and the fresco is surely a reproduction of a model of that period.  Such dependence is unusual in the Third Style, but the room may have been partially redecorated at a later period, or the painter may have sought to contrast the romantic painting of Andromeda with a classical composition; Roman eclecticism was given to this kind of juxtaposition.

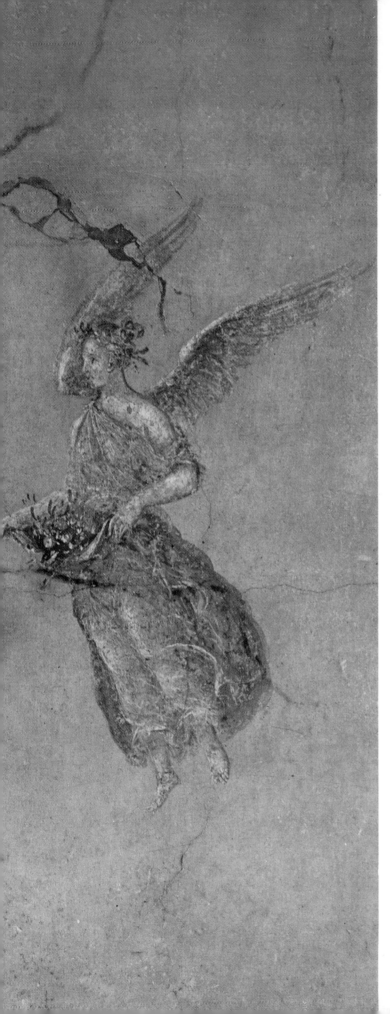

LXIII  In the "panel" formula of the Fourth Style, the center of a panel is often occupied by a figure or a pair of figures depicted as gliding through the air.  Such is the case in this fresco from Stabiae, showing a winged feminine genie.  The type is that of the Greek Nike and derives from a fifth-century original.  But the young woman here personifies a season, Summer, as the fruits she is carrying indicate.  She therefore has a cosmic meaning, as do so many other figures of this period.

LXIV  Painting on the façade of the shop of the draper Verecundus.  This is a singular example of the exterior decoration of Pompeian houses, which was very rich and varied.  Popular piety mingles here with what can be termed without anachronism public relations.  In the upper register is the Venus Felix (the Venus of good fortune) whom Sulla, after having made her his protector, designated as the patroness of his colonists in

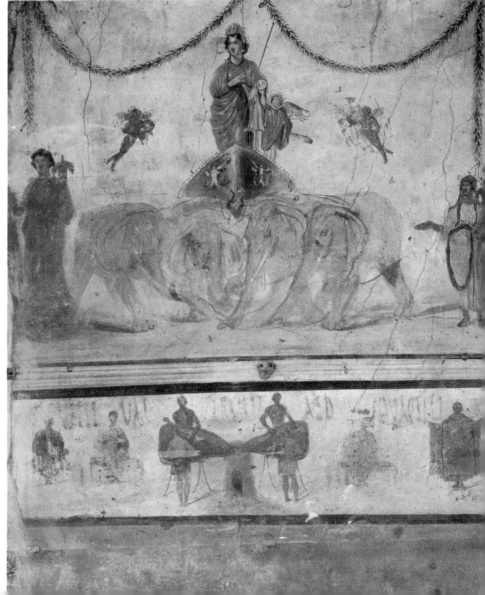

Pompeii. Modestly draped, this goddess has little in common with the Greek Aphrodite; the elephant-drawn quadriga that carries her resembles those of the emperors in certain triumph scenes, reminding one that this goddess dispenses victory. Cupid, who appears fully clothed in contrast to his usual state, accompanies her. Two other amors, who fly symmetrically at each side, foreshadow the angels of Christian art. At the left of the chariot is Fortune, and at the right is a Lar, a minor god who is a protector of houses and streets, and whose cult was associated with that of the Genius of the emperor. Compare the composition, as frontal and symmetrical as a coat of arms — and in fact it is the coat of arms of the city of Pompeii — to that of Verecundus preparing and dyeing the cloth. These scenes of everyday life which Greek art had ignored after the disappearance of vase painting played the same role in the popular art of Rome as that played by the scenes of war in official art.

LXV   Ostia; House of the Muses.   This house, contemporary with the House of Ganymede, shows even more clearly the concurrent survival and decadence of the Pompeian style of wall decoration during the first half of the second century; here, among the panels we again find fictive architecture, which at first glance seems very close to that of the Fourth Style but is robbed of all stability. The tendency toward incoherence, already evident in the Fourth Style, has increased, but the exuberance and richness have disappeared. Interest is focused only on the figures that stand out clearly from the background; during the second half of the century, Roman wall decoration will consist only of these panels, enlivened at the center with a figure and separated from each other by simple, flat, strongly accented frames. This frame style reaches its apogee under the Severi (193-235) and is the one found in the earliest catacombs.

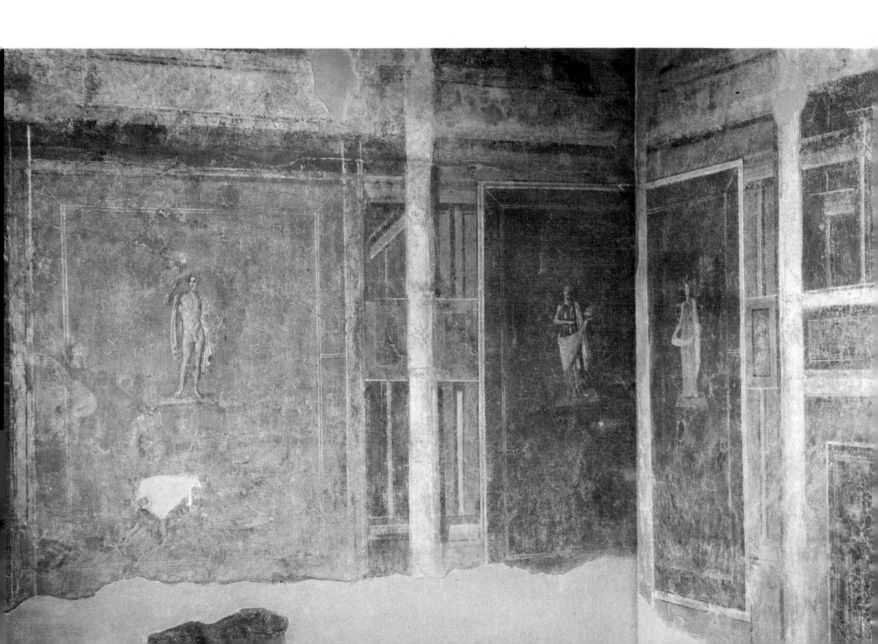

neither it nor the Io and Argos are shown in their original surroundings. They have been introduced into a new environment exactly as a modern collector does when he hangs one of his acquisitions in his gallery.

What is true of the pseudo-paintings is also true of the elements of architectural compositions. Each of them had been borrowed from an earlier model but incorporated in a new synthesis and endowed with a new meaning. An example of this is the Gate of Hell, an old motif from Egyptian funerary art, which was revived during the Ptolemaic period, as Bianchi-Bandinelli reminds us, and which does not cease appearing on tombstones and sarcophagi until the end of antiquity. It is not this history which is interesting and important, rather the fact that a motif in principle intended for a sepulchre is introduced into domestic art. Before long we will deal with the explanation of this astonishing transposition.

What happened with motifs also occurred with stylistic processes. Bianchi-Bandinelli has good reason to say that the "Romans" invented neither perspective nor the rendering of space; but it is one thing to use them in the interior of a painting and quite another to use them in order to create the "imaginary world on the other side of the wall." After the discovery of the laws of perspective at the end of the fifth century by Apollodoros and Zeuxis, paintings in three dimensions were constantly produced in Western art, except during Late Antiquity and the Middle Ages. On the contrary, "the world beyond the wall" appeared only in a very small number of compositions of the first century B.C. and the first century A.D. All of these have been found in Italy.

Technically, there is little more in these compositions than in the pictures; it is psychologically that they differ. Therefore, one is not prohibited from deducing that in the Hellenistic palaces were compositions with a "transparent wall" like those of Pompeii and Boscoreale. But this hypothesis is both gratuitous — since no trace of these compositions has been found — and improbable. In reality, the development of Romano-Campanian painting from Sulla until the death of Nero pursues a logical and irreversible course; each step follows that which precedes it, and prepares that which must follow, with neither a break nor a turning back. We are dealing here with a living art, one continually enriching and transforming itself, not with a dead art constituted solely of reminiscences and borrowings from the past. Certainly this art draws heavily upon tradition but always adapts that which it takes, transforming it and giving it a new meaning. This judgment is less contestable because by fortunate chance the death of this art takes place under our very eyes, some years before the catastrophe of 79 deprives us of the essentials of our documentation. Its demise coincides with that of Nero who must be considered, together with his painter Fabullus, as the last great creative figure. It is curious to note that Pliny, however impervious he was to art, felt that he was a witness to the extinction of an artistic current although he did not understand its nature. During the ensuing ten years of Vespasian's reign, Pompeian painters, while favored with many commissions,

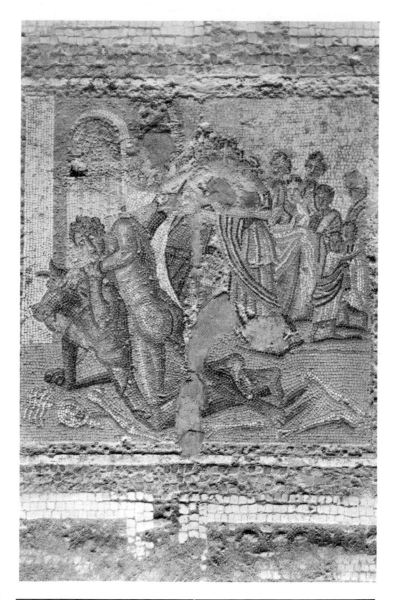

LXVI   Pompeii; Mosaic from the House of the Labyrinth: Theseus and the Minotaur.   From the myth illustrated here the House of the Labyrinth derived its name. (See pl. XXXI for its mural decoration in the Second Style.) The black and white border around the scene simulates the detours of the labyrinth; at the center we see Theseus overcoming the Minotaur in the presence of the young Athenians who were about to be devoured by it; the subject was also often treated in paintings. Except in very extraordinary cases, such as the mosaic showing the battle of Alexander (pl. XVI), the mosaic technique was not well suited to the depiction of perspective and complex poses: here the figure of Theseus is particularly awkward.

showed themselves incapable of renewing their inspiration and, for the first time, borrowed from their predecessors not various elements, but the syntax, of their compositions: cessavit ars.

Let us examine the early phases of Roman wall painting in relationship to the Greek and Etruscan. The initial phase is what we call, after A. Mau, the First Style; it is well

LXVII Herculaneum; Nympheum in the House of the Mosaic of Neptune and Amphitrite. Flavian period (69-96 A.D.). This wall mosaic is one of the most important works of its kind. A wall mosaic was exposed to fewer destructive forces than a floor mosaic, and artists were freer in their use of fragile materials, such as the glass paste and enamels which give this decoration its brilliant blue coloration.

known that vestiges of it have been found not only in Italy but above all in the truly Greek world of the eastern Mediterranean, particularly in Delos. Now the question before us concerns properly Hellenistic style; we have every reason to suppose that it, too, is the mature product of a regular and logical development which took place during the third and second centuries B.C. and whose steps we would be able to follow had the monuments been preserved. This First Style carries within itself the seeds of that which will constitute the originality and merit of the Second; thus, in one of the Delian houses, the upper part of the wall shows a pergola open to the outside; between the constituent pillars a blue tint suggests the sky. Here we have

the point of departure — but only the point of departure — for the opening up onto the exterior which characterizes the Second Style. It appeared, we find, at the beginning of the first century B.C., just before the onset of the great wars which, during the first two thirds of the century brought about the ruin of the East and the interruption of its artistic development. The Greeks in these years had only begun to glimpse the psychological possibilities offered by architectonic painting done with perspective. We believe, moreover, that they would not themselves have developed them any further. Their realistic temperament did not allow them to be carried away by a dream, and the unreal always took on a human aspect very quickly in their art as well as their literature. One also has the impression that they stopped themselves voluntarily each time that their technical possibilities were about to let them cross over the borders of reality defined by normal perspective. The Romans on the contrary were prepared to surmount the physical barriers in this area, owing to the long indoctrination they had received from the Etruscans. In an abstruse but profound work published shortly before his premature death, C. C. van Essen strongly

insisted on the tendency which Etruscan painters had from an early period to dissolve the spatial barriers enclosing the rooms which they decorated: "In the Tomb of the Augurs, the rear wall is decorated with a false door (it singularly recalls analogous doors in what is called the Second Style) which suggests the existence of another space, realized in the Tomb of the Lioness. Therefore, this illusion of space (in many cases, an illusion which in the Italian manner will be realized at first in the form of niches always placed on the axis of the first room) recalls the solutions of the earlier era. Another attempt in this genre (and we know how numerous the tries were during the archaic period which did not find their solution until much later) is indicated, in my view, by the strange effect achieved by the painter of the Tomb of the Baron. This tomb, in which the classical effect of the white walls is so impressive, has always presented difficulties because of the gray patches on which several figures are delineated. In my view, these patches have as their only function the breaking up of the background, the disjointing of the unity, so that the figures could be conceived of as being surrounded by space. When looked at closely, the composition figure-tree-figure-tree, frequent in the tombs of this period, aimed at the same thing in a less obvious and less simplistic manner. This was a situation, without doubt, of anticipated problems, the hour of which had not yet come; but they indicate the ways of the future." (*Précis d'histoire de l'art antique en Italie*, pp. 14-15.)

---

LXVIII Ostia; Mosaic of the Baths of the Seven Sages. Datable in the reign of Hadrian, this work offers the best example of the "inhabited vine scrolls" which were popular then in Italian mosaics. Elegant spirals of imaginary plants, geometrically stylized, enclose the figures of animals and hunters: this is what we have proposed calling the Hadrianic "flowered style." It is also met with in Africa, but in polychrome rather than in black and white.

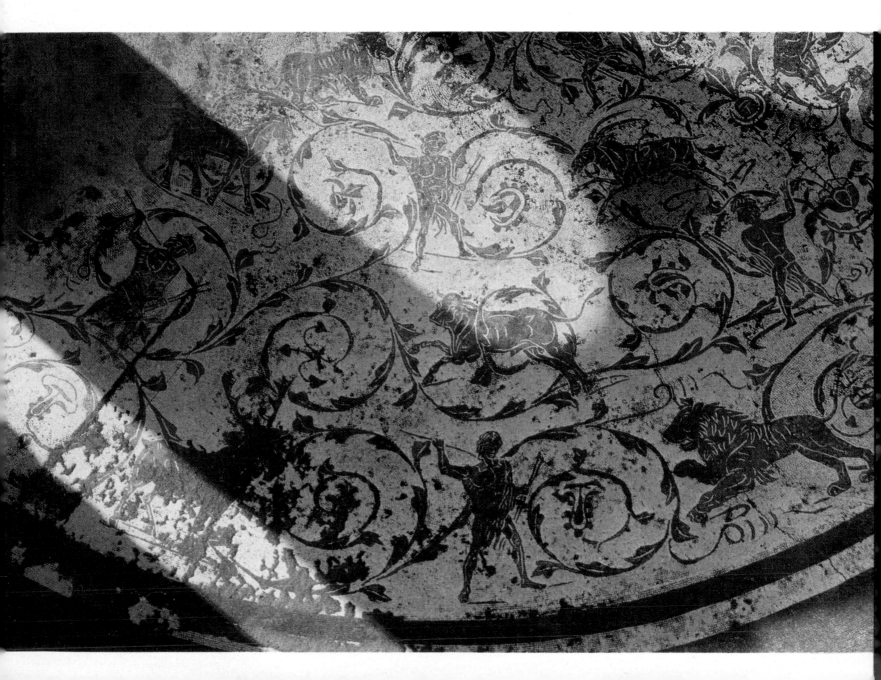

The transition from Etruscan funerary painting to the Second Style is made, as has been very well shown by J. M. Dentzer, by the tomb of C. Vestorius Priscus at Pompeii. The monument of this person, who was aedile for Pompeii, depicts themes traditional to Italian funerary iconography (garden and "paradise" populated by wild animals, a magistrate rendering justice, gladiatorial combats, etc.), among them the building with the half-open door which we have already seen in the Tomb of the Augurs, and which one remembers as a characteristic motif of the Second Style. "On Italian soil," writes Dentzer, "one begins to see in the area of mural painting proper, a continuity which has no equivalent in the Greek world. Doubtless this survival of an Italian tradition does not prove that Etruscan, Campanian, or Lucanian works exercised a direct influence on the Roman works. But even if there had been a rupture, some fundamental thing would have had to be transmitted just to make known the fundamental laws of decorative painting. Thus we would have to consider the Second Style

not as a Roman creation, but rather as a synthesis of Hellenistic elements which came to fruition on the favorable Italian soil." (*Mélanges de l'École Franç. de Rome*, 1962, pp. 593-594.)

Let us sum up our conclusions: (1) The most notable characteristic of Romano-Campanian painting is the "transparency of the wall," by which the painter suggests to the spectator the existence of an imaginary world extending beyond the decorated wall.

(2) This "transparency" appears during the second phase of the Second Style (Beyen's I B), *circa* 60 B.C. It is

---

*LXIX Ostia; Mosaic of the Baths of Neptune. The pavement of these baths, executed c. 140 A.D., is the masterpiece of a type found for the most part in bathing establishments in Italy during this period: marine divinities and Nereids are carried over the waves by horses or by centaurs whose bodies end in fish tails.*

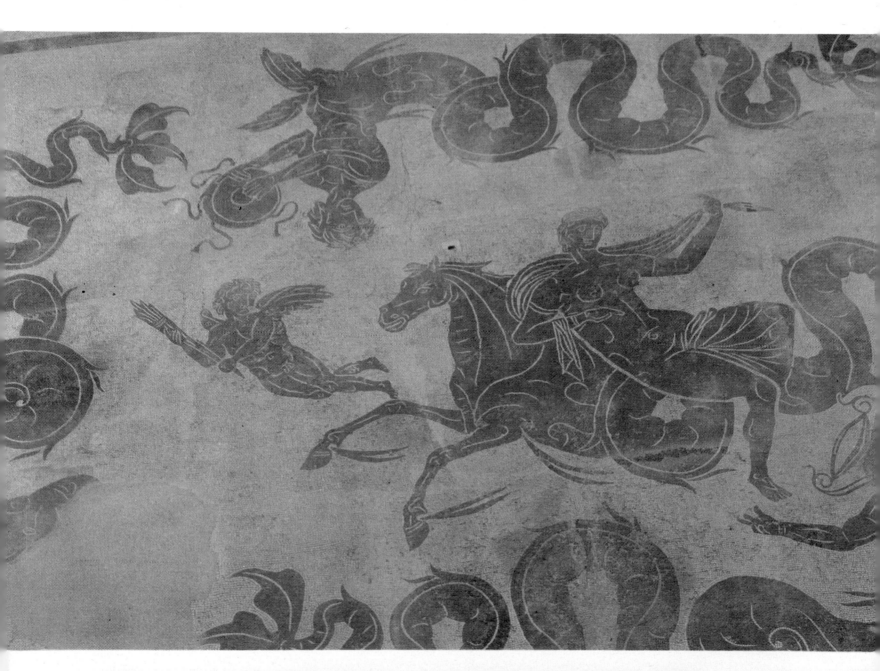

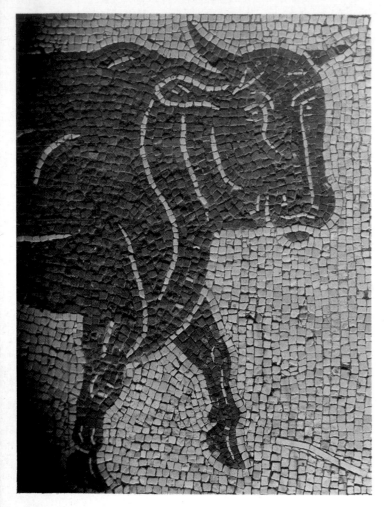

*LXX Ostia; Mosaic, from the Serapeum depicting the bull Apis. All of the mosaics of the Serapeum can be precisely dated to 137 A.D., and they are among the most important in Ostia. Although consecrated to an Egyptian god, these pavements show no influence of oriental art and belong totally to the tradition of the Italic school confining itself to the use of black and white.*

the culmination of a tendency which was already manifest in Etruscan painting by the sixth century B.C. and which was then formulated thanks to the discoveries of the Greek painters, who at the end of the fifth century B.C. had discovered the laws of perspective, and who by following them arrived at a convincing illusionism, which was gradually perfected; this illusionism was used to introduce the spectator into the fictive world, one mixing its own elements with those of the real world.

(3) Romano-Campanian painting evolves entirely in terms of the principle of transparency; the Third Style, a rationalistic and classicist reaction, suppressed the transparency, which reappeared with the Fourth Style in an atmosphere comparable to those giving rise to the baroque and to romanticism. A new rationalistic reaction, which followed the fall of Nero, marks a definite break in the development of painting.

We have now arrived at the most difficult task: to try to understand what this world "beyond the wall" meant to the Romans. No contemporary text tells us, and the painted walls themselves, those of the Second Style at least, are without a doubt intentionally imprecise — contributing to the atmosphere of mystery — but certainly thwarting the interpreter: one could look endlessly in the empty buildings for some living presence, some object, some attribute, which would inform us of the function of these walls. The explanations put forth by modern interpreters are extremely divergent. Some hold that the painters had no intention other than giving the proprietors the illusion of possessing larger and airier houses; one would be tempted to adopt this thesis when confronting the paintings from the "House of Livia" at Primaporta, now in the Museo delle Terme, or when viewing numerous Pompeian frescoes — there are many of them, for instance, in the House of the Vettii — which depict Mediterranean gardens with their well-kept arbors inhabited by birds. But it is less applicable to the greater part of the other themes and least so to the significant and oldest ones: that of the door, that of the circular pavilion. The best students of Pompeian painting beginning with H. G. Beyen, have preferred another explanation, which seemed more justifiable: the frescoes, they thought, reproduced the decoration of the theatre. It is necessary to explain at this point that in the antique theatres the stage area was limited in the rear by a wall pierced by doors and preceded by columns: the *scaenae frons*. For productions, drapes with appropriate decorations were hung between the columns; special décor was used, but not for each play, rather for each genre: the invaluable Vitruvius informs us that tragedy was played before palace façades decorated with colonnades and statues, and comedy before the façades of private homes; satyric drama, midway between the two aforementioned genres, was framed by a stormy, romantic landscape with woods, streams, and rocks. These descriptions seemed particularly applicable to the landscapes of the Second Style: the door would be a door from a stage set; the porticoes surrounding a round pavilion (which the Greeks called a *tholos*), features portrayed in the House of the Labyrinth, would represent the tragic palace. The street scenes, which we see in the so-called House of Livia and at Boscoreale, would form the sets for comedy, and the gardens, such as those found also at Boscoreale, sets for satyric drama.

At first glance, this explanation seems most convincing; it simultaneously accounts for the diversity of the themes and the uniformity of each category. It emphasizes the fundamental fact which we have already indicated: the aesthetic conception of the Second Style derives more from the techniques of spectacle than from those of painting. But it evokes, besides a host of difficulties which we cannot examine in detail, some radical objections. Why at first were only the doors from sets depicted, then only tragic sets, and still later, in one or two cases only, comic or satyric sets? But what most of all prevents us from accepting the theatrical origins theory for the Second Style is that it is perfectly applicable to the Fourth. We have already shown that the frescoes from the House of Pinarius Cerialis devoted to the loves of Attis (pl. XLIX) and to

Iphigenia in Tauris put the spectator into the presence of actual tragedies, played before his eyes by actors. The differences between them and the paintings in the House of the Labyrinth (pl. XXXI) are self-evident. We can say with all certainty that in the House of Cerialis the essence of the décor consisted of the same architecture as that in the *scaenae frons*, the elements of which we recognize very easily; we have seen them in excavations of theatres, only here a few simple additions have been made: trees, statues, garlands. In the House of the Labyrinth, on the contrary, there is neither scenery where the actors could perform, nor a door through which they could make an entrance. Is it only a question of the backdrop? This was supposed to be attached between the real columns of the *scaenae frons*; the reunification of real and imaginary architecture on the same plane would have destroyed precisely the effect of illusion which the painter wanted to create. Besides we know that the architectural part of the décor consisted of the porticoes of the *scaenae frons* (the accessories merely added as finishing touches); let us suppose that it had been necessary to make a *tholos* appear behind them — for example to represent a tomb; the backdrop would have had to show only this *tholos*, and not the portico before it.

It is therefore necessary to take up the problem again from the beginning, by examining the first images which suggest the disappearance of the wall; these are the images of the door, such as we find at Boscoreale (pl. XXX). This door is found in all the ancient arts, with the exception of that of classical Greece, for more than a thousand years, and it always has the same meaning. It is the entrance into the underworld or what amounts to the same thing, the entrance to the tomb. How could it have had another meaning in Romano-Campanian painting? The sepulchre of C. Vestorius Priscus at Pompeii is there to prevent a different interpretation. To stave off such temptation let us closely examine the frieze which surmounts the door (*janua*) at Boscoreale: there we see the hunt for the Calydonian boar, a funerary motif if there ever was one, as the Etruscan urns and Roman sarcophagi amply attest. This obvious conclusion, however, has been universally set aside until now, because no one was willing to admit that a Roman could have thought of having a tomb façade painted on his bedroom wall, a motif hardly conducive to pleasant thoughts; on the contrary, one likely to give terrible nightmares to whoever believed in ghosts, which was almost everyone. However, this apparently absurd idea becomes much less so if we remind ourselves of several well-known aspects of the old Roman religion. "The tomb," writes A. Grenier (*Religion Romaine*, p. 87), "is originally the common property of the family. The soul of the ancestor is supposed to survive, but on certain fixed days it haunts the home of the living. The Manes (shades of the dead) more or less mingle with the other gods of the house, the Lares and Penates. The very spirit of the father of the family is their emanation; he is represented by the serpent which emerges from the earth in order to come to taste the offerings of the family hearth." Thus it is not extraordinary that the Door of the Shades, which they pass through especially on the night of the Lemuralia, is in the chamber of the head of the family.

The origin of the theme of crossing over the wall is found, therefore, in our view, in the old Italian beliefs, which were very much alive in Pompeii, as the existence of a *lararium* and a family altar in each house proves. The substitution of the *tholos* for the door is easily explicable within this perspective: the most common intention of the circular colonnaded pavilion is a funerary effect. It depicts the tomb of the heroized ancestor-protector of the family.

The rapid evolution of the theme in the second half of the first century B.C. tempts one, however, to believe that some new ideas must have grafted themselves onto the religious principles which had given them birth. It is very difficult to pin down these ideas in the absence of all ancient texts. But it is certain that the idea of communication with the beyond remained as much alive as was painting itself, since, as we shall see, it is also expressed in the paintings of those phases when the wall is not opened-out but is self-contained.

## Mosaics

The art of mosaic was born in Greece toward the end of the fifth century. At first, pictures were made of varicolored pebbles, then from the third to the second century B.C. cut cubes were introduced.

Mosaics then really became paintings made of solid elements. The masterpiece in this medium is the Battle of Alexander and Darius III at the Issus, found in the House of the Faun, which is datable to *circa* 80 B.C. (pl. XVI). At the beginning of this period, figural mosaics became rarer; the floors were simply decorated with black geometric patterns on white grounds.

However, sometimes one finds inserted into the center of a room a true emblem picture of cubes, made with great finesse, and raised on a large tile which allowed it to be moved.

The Romans, who called a floor mosaic *tessellatum*, reserved the term *musivum* — from which mosaic is derived — for the revetments of walls and vaults. These appeared rather late in the first century A.D. At first they were used for the decoration of grottoes and fountains, also for the revetting of columns, although this was not considered in the best taste.

Toward the middle of the second century A.D. we find the same popular influence in mosaics which we so often found in painting, and which constantly crops up during the evolution of Roman art, saving it from dilettantism and from losing contact with life.

The second-century mosaics of Italy are almost always black and white, in contrast to those of the other provinces, especially Africa. But the subjects are more varied than those of the first century.

One tendency which develops during the third century is that the figures are treated like elements of ornament subordinated to the decorative warp, as was done in embroideries and tapestries (pl. LXVIII).

# CHAPTER III

## Mythological paintings, still lifes, landscapes

During the first centuries B.C. and A.D. the decorative system of Roman walls consisted of a combination of two elements, independent in principle: architectonic compositions, the development and meaning of which were examined in the preceding chapter; and imitations of paintings which were inserted into these compositions at the beginning of the phase of the Second Style classified by Beyen as IIA, roughly about the middle of the first century B.C. This was the era of "the renaissance of the image" (a phrase Beyen chose as subtitle for the section of his monumental work devoted to this phase). In Phase IIA the painting continues to be an important part of the overall composition; actually the reference here should be to paintings, in the plural, for there is a main painting in the center of the wall, set off by an aedicula, plus secondary pictures placed on either side. This importance given the image continues during phase IIB of the Second Style (notably in the "House of Livia" and the Farnesina) and during the Third Style. However, during the Fourth Style, the importance of the painting is affected by the theatrical tendency and by the tendency to use panels — and it is necessary to distinguish between the two. In the former the painting in a way melts into the architectural composition: its figures, liberated, are transformed into actors who are about to enact their roles in the scene painted on the wall. In contrast, in the series of panels we again find a painting in the center of the main panel which occupies the middle of the wall, and the less important scenes are enframed in the side panels. Since this series is much more important numerically than the theatrical series and has lasted longer, it is not stretching the point to speak of the "predominance of the image."

In addition to the pictures placed in the middle zone of the wall, Romano-Campanian painting includes friezes placed at the junction of the middle and upper zones – one example is the monochromatic frieze in the "House of Livia" – and predellas in the lower zone, or socle.

According to their subject, pictures, friezes, and predellas can be placed in three main categories; still lifes, landscapes, and scenes with figures. This classification is not absolutely rigid, since there are landscapes in which figures appear, but on the whole it is useful. One can make a sub-category for single figures, which appear either half-length or standing full-length.

The great majority of the scenes depict the adventures of the same gods and heroes who had stirred the Greek poets; a very few of the pictures were inspired by Latin literature, mainly the *Aeneid*. One is surprised never to come upon true historical subjects: no interior painter thought of reproducing any of the Roman triumphal pictures although they were exhibited in great numbers in the temples and public monuments. The illustrious persons of Greece are hardly better treated. However, there are a goodly number of pictures of poets, in particular the one of Menander which serves to designate the house in Pompeii of the illustrious *gens* Poppaea. The great fresco at Boscoreale, which doubtless depicts the youth of the Macedonian king Antigonus Gonatas, is unique (pl. XXXIII).

## The reproduction of Greek models

With a few exceptions, such as the Deliverance of Andromeda in the House of the Priest Amandus (pl. XLI), which we have already analyzed, the composition of the pictures is no more varied than their subjects: the same episode, repeated in different dwellings and at dates often widely separated, is always posed in the same way. It is evident that the painters tirelessly copied the same model.

The reason for this monotony is given by the texts. The Romans let themselves be persuaded by the Greeks that perfection had been attained in easel painting by the great masters of the fourth century; in the absence of equal skill, there was nothing to do but recopy their works, which were given a quasi-religious veneration.

In its treatment of great subjects, Romano-Campanian painting thus seems at first glance like a petrified art, interesting only as a reflection of the irretrievably lost paintings of classical Greece. It is from this point of view that it was long considered by art historians. In comparing the Pompeian repertory – catalogued by Helbig as early as 1869 – with the lists of painters and celebrated paintings transmitted mainly by Pliny, it has been possible to attribute with a high degree of probability the originals of the principal works to specific Hellenic masters: the method led to the identification of the Io and the Andromeda by Nikias, the Sacrifice of Iphigenia by Timanthes, the Medea by Timomachos, the Achilles and Briseis by Apelles. The results of this research were published by G. E. Rizzo in his *Pittura Ellenistico-Romana*.

We shall see that since then the study of classical Romano-Campanian pictures has been directed along perceptibly different paths. But first we must say a word about the other genres: landscape and still life. The landscapes were classified by M. Rostovtzeff in 1911; some of them evoke distant and exotic lands, especially Egypt, or rather the whole Nile Valley (pl. LVI), from the Sudan inhabited by Negroes, pygmies, and monstrous animals to the fertile delta with its farms and elegant villas. There is a good chance that these paintings were inspired by Alexandrian models; it was in the capital of the Ptolemies that the artists called "topographers" had first sought their inspiration in nature. One can also attribute to the same school the creation of the "sacral-idyllic landscape," a type portraying estates with great trees, monumental tombs, and innumerable little chapels consecrated to minor rural deities. This framework, which is that of bucolic poetry, could be adapted to any site along the shores of the Mediterranean. It is quite possible that in picturing it, Campanian artists added some details that lay directly before their eyes. They were not interested, however, in the agricultural labors about which Latin poets sang, and which much later supplied some motifs to the mosaicists. This abstention

proves that their independence of Greek models remained very limited. Perhaps they showed greater originality in painting urban landscapes, particularly scenes of harbors and seaside villas (pl. LXII), but so far no one has ever been able to identify correctly the sites represented.

The still lifes, which have recently been studied by J. M. Croisille, mainly depict eatables, recalling either feasts which the owner of the house prepared for his friends or offerings which he vowed to domestic divinities.

The balance sheet which we have just made out seems somewhat disappointing. From what we have seen of it so far, the Pompeian house is little more than a sort of museum, where the master of the house has assembled some indications of his literary and artistic interests, of his inclinations toward the exotic or the rustic, and even of his more sensual pleasures (to the greediness suggested by some of the still lifes must be added the eroticism of a few paintings). All that is missing is life and originality. We shall not discover here the curious problems that turned up in our study of the simulated architecture on the walls. Rather than stay longer with this banal and lifeless interior decoration, let us go on to consider the exterior décor of the houses – although less refined, it at least reflects the daily activities and living beliefs of the inhabitants.

## The meaning of Romano-Campanian paintings

As we look for the meaning of these paintings, it is fortunate that any ideas we may have gained so far on this subject are both incomplete and summary. Moreover, the fact that we have to search out these paintings in catalogues and in museums, where they have been regrouped artificially in modern times, is a positive help. The Romans, of course, were not able to see them in this way. They saw them as part and parcel of their overall setting. Thus, even if the paintings had been perfect replicas of original works, they would have acquired a new meaning from the total composition in which they had been incorporated.

The most significant attempt to rediscover the meaning of these paintings was made by K. Schefold. This scholar points out that the Romans were selective when borrowing from the enormous treasury of Greek paintings. This selectivity was not determined by the celebrity of the artists of the original works, for the most famous Greek masters, Zeuxis, Parrhasios, Apelles, are less well represented than secondary artists; indeed, the creators of the prototypes of very popular series of paintings, such as the Meeting of Dionysos and Ariadne at Naxos, and the Loves of Ares and of Aphrodite, cannot be identified. Nor did choice depend on the popularity of the myth depicted: in the exploits of Heracles the Pompeian painters have almost systematically excluded the twelve labors, a subject which came back into fashion only at the end of the second century A.D. Instead, these artists concentrated upon Heracles' love affairs with Dejanira, Hesione, Omphale, and Auge, not hesitating to depict him in the least favorable light. Sometimes different myths are united in the same house because they have analogous meanings, with the most significant episode in a given myth being depicted to the exclusion of others. Thus

one can ascertain a predilection for certain themes: abduction – from the myths of Ganymede, Europa, and Hylas; deliverance – from the myths of Andromeda, Hesione, Io, Dejanira carried off by Nessus, Orestes and Pylades saved by Iphigenia, and Theseus wresting Athenian youths from the Minotaur; supernatural flight – from the legends of Perseus, Bellerophon, Icarus, Phaeton. These attempts at analogy are not always successful; they seem contrived in the way they contrast the success of the virtuous or predestined hero with the defeat of the "sinner" or of those audacious figures who wanted to exceed the limitations imposed on the human condition.

One is tempted to explain this tendency as a psychological disposition of the proprietors of the houses, which would be in perfect accord with what was revealed of them in our analysis of the architectural compositions. It seems that the Italian aristocracy and the bourgeoisie had been motivated, toward the end of the Republican period and the beginning of the Imperial era, by a need for escape, a propensity toward a dream world and utopianism, which was also expressed in the most significant literature of the period, Virgil's *Fourth Eclogue*, for example. This need was also answered by certain religious ceremonies. Schefold stresses the basic importance of the doctrine and mysteries of the cult of Isis. He relates this cult not only to those paintings clearly depicting Egyptian deities, their symbols, Nilotic scenes, and the heroes and heroines such as Io who had been associated with them, but also to the majority of the mythological scenes. The most popular gods of the Greek pantheon were Dionysos, Aphrodite, and Artemis, and the initiates of the cult identified Dionysos with Osiris, and Artemis and Aphrodite with Isis herself.

Schefold's thesis, relayed here in an abbreviated version depriving it of all its nuances, has been subjected to severe criticism: to entirely practical minds it could seem more poetic than historical. We cannot argue it here nor give it full support. In our view, the cult of Isis was one of the currents running through Roman religious thought during the era of Caesar and Augustus, but did not constitute the whole of it. There were numerous people in Italian society during this era who had no religious life at all, nothing that transcended simple social rites, and no doubt they were in the majority. Must we therefore believe that these people accepted strictly for its decorative value an imagery selected by the adherents of a cult and presumably reflecting their beliefs, just as atheists today are able to admire the monuments of Christian art? Other interpretations can be found for the meaning of these paintings. We do know that there is a monument in Rome that is contemporary with the apogee of Campanian painting; that it was surely conceived by mystics – not, however, by adherents of the cult of Isis, but by Pythagoreans; and that the greater part of the Pompeian themes appear in its stucco decoration. This is the subterranean basilica near Porta Maggiore. The example suffices to prove that Schefold's attempt at exegesis is neither irrelevant nor fruitless. It needs modification, of course, yet with its emphasis upon religious thought, it opens a fertile field for the interpretation of Roman painting.

## The independence of the Roman painter in regard to his model

Other attempts, different in nature and method, have been made during the past few years to demonstrate the originality of Roman painting. Developments in art since the middle of the nineteenth century have taught us that the choice of subject matter does not always have the same importance for the artist as that which was formerly given it by critics and laymen. Thus one is quite capable of being a great painter without treating anything other than standard themes. However, the Pompeian painter did more than just servile copying. Even if one ignores the relatively brief Third Style, which saw the birth of original pictures – discussed in connection with the Deliverance of Andromeda, from the House of Amandus – it is evident that the majority of Roman works are transformations or adaptations rather than replicas of paintings. In the Io from the "House of Livia" (pl. XXXIV), for example, the muralist has added the figure of Hermes and the landscape, thus completely changing the balance and the meaning of the picture. One would give a great deal to know more about these painters. Of their names we are ignorant, except in a few cases, usually artists who worked in Rome: Ludius, a contemporary of Augustus, who according to Pliny had renewed landscape painting in some way as yet unknown to us; Fabullus, Nero's painter, mentioned earlier, so proud of his Roman citizenship that he wore a toga while working on the scaffold. In Pompeii there is only one signature. It belongs to a certain Lucius who painted the tragic Death of Pyramus and Thisbe in the House of Loreius Tiburtinus, or rather under the loggia of his garden. In order to compensate for this lack of information, a number of archaeologists have applied to Romano-Campanian painting the same method which produced results in the attribution of Greek ceramics. "The method," writes L. Richardson, who has made brilliant use of it in a treatise on the House of the Dioscuri, "relies on the painstaking and minute study, analysis, and comparison of the vocabulary and syntax of forms in pictures, especially the forms of the human figure, of the character of the brushwork and of the palette, handling of light, and composition. When enough of these qualities are the same in two paintings, we can be sure that both are by the same artist." (L. Richardson, Jr., "Pompeii: The Casa dei Dioscuri and its Painters," American Academy in Rome, *Memoirs* XXIII [1955], p. 111.) As a result of his research, Richardson identifies the work of seven painters in the House of the Dioscuri, whom he designates as the Dioscuri painter, the Io painter, the Achilles painter, the Meleager painter, the Iphigenia painter, the Theatre painter, and the Perseus painter. Each of these would have worked in other Pompeian buildings as well. One is surprised at first to find himself in the company of such a variety of executants; the management of the work could hardly have been easy! It is disturbing, too, to record that the advocates of this method seldom agree with each other; Richardson himself is extremely severe with other archaeologists who have pursued the same ends, particularly the illustrious H. Beyen

and C. Ragghianti, by both of whom his treatise had been generally well received. But there is an almost absolute law that a method which gives rise to debate becomes less trustworthy. In the case at hand it is not necessary to press the examination too far in order to perceive that the definition of criteria is very subjective. The whole method ultimately rests on the proposition that a painter does not change his style; but this proposition is contradicted by all that we know of the life and development of artists. How would this method deal with Picasso? He would end up as an army of phantoms! When one sees a historian recreate the careers of these artists whom he has brought into being, attributing ethnic origins to them, making one a Campanian, another a Roman or an oriental émigré, one cannot but admire the power of suggestion exercised on a reasonable mind, sustained by the theories which it has forged.

Fortunately the minute examination of the paintings which was necessary in order to build up these perverse conclusions was also one which produced valuable and fruitful scholarship. It led Richardson to the following judgment about the so-called Pompeian copyists: "In working, the copyist will unconsciously show his own individuality, his schooling in the handling of his medium, and his personal sense of forms and light... If one compares all the known copies of one especially popular composition, the Mars and Venus, for example, or the discovery of Ariadne by Bacchus, one finds the greatest possible variations from painting to painting, not only in palette and brushwork, but also in all the forms of the figures, in color values and chiaroscuro, even in gesture and facial expression. Even an unpracticed eye immediately realizes that only in rare cases could two copies of the same subject be by the same hand. However it was that the Pompeian painters worked, whether it was from a sketch or outline drawing with brief color notes, or from memory of great paintings seen in collections and museums or from a repertory learned as part of a painter's training, we can be sure that the work is always so far removed from the original that the individuality of the painter was not hindered from manifesting itself." (*Ibid.*, pp. 111-12.)

## The two basic tendencies in Roman painting: classicism and impressionism

The Pompeian painter inevitably differed from the Greek whom he imitated. First of all, differences were dictated by his method of work: whereas the Greek artist painted on a wooden panel placed on an easel, the Roman artist decorated a wall "according to a special method a tempera, based on the use of saponified lime," as R. Etienne put it when summing up the work of Selim Augusti.[16] Let us note in passing that the term fresco, which we use for convenience to designate a wall painting, is not meant to be interpreted here in its technical sense, for the paintings were not executed "a fresco," on wet plaster. As for the style itself, there seem to be two main tendencies; in one, the greatest solidity and stability possible are given to the figures by detailing their structure and expressing the modeling with

effects of light and shade; the lighting is direct and bold, stressing the sculptural forms. In the other tendency, however, the forms are dissolved by the play of light and the contrasts of chiaroscuro; the term impressionism has been used in discussing it, but it was evidently a spontaneous style, not at all based, as was Monet's, on a scholarly study of optics. The phrase *ars compendiaria* used by Petronius seems to fit it. These two tendencies are not in neat opposition; in fact, all the intermediary nuances can be found.

As is to be expected, the first tendency manifests itself mainly in the treatment of subjects inspired by myths of the heroes, subjects where the influence of the classical Greek masters is most evident. A good example is the Daedalus and Pasiphae (pl. LII) from the House of the Vettii; the "Ixion Room," where this fresco was found, was newly decorated during the reign of Vespasian and it exemplifies Flavian (late first century) classicizing tendencies. The figure of Daedalus, which coincides exactly with the central axis of the picture, has the firm pose of a statue; his extended arms define the intersection of two planes. One of the arms serves to indicate the plane of the group of Pasiphae and her followers, while the other arm is exactly perpendicular to the plane of the statue of the cow. We have here all the elements typical of a classical composition: clarity and stability of forms; simplicity of contrasting colors (the dark tone of Daedalus' body is contrasted with the light colors of the feminine figures and the statue of the cow); plus geometric precision in the compositional scheme. The whole is in harmony with its subject.

As an example of the *ars compendiaria* we could take any one of a number of landscapes, the Villa at the Seashore from Stabiae (pl. LVII), for instance. But the Ceremony of the Cult of Isis discovered at Herculaneum is more typical still (pl. XLII); it is connected with the "romantic" phase of the Third Style (also illustrated herein by the picture of the Deliverance of Andromeda, from the House of the Priest Amandus). The painter has rendered perfectly the mysterious, grandiose atmosphere of the ceremonies of a religion which gained the greatest hold over the Campanians: in Pompeii the Temple of Isis was one of the principal buildings in the city, and leading citizens, like Loreius Tiburtinus, did not hesitate to don the flaxen robe and brandish the sistrum (pl. LIII). Since services were conducted mainly at night, the painter of the Isis ceremony took advantage of this and bathed the whole scene in a soft moonlight which blots out the contours and gives people and objects a spectral unreality. This same technique was used also in simple landscapes.[16] The strictly balanced composition has at its center the figure of the grand priest, who is leaving the sanctuary, holding the bottle containing the sacred and life-giving water of the Nile. He stands between two assistants, each of them flanked by one of the statues of sphinxes that guard the door of the sanctuary. Another priest, a Negro whose ebony shoulders emerge from a long white tunic, holds out his hand in an imperious gesture toward a group of worshippers placed on his right. Another compact group, chiefly women, is massed on the other side of the staircase, which the procession is about to descend toward the altar, where the sacrificant has already

lit a flame; and finally there is a picturesque detail – the large Negro seated in the first plane on the right, playing the flute. The scene seems to take place in Herculaneum itself, before the Temple of Isis; as yet this temple has not been discovered but it must certainly exist. This, then, is an original picture, inspired by actual everyday events, as is, no doubt, a painting of some years later, which depicts the brawl between the Pompeians and the people of Nocera in 59 A.D. (pl. XLIII).

Certain effects seem, moreover, to belong to popular art, such as the compact masses of people where all individuality is lost. It is tempting to consider the *ars compendiaria* all in all as a specifically Italian means of expression. But it seems more likely that this sort of impressionism had already been conceived in the Hellenistic ateliers. Its first manifestations, which occurred during the last phases of the Second Style, are linked to some exotic landscapes, like the one which unfolds in the famous monochromatic frieze in the "House of Livia" on the Palatine. But the Italian painters are doubtless responsible for the introduction of this style, generally reserved for lesser subjects, to works of a nobler genre. Even a work typical of Augustan classicism, Pan and the Nymphs from the House of the Fatal Loves (pl. XXXVIII), includes a pine tree painted in this summary style. But it is chiefly the "romantic" phase of the Third Style which will elevate this technique, using it, for example, in a treatment of the Trojan Horse; this picture, one of the most interesting Romano-Campanian paintings, expresses, in our opinion, the Stoic ideals which Seneca preached, and is closely related to the Ceremony of the Cult of Isis in Herculaneum by the nocturnal lighting and the handling of the masses of people. Analogous effects are created in the massacre scene of the large Heraclean frieze in the House of Loreius Tiburtinus, and also in the nocturnal scene of sleeping Trojan soldiers at the right of the small frieze immediately below (pl. LV).

Recent discoveries in Stabiae show still more clearly the utilization of impressionistic methods in monumental painting. The painter of the "Loggia of the Planisphere" employed them in order to give the figure of Autumn the ecstatic expression of a Bacchante (pl. LVIII). In the same house a more daring artist achieved a complete dissolution of form in his Medusa, his "face of a young melancholy man," and his "young man with red hair." W. Dorigo has admirably demonstrated that in executing them this "innovating master," as he calls him, applied the lessons learned from Ludius and Fabullus, and thereby reached a decisive stage in the evolution which progressed from Hellenistic art to the art of the Late Antique (*Pittura Tardo-Romana*, pp. 40-44).

It is necessary to compare these observations with those of Richardson on the manner of the "Dioscuri painter." The American scholar has pointed out in the paintings which he attributes to this artist what he considers to be errors in the rendering of anatomy: breasts too small and placed too high, hips too large, feet too small, for the female figures; and analogous errors in the drawing of hips, legs, shoulders, and feet for the male figures. In actual fact, these are deviations from the canon for the human figure established by classical Greek artists in the fourth cen-

tury. Similar deviations will appear in provincial works of art beginning with the first century; they will become the rule by the end of the second century and will engender a new canon.

## Composition: The tendency toward frontality: Color

Attempts at revival are conveyed not only by the style, but by the composition. The Greek masters of the fourth century B.C. had already discovered that the effect produced by a picture is more intense when the axis of the composition is parallel to the spectator rather than perpendicular to him: in the latter, the figures are seen principally in profile and pass by in a plane deprived of depth by the limits of an artificial background. This is the frieze picture, the only one known to all the arts – Egyptian, Etruscan, as well as Greek – until about 400 B.C. Its composition makes possible an almost complete avoidance of the representation of the third dimension, an insurmountable obstacle until the discovery of perspective. The latest figured vases, the mosaics from Pella, and a certain number of other documents (which one can find conveniently collected in an article by P. Moreno, "Il realismo nella pittura greca del IV secolo," *Rivista dell'Ist. Naz. d'Archeologia*, XIII-XIV, 1964-65) show that without abandoning the principle of the frieze, the painters of the fourth century tended to present a certain number of figures frontally or from the back, thereby deepening the space in a painting. In the Alexander Mosaic (pl. XVI) executed a little after 300 B.C., a copy of an original (by Philoxenos of Eretria?), the whole of the action continues to unfold perpendicularly to the viewer (no longer in a single plane, but in a sort of stage space having limited depth). However, the most remarkable group, massed near Darius' chariot, is turned so that it faces the spectator; in front of Darius the view of the horse's rump constitutes a touch of bravura interesting in itself because of the foreshortening effect, which introduces an element of intended disorder into the composition, marvelously expressing the disarray of the Persian army.

In the majority of the Pompeian pictures with figures, the action is directed toward the spectator. This is the case even in those compositions embodying a more classical spirit, like the Daedalus from the House of the Vettii (pl. LII), which we have already analyzed, or the Meeting of Jason and Pelias from the "House of the Fatal Loves" (pl. XXXVII). The latter work is particularly notable for the rigorous symmetry of the figures: the old king, supported by his two daughters, is placed exactly on the axis of the picture and directly faces the spectator. Here is a foreshadowing of the tripartite groups of medieval art: the sovereign and two attendants in a frontal position. The other two figures in the painting are placed laterally below the major group, thus forming an equilateral triangle. This geometric figure plays an essential role in a large number of Roman compositions, doubtless because of the mystical meaning given it by the Pythagoreans. One must be careful to note, however, that although this system of construction is very satisfying to the eye and the mind, it does not fulfill what

ought to have been the principal aim of the painter, namely a clear depiction of the drama. The myth recounts that Pelias had been warned by an oracle that he would perish by the act of a man who would present himself with one foot unshod; this is Jason, the young man whom the king has just recognized as his future murderer. But the respective positions of the story's two main actors are poorly rendered in the painting – Jason's naked foot is hidden from Pelias' eyes by the table and vase placed at the traveler's side; the painter has, therefore, sacrificed the telling point of the scene to the exigencies of the composition. This work is based upon exactly the same principles as those of the Ceremony of the Cult of Isis at Herculaneum: emphasis upon the main figure through use of the frontal position, the symmetrical placement, in regard to him, of the assistants, and finally the use of architectural accessories, of which the main one is the staircase.

Polarization of the composition toward the spectator reoccurs in a whole series of pictures which warrant comparison because of the similarity of the subject matter: their common theme is the triumph of the gods. One such is a picture in the House of M. Lucretius Fronto, depicting the triumph of Bacchus (pl. XLIV); another, with this same subject, was discovered in Stabiae in 1963, in the Villa Libero d'Orsi; still another from Stabiae depicts the Abduction of a Nereid by Neptune (pl. LX); and finally there is the fresco on the façade of Verecundus' shop on the Via dell'Abbondanza in Pompeii, illustrating the Triumph of the Venus of Pompeii (pl. LXIV). We shall examine this last one first since it belongs to a category that we have not yet discussed. It has been well demonstrated that the paintings which decorated the exteriors of Pompeian houses belong to a genre that is less sophisticated and less artificial than that of the interior murals; they directly reflect the emotions, the familiar preoccupations, of the common people. The gods which they depict had been neither worn out nor secularized by literature. The people truly believed in them and placed themselves under their protection. The modestly draped Venus from Verecundus' shop is the tutelary goddess of Pompeii – not the lewd Greek Aphrodite; the simple man who had commissioned the painting wanted to put his industry and his cloth business under her protection. In the predella under the goddess's chariot the workshop of the fullers is represented. It is not surprising that this painting calls to mind a medieval or modern devotional image; the indicia of this genre – frontality, heraldic symmetry, and so on – hardly vary through the ages and seem indeed to reflect an enduring popular concept of divinity. But it is most remarkable that one finds them again, in a scarcely less naïve form, in the triumph scenes, which, in principle, belong to the category of sophisticated paintings.

Frontality and symmetry are clearly evident in the Triumph of Bacchus from the House of M. Lucretius Fronto (pl. XLIV), in which a pyramidal composition exactly coincides with an equilateral triangle having as its base the lower side of the square frame. In the two pictures from Stabiae mentioned above, the movement is oblique in relation to the spectator, as it is in the celebrated relief of

the Triumph of Titus on the Arch in Rome, which is later by only a few years. However, many details betray the influence of popular taste: the billowing veil over the head of Neptune (pl. LX) is held by *amorini*, ancestors of the angels who will hold the canopy suspended over the Madonna in Majesty. The abducted Nereid, whose white body lies in sensual contrast across the bronzed one of her ravisher, turns her face coquettishly toward the viewer, to seek, it would seem, his sanction.

The aim of all these endeavors, which pave the way (as W. Dorigo has shown so well) for the great aesthetic revolution of the late second century is to add an emotive and human element to the overly rigorous and rational legacy from Greece. With the same intention, the Pompeian artists also tried to enrich their palettes. Pliny states that the masters of the fourth century – he cites them by name: Apelles, Echion or Aetion, Melanthios, and Nicomacer – used only four colors: white, yellow, red, and black; this is confirmed by the mosaics from Pella and even by the Alexander Mosaic which, notwithstanding its wealth of tones, uses nothing but variations of the four fundamental colors. It is particularly remarkable that the Greeks used no blue worth mentioning, except for a very dark blue which renders the shadows in the mosaics at Pella. In Greek paintings the sky was always uncolored. The Alexandrians were undoubtedly the first ones to paint it blue, as the funerary decorations in Sciatbi demonstrate. Curiously, the Etruscans, who freely used azure and a delicate green, did not continue the use of blue for the sky. Pliny and Vitruvius are alike in pointing out and deploring their contemporaries' taste for rich colors, prepared, they add, with the help of rare and costly ingredients which were imported from the Far East. What most concerns us here is the famous Pompeian red and gold, royal colors, which glow especially in the decorations of the Third Style. Moreover, one finds them more often in architectonic compositions than in the pictures of this period, where light and delicate tints dominate. The Room of the Masks in the house lately discovered on the Palatine by Carettoni is very characteristic in this regard (pl. XXXVI): its architecture is red and gold; red, violet, and a very harsh green are used for the masks (these colors and the "dissolution" of their forms giving them a supernatural and startling aspect); and the landscape with a sacred stone, which occupies the place of honor in the central aedicula, is painted tone on tone with grays, mauves, and faded golds. On the other hand, the painter of the House of Amandus (pl. XLI) dresses his Perseus like a Roman emperor with a purple *paludamentum*, which contrasts vividly with the violet granite rock from which the young crucified girl stands out clearly, not nude as in the picture by Nikias, but garbed in yellow. The Fourth Style, unfortunately for scholarship, gives up the landscapes which rejuvenated the hackneyed genre of mythological painting in order to return to the well-worn methods of the Greeks. The contrast between the sunburned masculine bodies and the light feminine figures is found again almost everywhere, as in the Daedalus and Pasiphae (pl. LII) from the House of the Vettii. Fabullus, however, used less vulgar effects in the Golden House, and the Master of Stabiae used

sumptuous reds. But above all, it is the deep blues of the seascapes, the cameos of nocturnal scenes, which bear witness to the mastery of the last Pompeian colorists.

In general one can observe in late Pompeian painting a tendency to reject the aesthetic principles of Greece in order to adopt new formulae which were to give rise in their development to the art of Late Antiquity. Formerly this trend was attributed to the decadence of art; this old myth, which seduced even Pliny and Vitruvius in their day, has ceased to mislead our contemporaries. What is certain is that a decisive stage in the evolution of art took place toward the end of the reign of the Julio-Claudian dynasty. The coincidence of stylistic trends with political events cannot be attributed to chance. The fall of Nero also marks the disappearance from the political scene of the true Roman aristocracy, which had achieved the conquest of the world but had proved incapable of organizing it. Thereafter the emperors would be bourgeois, Italian or provincial, and the real power would belong to the administration rather than to the political organs inherited from the Republic. But it was this aristocracy which had inspired Romano-Campanian painting; the houses on the Palatine which introduced us to the principal phases of the Second Style belonged to its most distinguished members. Those at Pompeii and Herculaneum were inhabited for the most part by a middle class that was busy copying the upper class.

During the second half of the first century A.D., the nobility's intellectual preponderance was in jeopardy, as was its political preponderance. We have a prime document concerning this crisis: the *Satyricon* by Petronius – beyond doubt the most interesting ancient work from a social point of view. This is a lampoon, by an aristocrat, of the newly rich of servile origin who are about to ruin the upper classes and usurp their place. In the episode about Trimalchio the décor of his house is described, and evidently it represents the height of bad taste to Petronius. Although Trimalchio was born in Asia, this décor is of neither Hellenistic nor oriental inspiration. On the contrary, it is related to truly Italic art, most particularly to the exterior paintings on Pompeian houses – which is not surprising, since Trimalchio received in Italy whatever little education he had. Doubtless Petronius exaggerates, since no house has yet been found decorated on the interior with scenes from contemporary life (however, in the story of Trimalchio, the muralist had added scenes from the *Iliad* and the *Odyssey*). But he is not mistaken when dealing with the heart of the matter, which is the conflict between "great" and "plebeian" art: great art was, in fact, already doomed.

In order to understand Romano-Campanian painting one must be aware of the profound culture of the Roman nobility, of its attachment to Hellenism and desire to implant it in Italy. All of these characteristics were in large measure opposed to the nationalism of the middle and lower classes. This intellectual attitude explains the conservative element in Pompeian painting. But the nobility was surely responsible also for the creative aspect of this same painting and

for the striving for freedom, of an intellectual kind a least, which manifests itself in such interesting and remarkable forms as the "open walls" of the Second and Fourth Styles and the "romantic" paintings of the Third Style. To understand this, we must remember that an important faction of Roman aristocracy, represented at first by the circles of Catiline, Clodius and Clodia, later by the groups around the two Julias, by that around Messalina, and finally by Nero, was in open revolt against the traditional structure of society and against the traditional morality to which it was bound. It was this "libertinism," somewhat comparable to that of the eighteenth century, which gave birth, in our opinion, to what was most lively in Latin literature as well as in art at the end of the Republic and the beginning of the Empire: the poetry of Catullus and Romano-Campanian mural painting.

# NOTES

1. Pliny, *Natural History* XXXV, 22-29.  Painting not preserved.

2. See Pallas Library of Art, Vol. II, F. Chamoux, *Greek Art,* 1966, pp. 68 f., and figure 46.

3. Bianchi-Bandinelli, end of article "Arte Romana," *Enciclopedia dell'Arte Antica,* Vol. VI, pp. 16-18.

4. Wickhoff, *Die Wiener Genesis,* 1895.

5. C. Picard, *Auguste et Néron,* pp. 93 ff.

6. C. Picard, *La sculpture antique,* Vol. II, p. 176.

7. See E. A. Sydenham, *Roman Republican Coinage,* p. 145 and pl. 24, no. 879.

8. In the Ostia Museum.  See Russell Meiggs, *Roman Ostia,* 1960 pl. XXX a.

9. In the Edmond de Rothschild Collection, Paris.  See J. Charbonneaux, *L'Art Romain au Siècle d'Auguste,* pls. 81 and 82.

10. The Ara Pietatis reliefs were reused in the façade of the Villa Medici.  See R. Bloch, in Cagiano de Azevedo, *Antichità di Villa Medici,* pp. 9-23, and C. de Azevedo, *ibid.,* pp. 56-64, pls. III-XII.

11. Bianchi-Bandinelli, *op. cit.*

12. In Vatican Museum.  See F. Maggi, *I Rilievi Flavi della Cancelleria.*

13. Mosaic *in situ* in Piazza dei Corporazioni, Ostia.  See G. Becatti, *Scavi di Ostia,* Vol. IV, *Mosaici.*

14. This relief was reused with seven others from the same monument in the attic of the Arch of Constantine.

15. Selim Augusti, *La tecnica dell'antica pittura parietale pompeiana,* pp. 313-54.  R. Etienne, *La Vie quotidienne à Pompeii,* pp. 320-21.

16. A similar use of light and dark appears in literature, for example in the episode of Nisus and Euryalus, *Aeneid* IX, 370 ff.

# BIBLIOGRAPHY

## ROMAN ART — GENERAL

F. WICKHOFF: **Die Wiener Genesis,** 1895

D. E. STRONG: **Roman Imperial Sculpture,** 1961

R. BIANCHI-BANDINELLI: **Storicità dell'Arte Classica,** 1950

R. BIANCHI-BANDINELLI: **Arte in Enciclopedia dell'arte antica classica ed orientale,** VI, 1965

C. C. VAN ESSEN: **Précis d'histoire de l'art antique en Italie,** 1960

## ROMAN PAINTING

A. MAU: **Geschichte der dekorativen Wandmalerei in Pompeji,** 1882

W. HELBIG: **Wandgemälde der von Vesuv verschütteten Städte,** 1868

A. SOGLIANO: **Le pitture murali campane,** 1879

G. E. RIZZO: **La pittura Ellenistico-romana,** 1929

L. CURTIUS: **Die Wandmalerei Pompejis,** 1929

H. G. BEYEN: **Die Pompejanische Wanddekoration von zweiten bis zum vierten Stil,** I 1938; II, I, 1960

K. SCHEFOLD: **Pompejanische Malerei: Sinn und ideen geschichte,** 1952

K. SCHEFOLD: **Die Wände Pompejis,** 1957

K. SCHEFOLD: **Vergessenes Pompeji,** 1962

FR. WIRTH: **Römische Wandmalerei von Untergang Pompejis bis an Ende des dritten Jahrhunderts,** 1934

M. BORDA: **La Pittura Romana,** 1958

# INDEX